WILLIAM GILLIES

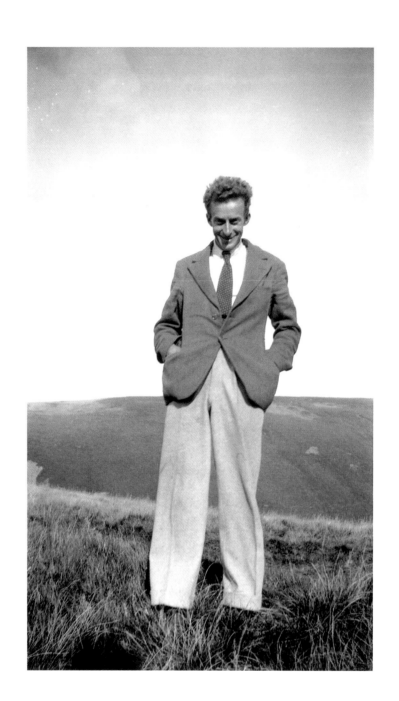

JOANNA SODEN
AND VICTORIA KELLER

WILLIAM GILLIES

CANONGATE

in association with The Royal Scottish Academy
and supported by

THE POST OFFICE

First published
in Great Britain in 1998
by Canongate Books Ltd
14 High Street · Edinburgh EH1 1TE

British Library Cataloguing-in-Publication Data
A catalogue record for this book is available on
request from the British Library

Hardback ISBN 0 86241 788 0
Paperback ISBN 0 86241 759 7

Designed by Dalrymple
Typeset in Eric Gill's Golden Cockerel and Gill Sans
Printed and bound by Toppan
Singapore

Front cover: detail from
W.G. Gillies, *Mauve Landscape*, c.1956
oil, 61.5 × 74cm, plate 141
(*Royal Scottish Academy*)

Back cover: Gillies at Loch Tummel, 1936
(*Royal Scottish Academy*)

Frontispiece:
Gillies on the Lammermuirs, late 1920s
(*Royal Scottish Academy*)

FOREWORD

ROYAL SCOTTISH ACADEMY

When Sir William G. Gillies died in 1973 he left no direct descendants, and his entire estate was bequeathed to the Royal Scottish Academy with which he had enjoyed a long and close relationship since he first became an Associate in 1940. Sir Robin Philipson, President of the Academy at the time of Gillies's death, and Sir William MacTaggart (Past President of the Academy), were executors of his estate. Certain paintings and some of his large collection of bric-a-brac were passed on to colleagues and friends. Other articles were distributed among the Scottish colleges of art for use in the studios (as Gillies had used them). The residue of Gillies's possessions – a vast collection of his own paintings and drawings, personal items and furniture – passed into the collections of the Royal Scottish Academy (RSA). After much deliberation the RSA decided to sell the Gillies home in the Midlothian village of Temple, and to create a special fund to be used for educational and charitable purposes. The Academy's 'Gillies Fund' has since that time assisted Members of the Academy, young artists and art historians in the furtherance of their work.

The Royal Scottish Academy has long wished to acknowledge Gillies as a benefactor and also his importance as a most distinguished painter and teacher over a long career. It was decided to do this by celebrating in 1998 the centenary of his birth in several ways. One of these is the publication of this book, which offers a fascinating insight into the life of Gillies. By relying heavily on previously unpublished material from the Gillies Archive, now held in the RSA, and also on his personal collection of paintings (many of which have been unseen since the 1920s and 1930s), this attempts to assess fully his life, work and importance.

The Academy has been most pleased to collaborate with the publisher, Canongate Books, and has enjoyed the most generous support of the sponsor, The Scottish Post Office Board. We, in the Academy, must express our sincere thanks to Bill Smith of Robert Fleming Holdings for giving of his time to act as editor; to Joanna Soden and Victoria Keller who have researched and written the text; to the Administrative Secretary, Bruce Laidlaw in his role as co-ordinator of this project; and to fellow members of the Gillies Working Party for their contributions overall.

We also wish to acknowledge the individuals and institutions who have generously assisted in this project with practical advice or their personal memories of Sir William Gillies as artist, teacher, colleague and friend.

WILLIAM J.L. BAILLIE CBE
President, Royal Scottish Academy

opposite detail from W.G. Gillies, *Beach at Laide*, 1937
pencil and watercolour, 47.9 × 63.0cm, RSA, plate 21

FOREWORD

THE POST OFFICE

Art is surely one of the great pleasures and challenges of life. It also provides a special, many faceted window on times past; and, in this century especially, a fascinating reflection of the turmoils that have left almost no branch of human thought, endeavour and activity untouched – often dramatically, and sometimes beyond all past recognition.

To see art so is to see art operating as artefact and symbol, both on many levels; and it is to see the artist as a person of special creative and symbolic importance. That is why careful reading of this excellent book and, even more importantly, scrutiny of Sir William Gillies's paintings and drawings will provide much pleasure and insight, in an appropriately modest and quiet Scottish way, of course, into much that has stirred Scotland – and Europe – and insight into many of those values, emotions, scenes which are perennially Scottish, indeed perennially human.

We in The Post Office are proud of our links with the Royal Scottish Academy, especially with the postage stamp bearing its coat of arms which we issued as part of a set of stamps marking the 300th anniversary of the Revival of the Order of the Thistle in 1987. We are also proud of our small but, we hope, not insignificant encouragement of the arts in Scotland.

We take our prompting for support of this meticulously researched, elegantly written and beautifully produced book, above all, from the continuing importance of the daily work we do in serving the disparate communities with their differing business and social needs the length and breadth of Scotland. The more so, perhaps, in our rural and remoter parts which Gillies himself knew and loved so much.

There are many enduring lessons to be learnt from the essentially private but, I think, contented life and work of Sir William Gillies and his honourable place in the art of Scotland. This book can be relied on as a discrete but authoritative guide to art and man. Of that, and our support, I would like to think, Gillies would have approved.

JOHN WARD CBE
Chairman, Scottish Post Office Board

ACKNOWLEDGMENTS

The authors wish to acknowledge those individuals and organisations who assisted us in all areas of the production of this book. Those named below, and many others who are not listed, generously gave their time and shared their experiences. Without them we could not have done justice to William Gillies:

Janis Adams; Mrs Beatrice Anderson; William J. L. Baillie; William Buchanan; Alex Campbell; Miss Ena Cockburn; Kirsty Colam; Peter Collins; Thora Clyne; Glen Craig; Fine Art Department, Edinburgh City Libraries; Kate Fanning; Mrs E. Fletcher; Mrs Alison Geissler; Haddington Historical Society; Keith Hartley; Pru Haynes; James Henderson; Mrs E. Hendry; John Houston and Elizabeth Blackadder; Miss H. Lauerner; Kathleen and Margaret Moodie; James Mowat; Doris Mundy; National Monument Record for Scotland, Library; Cordelia Oliver; Perpetua Pope; Mrs Mary Rankin; Philip Reeves; Royal Academy Library; The Scottish Gallery, Edinburgh; Alan Soden; Tate Gallery Archive; Margaret and Mary Thomson; National Art Library, V&A; Meta Viles; Henry and Sula Walton; Henry T. Westwater; Sir Anthony and Lady Wheeler; Mr and Mrs John Winthrop; Anne Wishart.

The publishers wish to thank the following for permission to reproduce illustrations. References are to plate numbers.

Photo: Associated Newspapers, © Solo 50; Tom Baker 42, 73; Edinburgh College of Art: 49; Photo: © Hunterian Art Gallery, University of Glasgow / Tom Scott: 86; National Galleries of Scotland Picture Library: 18, 52, 63, 121 (Antonia Reeve), 131 (Antonia Reeve); Photo: George Oliver, © Cordelia Oliver: 31; George Outram & Co. Ltd. / The Herald and Evening Times: 28; C.F. Partoon: 6; Photo courtesy of Perth and Kinross Council Arts and Heritage Division / John Watt: 85, 118, 128; Antonia Reeve: 1, 4, 5, 7, 10, 11, 14, 21, 35, 39, 40, 43, 45, 46, 47, 48, 51, 54, 55, 59, 61, 62, 64, 65, 68, 69, 72, 74, 75, 76, 77, 79, 80, 82, 84, 87, 88, 92, 93, 95, 97, 98, 99, 100, 101, 104, 105, 108, 112, 113, 114, 116, 119, 120, 123, 124, 126, 127, 136, 137, 141, 145, 147; Tom Scott: 94; Photo: © Tate Gallery / John Webb: 89; White House Studios: 8, 15, 16, 17, 27, 37, 38, 41, 44, 53, 58, 60, 66, 67, 70, 71, 83, 91, 106, 107, 109, 110, 111, 117, 125, 129, 130, 132, 133, 134, 135, 138, 139, 140, 146, 148. All plates not listed here were taken by unknown photographers..

Extracts from *Still Life with Honesty* (1970), Films of Scotland Collection, are reprinted by permission of the Scottish Screen Archive.

ABBREVIATIONS

AAGMC Aberdeen Art Gallery and Museums Collections

ACGB Arts Council of Great Britain

ARA Associate of the Royal Academy

BC British Council

CAC City Art Centre, Edinburgh

CEMA Council for the Encouragement of Music & the Arts

ECA Edinburgh College of Art

EIF Edinburgh International Festival

GMAG Glasgow Museums and Art Galleries

JM John Moores Liverpool Exhibition

PAMAG Paisley Museums and Art Galleries

PEMAG Perth Museum and Art Gallery

RA Royal Academy

RGIFA Royal Glasgow Institute of Fine Arts

RSA Royal Scottish Academy

RSW Royal Scottish Society of Painters in Watercolours

SAC Scottish Arts Council

SNGMA Scottish National Gallery of Modern Art

SSA Society of Scottish Artists

The initials at the end of each chapter
indicate its author:

V.K. Victoria Keller

J.S. Joanna Soden

All dimensions are given in centimetres,
height precedes width

CHRONOLOGY

1857 Father, John Gillies, born Duns (19 February).

1864 Mother, Emma Gillies (née Smith), born Kirriemuir (27 October).

1895 Sister, Janet Louisa Dunn Gillies, born Haddington (29 June).

1898 WILLIAM GEORGE GILLIES born Haddington (21 September)
(ref. passport 1946, described as 5ft 7in, grey eyes, fair hair, no special peculiarities).

1900 Sister, Emma Smith Gillies, born Haddington (24 April).

1909–16 Secondary education at Knox Academy, Haddington (awarded the Dux Medal in 1916).

1916–17 EDINBURGH COLLEGE OF ART: studied for two terms before being called up for war service.
First teachers: John Menzies, Miss Simpson, Annie Morgan and Campbell Mitchell (Morley Fletcher was Director).

1916 Enlisted at Glencorse, Private with Scottish Rifles (Cameronians) (24 August).

1917 Called up for war service.

1918 Admitted into Bellahouston Hospital, Glasgow (12 August).

Removed to Barshaw Aux. Hospital, Paisley (30 August).

1919 Discharged from Army on Tuesday 25 March.

The Discharge Certificate reads 'Being no longer physically fit for War Service ... after serving one year 355 days with the Colours, and nil years 224 days in the Army Reserve' (also a ref. to wound scar on right thigh and 'two wound stripes').

EDINBURGH COLLEGE OF ART: resumed studies. Staff this time: David Alison (Head of Drawing and Painting), D.M. Sutherland, A.B. Thomson, David Foggie and Donald Moodie. Fellow students included: George Wright Hall, George C. Watson, David Gunn, William MacTaggart, William Geissler, A.V. Couling, William Crozier, Alexander Munro and Harold Morton.

1920 Painting trip: Comrie, Perthshire (August).

1921 FATHER DIED, Haddington (16 July).
Awarded ECA Minor Travelling Bursary of £20 (also one to William Geissler) with which he went to London (Easter vacation).
Painting trip: Thornhill and Dumfriesshire with Harold Morton (July).

1922 Awarded Diploma in Drawing and Painting by ECA at end of session 1921–22. Post-Graduate Studios and Maintenance Scholarships of £66 awarded to W.G. Gillies and William Geissler for 1922–23 Session. Qualified as Teacher of Drawing. Certificate awarded by National Committee for the Training of Teachers in Scotland.
RSA Stuart Prize: Commended.

Founder member of 1922 Group with annual exhibitions at The New Gallery, 12 Shandwick Place, Edinburgh.

1923 Awarded ECA Travelling Scholarship of £120 (also to William Geissler) at end of session 1922–23.
ECA Diploma was endorsed (highly commended), meaning he had satisfactorily completed a year's postgraduate study.
Travelled to FRANCE: Paris, Carte d'Identité states purpose to study with André Lhote, 38 lu, rue Bollard (7 November).

1924 Passed through Montreux (17 March), on the way to Florence.
Arrived in Italy (1 April), stayed in Florence (Pensione Giannini, Lungarno Serristori 21), also visited Padua, Ravenna and Venice, returned to Scotland in late May.
Gerald Moira appointed Principal ECA.

1924–25 INVERNESS ROYAL ACADEMY: Assistant Art Master, 24 September – 31 August

1925 EDINBURGH COLLEGE OF ART: part-time teaching post (session 1925–26), became life-long friend of Donald Moodie, and John Maxwell who joined the staff in 1929.

1926 Painting trip: Ballinluig, Perthshire; Mallaig and Arisaig, Morar; Tyndrum and Killin, Perthshire (August).

1927 Painting trip to France: Paris; Tours; Dax; Quimper, Audierne, Douarenez and Tréboul, Brittany (July).

1928 Painting trips: Lochearnhead and Callander, Perthshire (July); Crianlarich, Spean Bridge, Fort William, Mallaig (August).

1929 Settlement on purchase of house: 162 Willowbrae Road, Edinburgh (3 July).
Painting trip: Kirkcudbrightshire (August).

1930 Painting trips: Inverary, Argyllshire; Killin and Dunkeld, Perthshire (July); Alnwick, Northumberland to visit Dakers (August); St Monance, Fife (September).

1931 Painting trip: Glencoe, Fort William and Morar, Inverness-shire (August).
SSA Annual Exhibition included twelve works by Edvard Munch.
Began to share a studio at 45 Frederick Street with William MacTaggart (January). Invited to join The Society of Eight (December).

1932 Painting trips: Fearnan, Perthshire (July); The North – Ross and Cromarty; Macduff and the Banff coast (September).
Visit to Oslo and Gothenburg (July).
Hubert Wellington appointed Principal ECA.
ECA Annual Report recorded Gillies teaching Life Drawing and Still life.

1933 Painting trips: Callander and The Trossachs, (July); Morar and Mallaig; Drumnadrochit and Muir of Ord, Inverness-shire (August); Durisdeer, Dumfriesshire with Emma and John Maxwell (September).
S.J. Peploe joined staff of ECA.
Herbert Read, Watson Gordon Professor of Fine Art at the University of Edinburgh, delivered lectures at ECA in 1932–33 session on 'Modern German Art'.

1934 Painting trips: Shinness, Sutherland (July); Durisdeer, Dumfriesshire; Loch Tummelside, Perthshire (visited A.B. Thomson at Fearnan) (August).
SSA Annual Exhibition included twenty-five works by Paul Klee.

1934–35 Because of S.J. Peploe's illness, Gillies taught his Life Painting class for most of the session.

1935 Painting trips: Glenisla, Angus (July); Spinningdale, Sutherland (camped in Mrs Macrae's garden); Taynuilt, Argyllshire (camped at Brough Farm with Maxwell, met D.M. Sutherland) (August–September).
SSA Annual Exhibition included work by Braque and Soutine.

1936 SISTER EMMA DIED at Jordanburn Nerve Hospital (18 March).

Painting trips: Acharacle, Ardnamurchan (July);
Loch Tummel-side, Perthshire; Speyside (September).
Gillies now teaching Life Painting, Life Drawing and Still life.

1937　Joined SSA as Professional Member.
Painting trips: Laide, Wester Ross (July);
Comrie, Perthshire (August).
Trip to France: Paris, visited Exposition Universelle; Chartres, St Cloud, Versailles (with Harold Morton and John Maxwell) (September).

1938　Painting trip: Laide, Wester Ross (met D.M. Sutherland and family) (July).
Painting trip to France: Paris; Chartres; Rouen; St Valery-en-Caux; Calais (with Bill Logan and John Maxwell) (August).

1939　Painting trips: Rhynie, Aberdeenshire (with Harold Morton) (August); Alness, Dornoch and Spinningdale, Sutherland (August).
Moved to Temple, Midlothian, with his mother and sister Janet.

1942　ECA Annual Report 1941–42: resignation of Hubert Wellington and appointment of Robert Lyon as Principal.

1945–46　Appointed Acting Head of the School of Drawing and Painting, on retiral of David Alison, teaching Life Drawing and Painting.

1946　Formally appointed Head of Drawing and Painting.
Trip to France: took twenty-four Drawing and Painting students to Paris, housed at Cité Universitaire (September).

1947　Elected RSA.
The 1947–48 ECA Prospectus lists Gillies as Head of Drawing and Painting with the following Assistants: A.B. Thomson, D. Moodie, Allan E.J. Carr, Derek Clarke, P. Beaton, W. MacTaggart, Henderson Blyth, J. Hunter, E. Carolan, R.J. Philipson, C.D. Pulsford.

Painting trip: Pittenweem (camped at Kellie Castle), Anstruther, etc. Fife (July).

1948　RSA duties: Council and Committee of Arrangements (Painting Section, with A.B. Thomson and Donald Moodie.
Vuillard and Bonnard: EIF exhibition.
Painting trips: Dalbeattie, Galloway (with John Maxwell) (September).
Became Member of the Educational Institute of Scotland.

1949　RSA duties: Council and Curator of Library.
Visited Tigh na-Choille, Fearnan, Perthshire with William and Fanny MacTaggart (July).
Painting trips: Pittenweem (camped at Kellie Castle) and Anstruther, Fife; Perth; Balmacara, Wester Ross (July-August).

1950　Elected RSW.
Painting trip: Hospitalfield, Arbroath; Macduff and Gardenstown, Banffshire (with Henderson Blyth) (July).

1951　RSA duties: Committee of Arrangements (Painting Section), with John Maxwell and R Henderson Blyth.
Painting trip: Gardenstown (Afforsk Farm, Gamrie), Banffshire (September).

1952　*Ecole de Paris* exhibition arranged by British Council for Scottish Committee of ACGB.

1953　Painting trip: Dumfries; Dalbeattie and Newton Stewart, Galloway with John Maxwell (August-September).
Trip to Italy: Milan to see ECA student entries in Exposition Internationale des Academies des Beaux Arts; Florence (30 October – 7 November).
Commissioned to design poster of Balquidder for General Post Office.

1954　Painting trip: Dalbeattie, Galloway.

1955　RSA duties: Council.
Painting trips: Loch Tummelside, Perthshire (July); Coldingham; Eyemouth and St Abbs, Berwickshire (August).

1956 RSA duties: Council and Committee of Arrangements (Painting Section, as Convenor with William Wilson and Sinclair Thomson).
Braque: EIF exhibition at RSA.
Painting trips: Ardnamurchan; Killin and Lochearnhead, Perthshire (July); Berwickshire, etc. (August).

1957 Awarded CBE.

1958 Painting trip: Northumberland; Kendal and Cartmel, Cumbria; Lochearnhead, Perthshire (April).

1959 Appointed Principal, Edinburgh College of Art with his first Annual Report in the 1959–60 session.

1960–61 ECA Prospectus lists Gillies as Principal with Robin Philipson as Head of the School of Drawing and Painting.

1960 SISTER JANET DIED, Temple (8 November).

1961 RSA duties: Committee of Arrangements (Painting Section) with Mary Armour and Denis Peploe.

1962 Death of John Maxwell.

1963 RSA duties: Committee of Arrangements (Painting Section) with A.B. Thomson and Alberto Morrocco.
MOTHER DIED, Temple (15 February).

1963–69 President RSW.

1964 RSA duties: Council and Curator of Library. Elected ARA.

1965 RSA duties: Council, Curator of Library and Committee of Arrangements (Painting Section) with H.A. Crawford and John Houston.
Julius Bissier and Giorgio Morandi: SNGMA exhibitions.

1966 Retirement from ECA announced for end of 1966–67 session, succeeded by Stanley Wright.

Doctor of Letters (DLitt), University of Edinburgh.
Elected FEIS.

1967 RSA duties: Adjudicator of the Academy's School of Painting.

1968 RSA duties: Adjudicator of the Academy's School of Painting and Committee of Arrangements (Painting Section) with J. Miller and D. Michie.

1970 Knighted 'in recognition of his services to art in Scotland'.
RSA duties: Adjudicator of the Academy's School of Painting and Governor of ECA.

1971 Elected RA.
RSA duties: Adjudicator of the Academy's School of Painting, Committee of Arrangements (Painting Section) with A. McGlashan and W.J.L. Baillie, and Governor of ECA.
Painting trip: Campbeltown, Kintyre (October.)

1972 RSA duties: Adjudicator of the Academy's School of Painting and Governor of ECA.
Painting trip: Fyvie, Aberdeenshire (October).

1973 DIED, TEMPLE, 15 April.

WILLIAM GILLIES

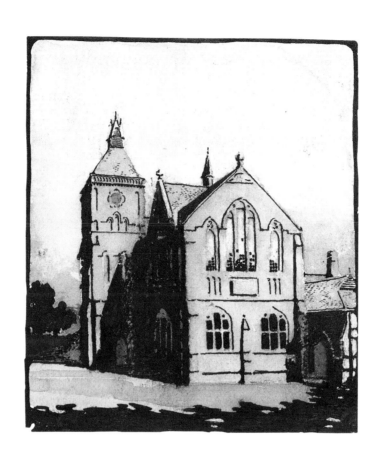

CHAPTER ONE

—

LIFE AND TIMES OF
THE ARTIST

—

Haddington, now the administrative centre for East Lothian but once the county town of Haddington-shire, is situated in fertile countryside about seventeen miles east of Edinburgh. At the end of the nineteenth century its population was a little over 4,000. A contemporary account noted that 'Lying 150 feet above sea-level, the town occupies a pleasant situation, almost in the centre of the county, on the left bank of the river Tyne ... and it is overlooked by the Garleton Hills (590 feet) about 1½ miles to the N'.[1] Although by-passed by the main-line railway from Edinburgh to London, it lies on one of the most important routes to England. Its geographical position may have resulted in plunder and devastation at times, yet it also led to trade and prosperity. The town evolved as an industrial and trading centre for the rich farmlands of the Tyne valley and adjacent lowlands. In contrast to these gentle surroundings are the open-topped Lammermuir Hills not far to the south, whilst beyond the lumpish Garleton Hills to the north are the cliffs and sandy beaches of the North Sea coast.

William George Gillies was born in Haddington on 21 September 1898. His father, John Gillies, was born in the town of Duns in Berwickshire. He had been a tailor by trade, and he settled in Haddington in partnership with his brother. However, following a disagreement, they separated and John Gillies took over a tobacconist and candlemaker's shop. William Gillies's mother, Emma Smith, was the daughter of a horse-hirer who later became an hotelier and carrier in the Angus town of Kirriemuir. John and Emma Gillies were to have three children. William's elder sister Janet had been born in 1895 and his younger

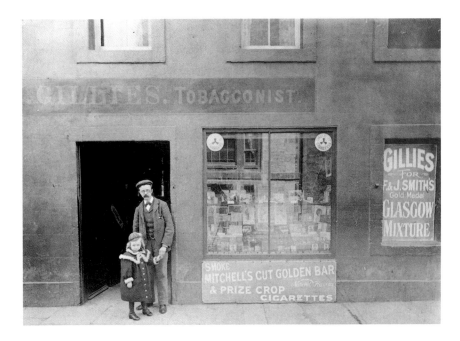

sister Emma was born in 1900. To begin with the family lived above the shop in the High Street [2],[2] but later they moved to Westlea, a newly built house in Meadow Park. Situated on the outskirts of the town, their new home was both close to the River Tyne and to the open fields. All three children were educated at the local primary school and at the town's Knox Institute (now called Knox Academy). William was a clever and dependable schoolboy, and he won the Dux Medal of the Knox Institute in 1916.

At school William displayed an early interest in drawing and painting [1]. There was no specialist art teacher at the Knox Institute and Miss Fordyce of the English Department took responsibility for art classes. In a speech given in 1966 Gillies described his own art education:

2 *above* John Gillies and Janet outside the family shop, Haddington, c.1900
RSA

1 *opposite* W.G. Gillies, *Knox Institute, Haddington,* c.1916
pen and wash, 10.2 × 10.05cm, RSA

… When I was at school (over 50 years ago), a very good country school, there was no Art Master at all and the English teacher obliged … so that I could take Higher Art. I still remember the examination test – I drew and shaded (and I enjoyed shading) the immense black range in the Cookery Department, with all its black pots and pans … I could lay a transparent wash down with the best, letting the colour come thicker as it settled down the page. We had, too, sheets on 'How to Draw Trees' with the recipes for rendering Silver Birch, Beeches, Chestnuts, etc … I was allowed to go away on my bike and make sketches of landscape, using all the tricks from the sheets, and colouring them until I had something I thought just as good as Sir Alfred East's, whose book on 'Landscape Painting' was my bible at the time …[3]

Family connections on the maternal side were strong when William was a schoolboy. By good fortune one of his uncles provided early stimulus for his artistic development. From 1887 to 1927 William Ryle Smith (1862–1945) [3], was art master at Grove Academy in Broughty Ferry, then a little town in its own right on the eastern outskirts of Dundee.

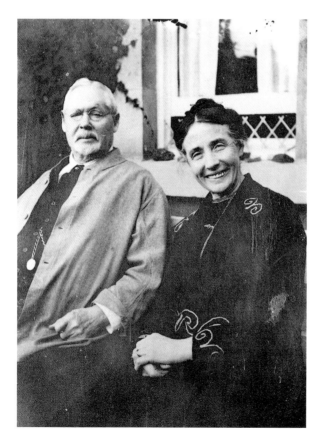

3 Mr and Mrs William Ryle Smith, Broughty Ferry, 1924
RSA

Although not well-known as a painter today, he had trained at South Kensington and Leipzig. He encouraged his nephew in the holidays, both in Angus and on his summer visits to Haddington. They went on sketching trips together. A watercolour titled *A Corner of Kirrie* (1912) [4], initialled by both of them, proves that they worked together. William Ryle Smith also introduced him to *The Studio*, the leading art journal of the day, which discussed and illustrated, both in black and white and colour, contemporary art from all over the world. Together they visited art galleries, such as The Orchar Gallery[4] in Broughty Ferry, and Dundee Art Gallery, and the annual exhibitions of the Royal Scottish Academy (RSA) and Society of Scottish Artists (SSA). His uncle had his own art collection and Gillies recalled being impressed with two watercolours by the Angus painter James Watterston Herald (1859–1914)[5] as well as a portfolio of colour reproductions of the work of English watercolourists.

Closer to home Gillies received encouragement from Robert Alexander Dakers, editor of *The Haddingtonshire Courier* and himself an amateur artist. In his teens he spent weekends with Dakers either painting in the countryside or finishing work in his attic studio. Dakers also possessed an art collection, comprising in the main paintings by artists who had worked in East Lothian in the nineteenth century. Gillies was especially interested in the pastoral work of William Darling McKay RSA (1844–1924), whose late landscapes portray the changing colours and seasons of the local scenery. Through contacts such as these the young Gillies developed a familiarity with recent Scottish painting as well as an awareness of art movements further afield, which acted as a stimulus to his pre-college work. His precocious talent is quite clear in an album of thirty-four watercolours and drawings of landscapes dated between 1913 and 1915, in which he is experimenting with line, colour, stylised forms and naturalism [5].

The young student was also assisted by Alexander Wright, a local watchmaker and enthusiastic collector. It was he who gave Gillies his first one-man show in 1920. This was in a side window of his shop in Hardgate, just round the corner from the High Street in Haddington. Many of the watercolours

displayed there were bought by local people.

On 24 August 1916, a month or so before his eighteenth birthday, Gillies was conscripted into the Scottish Rifles as a Private and thus became embroiled in the horror and tragedy of the Great War. He was not called up immediately, however, and so he enrolled at Edinburgh College of Art to begin the standard two years' preliminary course. In 1916 the College was less than ten years old, yet it was run on traditional lines, with great emphasis on drawing, by its Principal, Frank Morley Fletcher (1866–1949), and Head of Drawing and Painting, Robert Burns (1869–1941). As a first-year student Gillies had classes in drawing and painting, clay modelling, architecture, design and historical studies. Many of the male staff were away on active service at this time and women played an important role in teaching. He remembered his first teachers as Miss (Christina) Simpson and Annie Morgan, along with John Campbell Mitchell (1862–1922) and John Menzies.[6]

Gillies's first period at college came to an abrupt close at the end of the second term when he received the inevitable call-up papers [6]. His New Testament Bible bears an inscription on the flyleaf: 'This Testament was carried by Private W G Gillies, Scottish Rifles (Cameronians) during the Great War, and was with him at Arras, and in other places in France.'[7] More revealing is a diary in Janet Gillies's handwriting, giving a terse record of her brother's movements on active service. '1 January 1918. 1st letter sent', '24 March 1918. Wounded', '25 May 1918. Gassed', '4 August 1918. Admitted into Hospital ... with Dysentery', '12 August 1918. Admitted into Bellahouston Hospital, Glasgow ... ', '10 September 1918. Removed to Paisley (Barshaw Aux. Hospital ...)', and finally, with an almost triumphant note, 'Willie discharged from Army on Tuesday 25th March 1919.'[8] Gillies never talked about his experiences of the dreadful carnage, but he did lament the enforced break in his artistic training: 'There was no-one to discuss art with, no opportunity to keep your hand in. I did an occasional portrait sketch or a pencil scribble of trenches and war blasted landscapes – that was all. It was two years of wasted time.'[9] Several of these pencil 'scribbles', for example *Our Post Behind Our Wire* (1918), survive as lyrical and poignant renderings of the ghastliness of

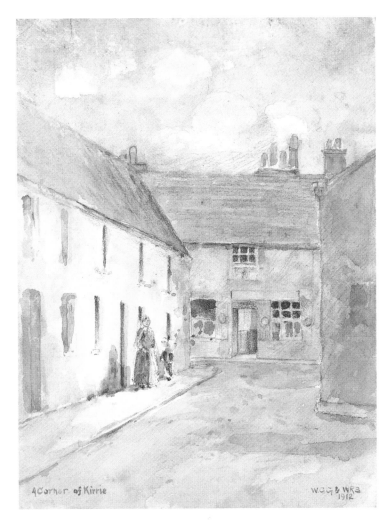

A Corner of Kirrie

4 *above* W.G. Gillies and William Ryle Smith, *A Corner of Kirrie*, 1912
pencil and watercolour, 23.4 × 17.4cm, RSA

5 *left* W.G. Gillies, *Beeches, Letham*, 1915
ink and wash, 14.6 × 12.1cm, RSA

life and death on the Western Front [7].

In 1919 Gillies resumed his studies at Edinburgh College of Art. Since his departure in 1917 there had been many changes in both staff and students. Among the teachers who had returned from war service were David Alison (1882–1955) and David Macbeth Sutherland (1883–1973), who had served with the Royal Scots, and Adam Bruce Thomson (1885–1976), who had served with the Royal Engineers. All three were to become important to Gillies's development. Among the students there was William Geissler (1896–1963) who had served with the Royal Scots, and there were also younger men and others who had not been called up such as William Crozier (1897–1930), William MacTaggart (1903–81) and Robert H. Westwater (1905–62).

At last Gillies was able to finish his preliminary course at the College. He then moved on to the diploma course, which included drawing, colour study, anatomy, painting, figure composition and historical studies. The teaching structure remained rigid with much stress on life drawing and painting. The practice of copying the work of other artists, especially the Old Masters, was encouraged; Gillies later explained: 'I took things from everybody ... I even became adept in copying Walter Grieve, who taught me life painting ... '[10] He also appreciated the teaching of David Alison, who had taken over from Robert Burns as Head of Drawing and Painting, and

more particularly that of D.M. Sutherland, of whom he remarked: 'There was something special about him and his brilliant handling of colour ... at the time he was using broken colour, while emphasising pattern and structure as well as atmospheric tone.'[11] Gillies lived in lodgings in Edinburgh at this time and was therefore also able to attend the College's evening classes in life drawing. In addition he explored the college library, studying the achievements of Impressionism and Post-Impressionism. By way of contrast, and indicative of things to come, Gillies and a group of friends would go into the countryside at weekends to paint, free from the constraints imposed by college teaching.

Gillies was a precocious student. In 1954 R.H. Westwater acknowledged that 'he was by far the most brilliant student of his day, winning all possible awards, including a post-graduate scholarship for study in Europe.'[12] He won a Minor Travelling Bursary of £20 to enable him to visit London in the Easter vacation of 1921 [8]. The intention was that students should follow an approved plan of study at the National Gallery and visit art exhibitions. The following year he was awarded his Diploma and also received a commendation in the RSA's Stuart Prize. Both he and William Geissler were granted Maintenance Scholarships of £66 to enable them to study at the College for a postgraduate year. No longer tied to a formal timetable, Gillies was able to follow his own

6 W.G. Gillies in the uniform of a Private in the Scottish Rifles, 1917
RSA

7 W.G. Gillies, *Our Post Behind Our Wire*, 1918
pencil, 9.0 × 12.7cm, RSA

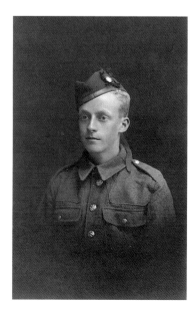

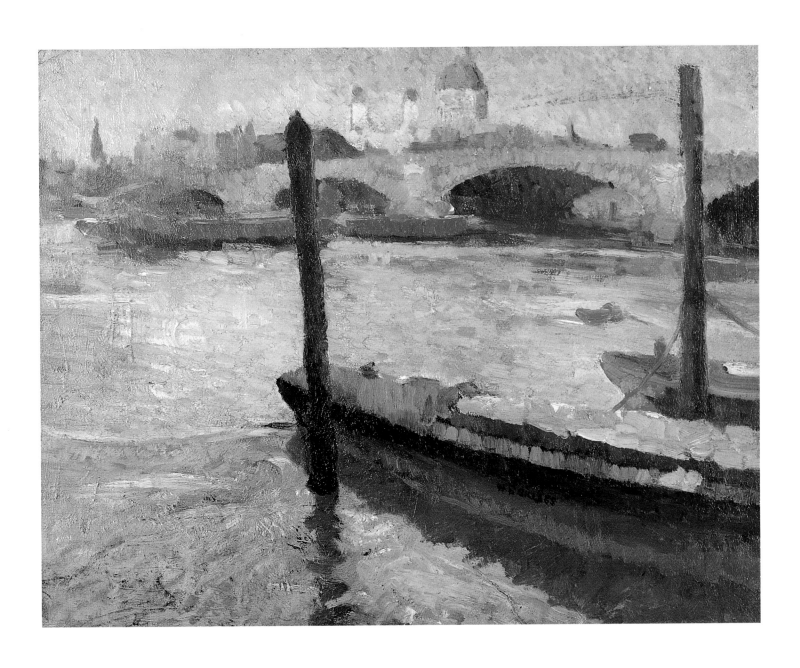

8 W.G. Gillies, *St Paul's and the River Thames*, c.1921
oil, 32.0 × 39.5cm, Private Collection

inclinations. He painted a series of fine portraits of his friends and family and he experimented with etching. At the end of that year Gillies had his Diploma endorsed (with a high commendation) and both he and Geissler won Travelling Scholarships of £120 in order to pursue their studies in Europe.[13] William Crozier, another Edinburgh student, was awarded the RSA Carnegie Travelling Scholarship the same year. Thus these three young men were set to travel to Europe together.

In 1970 Gillies, looking back on his art college training, described its conservatism:

… I went through college a long time ago. I got my Diploma in 1922. Scottish painting, maybe I should say Edinburgh painting, in the early twenties was pretty much a back-water, quiet and placid. It had in the main begun to absorb Impressionism. The Fauves were unknown. But Peploe, Cadell, Leslie Hunter were active. *They* were experimenting. They all had contact with French contemporary painting. They, however, were only as yet accepted by the few. I can remember as a student being warned not to be influenced by Peploe – *he* put black lines round things, and no black lines existed in nature. Paul Nash's and Nevinson's war paintings were a strong private influence. Gauguin's Breton landscapes were now and then reproduced in magazines. Wyndham Lewis was interesting and provoking but the Academic held the stage. We knew *nothing* of the great European movements. The 14–18 war had, in itself, caused a hiatus. It was into this atmosphere that photos of Picasso and Braque Cubist paintings burst like a bomb. Morley Fletcher, our Principal in 1921 I think, spent a long holiday in Paris, came back and gave us a wonderful lecture, with slides, on what was happening. He sent that year's Travelling Scholar … to Paris, to study under André Lhote … ; he sent William Geissler and me the next year … '[14]

André Lhote (1885–1962) was born and raised in Bordeaux. Inspired by both African woodcarving and the work of Gauguin, he began to paint around 1906. He then moved to Paris and had his first one-man exhibition in 1910. Thereafter he became part of the Parisian avant-garde, closely associated with the Cubists. Lhote applied Cubist principles to his work in an analytical and disciplined way. Although his paintings were seen to be modern, their premise remained academic. In 1922 he established his own school, the Académie Montparnasse, gaining a reputation as a gifted teacher of both French and foreign students.

Gillies and Geissler arrived in Paris [9] to enrol with Lhote early in November 1923, Crozier following a little later. Gillies recalled that Lhote was not

9 W.G. Gillies in Paris, 1924, RSA

10 W.G. Gillies, *On the Road to San Miniato, Florence*, 1924
pencil, 26.5 × 28.0cm, RSA

particularly impressed with their college portfolios: 'he thought that technically we were very good but that our ideas were terribly old-fashioned.'[15] The students worked long hours in Lhote's studio. His teaching methods were described in a report which William Crozier wrote to the RSA a few months after enrolment:

M. Lhote is a painter of high standing and though his work is essentially modern … his teaching, both as regards life and composition, is very good, and is based on study of the Old Masters. He has a very helpful trick of pulling out of his pocket postcards and prints to point an explanation or a criticism … one is more likely to benefit later after time and thought than at present in the not too comfortable conditions of a crowded studio.[16]

The stress on teaching modern ideas through the study of Old Masters is further illustrated by one of Crozier's sketchbooks of the period, which contains detailed notes and analytical pencil studies made in the Louvre.

Although a gifted and hard-working student, Gillies's months in Paris did not come up to expectations. At first he reported home with optimism: 'Getting along splendidly … ',[17] but later disillusionment with Lhote's teaching methods set in:

What started off as appearing to be a new and exciting way of producing pictures turned out to be a dismal cul-de-sac. I did not long employ Lhote's principles in my paintings … The hours were long and constant, so that we came into contact with no other French painters … we went to exhibitions or out sketching at weekends … that was all.[18]

Despite the long hours spent in the studio, Gillies visited the Louvre and also had the chance to see paintings by Cézanne, Gauguin, Bonnard, Vuillard, Braque and Picasso. However, he claimed to have been attracted to the work of younger painters such as Derain, Ozenfant, Matisse, Metzinger, Gleizes and Marquet. Among the books he bought during his time in Paris were three short books on Picasso, others on Cézanne, Corot (written by André Lhote) and Derain, and the February 1924 issue of the *Bulletin de L'Effort Moderne* edited by Léonce Rosenberg, dealing at length with aspects of Cubism and con-

taining an article by Fernand Léger. Although Gillies claimed to have been disappointed with Lhote and his teaching, the teacher thought highly of his pupil. A report sent back to Edinburgh College of Art described Gillies and Geissler as *'le type de l'élève tel que je le rêve'*.[19]

Gillies, Geissler and Crozier remained in Paris until the end of March 1924, when they travelled by train through France and Switzerland into Italy. By the beginning of April they were settled in Florence, having found lodgings at Giannini's Pensione which overlooked the River Arno.[20] From there they visited museums and churches and went sketching in the towns and the countryside [10]. Later Gillies travelled north to Ravenna, which he found 'terribly hot', and then on to Padua and Venice where it rained. He ran out of money and returned to Scotland in May. Judging from the work he executed in Italy, Gillies was especially interested in the frescoes of the Italian quattrocento painters, for example in the church of S. Maria Novella in Florence. He made drawings and watercolour copies of them. He bought books on Fra Angelico and Filippino Lippi. In his studies of landscapes and street scenes the influence of Cubism as taught by Lhote can be seen. Sketches done during his travels were worked up in oils on his return to Scotland. The impact of Cubism lingers on through them and into other phases of his artistic development.

As well as gaining his art college diploma, Gillies had obtained his teacher training certificate from Moray House College in Edinburgh in July 1922. Although he was an exceptional art student, he had decided to earn his living through teaching, rather than through painting. Before leaving for Paris and Italy, Gillies had already been appointed Assistant Art Master at Inverness Royal Academy for the academic year 1924–25. Thus he had a short summer to digest his experiences in France and Italy before travelling north to take up his teaching post. As this was a full-time appointment there was little opportunity for his own work and he remembered 'only one oil painting, a still life in the cubist manner done during the Easter vacation.'[21] However, in the RSA collection there is a watercolour *Inverness* (1925) [11], which interprets a recognisable landscape in a cubist

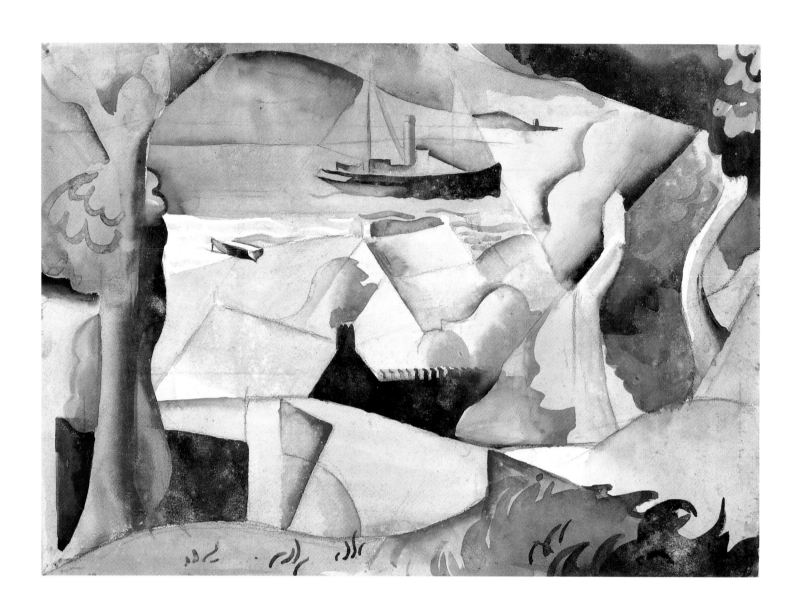

11 W.G. Gillies, *Inverness*, 1925
pencil and watercolour, 25.4 × 35.6cm, RSA

manner, demonstrating that Gillies had not yet abandoned the lessons of Lhote.

In the late summer of 1925 Gillies left Inverness for the family home in Haddington and prepared to take up a part-time teaching post at Edinburgh College of Art. Whilst he had been a student, there had been a number of changes in family circumstances. In 1921 his father John Gillies had died. To keep the family business going, his younger sister Emma left her office job with *The Haddingtonshire Courier* to look after the tobacconist's shop in the High Street. She ran the business single-handedly, but Gillies and his elder sister Janet helped out to enable her to take holidays. The family was a closely knit unit, very supportive of one another. Someone, most probably his elder sister Janet,[22] was a keen photographer, because many hundreds of snapshots, dating from the early 1920s onwards, reveal details of family life. There are photographs of Janet's office outings, of their mother with her relatives in the garden, of the whole family enjoying picnics beside the motor car [12], and of a

time working in the locality. A sequence of oil paintings of the 1920s, based upon the riverside walks around Haddington (a mere five minutes from his doorstep), shows him experimenting with modern trends drawn from the work of all manner of artists from Delaunay to Vlaminck.

At the time of his graduation in 1922 there were few opportunities for young artists to show, or indeed sell, their work. The regular exhibiting societies, such as the Royal Scottish Academy and the Royal Scottish Society of Painters in Watercolours, tended to favour established painters and treated new and forward-thinking work with extreme caution. In response to this Gillies and William MacTaggart founded 'The 1922 Group', which consisted of recent graduates from Edinburgh College of Art. They established a pattern of holding annual exhibitions of their work in The New Gallery at 12 Shandwick Place, Edinburgh. The first was mounted in 1923 and Gillies exhibited with the group until 1929. Many years later he described this movement:

12 *below left* W.G. Gillies and Mrs Gillies 'On the Road, Loch Ness-side'
RSA

13 *below* Janet Gillies and 'Clinker', Haddington, 1927
RSA

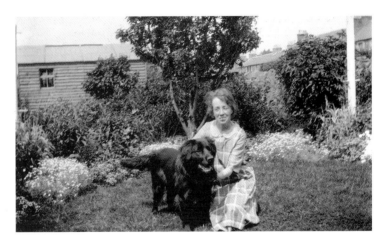

succession of spoilt family dogs [13]. Many had been pasted into albums with either prosaic identifications and dates written in Janet's neat handwriting or witty epigrams in Emma's rather schoolgirl hand. Some of the early photographs reveal places where Gillies went sketching: the trees beside the River Tyne, Tantallon Castle on its rocky promontory near North Berwick, and the windswept tops of the Lammermuir Hills. Although Gillies was teaching at Edinburgh College of Art, his hours were short and his landscape painting shows that he spent much

... Now, we could not look forward to our being accepted by the establishment art societies so we decided to unite and run our own group shows – the 1922 Group came into being. It caused quite a stir in Edinburgh. Peploe encouraged us, we found quite a few people willing to buy our efforts ... and [it] was invaluable to us as an incentive to carry on painting.[23]

Unfortunately few catalogues have survived and our impression of these exhibitions is hazy. Their importance lay both in the focus they presented of

'modern' painting in Edinburgh, albeit tempered by traditionalist training, and in the practical exhibiting experience this afforded the young artists themselves. In a review of the first show a contemporary critic was enthusiastic:

There is a delightful freshness of outlook about the whole exhibition. The note of individuality is everywhere. There is no hidebound adherence to tradition or convention. Yet there is nothing revolutionary in the exhibition, and there is a complete absence of the ultra-modern tendencies in art.[24]

Significantly the first exhibition was mounted before Gillies went abroad and the series of portraits he submitted were well enough received, but without particular comment. Following his exposure to French painting, reactions to later exhibitions were different: 'Mr W Gillies has a feeling for colour and design, as expressed in his still lifes. Some of his other work shows modern French influence.'[25] [14]

Gillies took up his part-time post at Edinburgh College of Art in the autumn term of 1925. Over the next forty-one years he taught at the College without a break. He enjoyed the work. He said of his appointment that it was 'One of the most important events of my life; I had contact with students, which ever since has kept me from turning into an old fossil, and with artists not only in my sphere but in others such as sculpture, yet it left me with enough leisure to devote to my painting.'[26] At the outset many of his new colleagues were his former teachers: for example David Alison, David Foggie (1878–1948), D.M. Sutherland, A.B. Thomson, and Donald Moodie (1892–1963). He was also joined by fellow students such as Geissler and, later, John Maxwell (1905–63) and MacTaggart. Close and life-long friendships developed between these painters. The structure of teaching and its approach had changed little since Gillies had been a student. He taught life drawing and painting, and also some drawing from the antique and still life classes. Gradually his hours were extended until he was appointed on a full-time basis in 1934. In addition to his weekday teaching duties, Gillies took an informal Saturday morning sketching class for a small group of design students. They went to places such as Cramond or Duddingston, then on

the fringes of the city, where he encouraged them to paint in watercolour directly from landscape subjects. A student who remembers these visits says that he would stress the need to capture the essence of the place in as little time as possible – speed was of the utmost importance.[27] Such teaching was in contrast to the approved methods at the College and very much reflected Gillies's own approach to landscape painting.

In July 1929 the Gillies household moved from Haddington to a new home in Edinburgh at 162 Willowbrae Road.[28] As an affectionate reminder of their East Lothian origins they named the house 'Garleton' after the hills on the edge of Haddington. Situated on the eastern outskirts of the city and backing onto the haunch of Arthur's Seat in Holyrood Park, it offered open vistas north to the Firth of Forth and east towards the Lammermuirs. By this time Janet was working in the office of a city legal firm. Emma too was about to enter Edinburgh College of Art to study ceramics. It appears that the move from country to town was a considerable wrench for them all. Although it was much more convenient for commuting daily to the College, it entailed a significant change in Gillies's term-time pattern of work. Instead of using the East Lothian countryside as the basis of his painting, he now turned to the urban subjects which were, quite literally, on his doorstep. He sketched Willowbrae Road from all angles [15], he painted Northfield, the new housing scheme across the road, and he executed many studies of the gardens at the back of the house. In his own garden he erected an old army hut to use as a studio, where he could set up still life arrangements.

In 1930, as a consequence of the early death of his friend William Crozier, Gillies inherited a share in a studio at 45 Frederick Street, Edinburgh, alongside his friend and colleague William MacTaggart. There is a closeness in their work of the late 1920s and 1930s, particularly in landscape painting. In adjoining studios at the same address were two notable women artists, Agnes Falconer (1883–c.1967) and Lily McDougall (1875–1958), who encouraged and helped their younger neighbours. Lily McDougall specialised in large, colourful oil paintings of great clusters

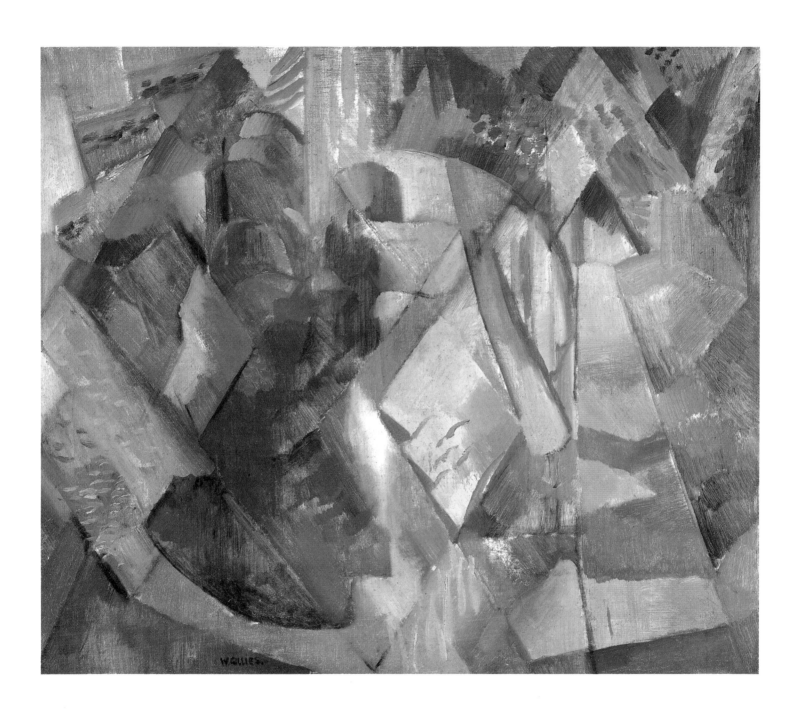

14 W.G. Gillies,
Trees on the Tyne, Haddington, c.1924
oil, 55.8 × 64.8cm, RSA

15 W.G. Gillies, *View from 162 Willowbrae Road*, 1932

oil, 65.5 × 76.1cm, RSA

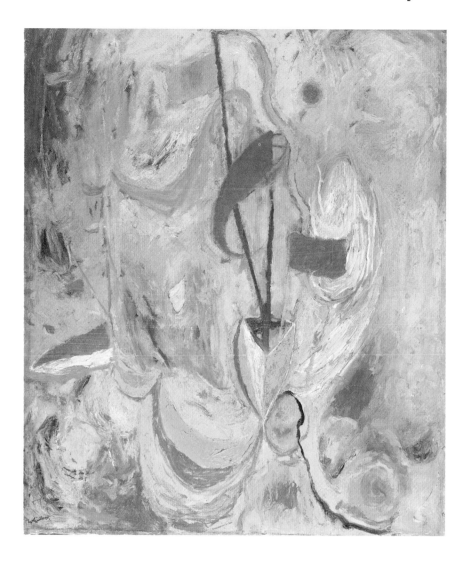

16 W.G. Gillies, *Flags and Bunting*, c.1935
oil, 76.2 × 65.7cm, RSA

Throughout the thirties John Maxwell and Gillies went every Sunday night to the home in Morningside of Dr Frederick Porter, Mrs Porter (Peploe's sister) and Marjory, their daughter. Dr Porter was a very gifted amateur painter, interested in everything pertaining to contemporary thought in the art world, and those Sunday evenings became of vital importance as influence on the outlook of … Gillies.[31]

During the 1930s he painted a series of fine portraits of Marjory. These are significant not only for their quality and experimental nature, but also for being virtually the only portraits he painted outside his immediate family after leaving college.

From the late 1920s Gillies was increasingly exhibiting his work. In 1927 he had two drawings hung in the Royal Scottish Academy's Annual Exhibition. That year, and until 1931, he also showed work in certain group shows at the St George's Gallery in London's Grosvenor Street. This small gallery was run by Arthur R. Howell who used it to present the work of young artists. He explained that 'The St George's Gallery was interested in all contemporary work, especially that of the younger and more advanced artists, provided such work reached the standards for which the Gallery stood. These standards were to be found only in the picture itself judged as a work of art, unaffected by any commercial appeal.'[32] It is significant that Gillies, who both lived and worked so far from London, was one such figure. Although the life of the gallery was brief (it was forced to close in the autumn of 1931) it served as an important opening for new talent. Sir Edward Marsh described the gallery as 'a delightful place to visit, and one was sure to find something of interest. I well remember getting my first David Jones there, and I believe that I am right in thinking that Henry Moore and Frances Hodgkins were two of the now acclaimed artists that Mr Howell was the first to divine and display.'[33] Unfortunately, references to Gillies's paintings at the St George's Gallery are scarce, but a cluster of English newspaper cuttings from October 1928 demonstrate that his work on display there was already being discussed with respect: 'Mr Gillies, who shows landscapes and still-life subjects in oil and water-colours, is intelligently

of flowers. In 1938 Gillies painted *Flowers on a Round Table* as a tribute to her. By the end of his life he owned three excellent examples of her work. It was in this studio that Gillies painted many of his portraits of the 1930s, later recalling that 'that studio in Frederick Street held many happy artistic associations.'[29]

Another significant Edinburgh address in the life of Gillies at that time was 65 Morningside Road, the home of Dr and Mrs Frederick Porter and their daughter Marjory. Mrs Porter was the sister of Samuel John Peploe (1871–1935), one of the four painters known as the Scottish Colourists.[30] Peploe had already supported Gillies's activities with The 1922 Group and, as we shall see, was to act as his sponsor for membership of The Society of Eight. Some notes in Gillies's own hand describe the background:

adapting Continental principles of design to his native impulses – most of his landscapes being in the Highlands ... '[34]

In Edinburgh in December 1931 Gillies was invited to join The Society of Eight. This select group of artists had been created in 1912 with a fixed membership of eight established painters, new members being 'invited' only on the resignation or death of existing ones. The Society held annual exhibitions at its permanent venue at the New Gallery in Shandwick Place; each member[35] was entitled to 'a wall'. Peploe and F.C.B. Cadell (1883–1937) were Gillies's sponsors on this occasion. Gillies regarded the invitation to join as a great compliment. He first exhibited with the group in February 1932. From the outset the Scottish critics found his work provocative: 'One of the more prominent of the Edinburgh painters, with a penchant for the emphasised aims and effects of the advanced school, Mr Gillies's appearance adds a certain piquancy to the collection ... '[36]

As the years passed and Gillies explored different avenues, his work became no easier for visitors to The Society of Eight's exhibitions. A critique dated 1934 struggles to come to terms with his paintings:

The landscapes of this artist are notable for an extraordinary fluidity, a sense of imminent disintegration into their component atoms. It is as though Mr Gillies saw through outward appearance into the whirling vitality which underlies the most inanimate objects, and somehow manages to express that vision in paint, though his still lifes are completely static, being interesting and provocative arrangements of mutually independent shapes.[37]

Though toiling to comprehend Gillies's oil paintings (his watercolours were more easily understood) this observer makes it quite clear that his landscapes and still lifes of the period were treated in quite different ways. For Gillies, landscape painting was the emotional reaction to a place and a time, whereas still life was a considered and analytical exercise.

In 1935 Gillies exhibited work in an even more abstract style, carrying titles such as *Balanced*, *Shapes in a Recess* and *Two Reds*. Not surprisingly these were received by a puzzled press: 'We take it that Mr Gillies really means to do what he is doing. That is to say his work is not merely an attempt to be ultra-

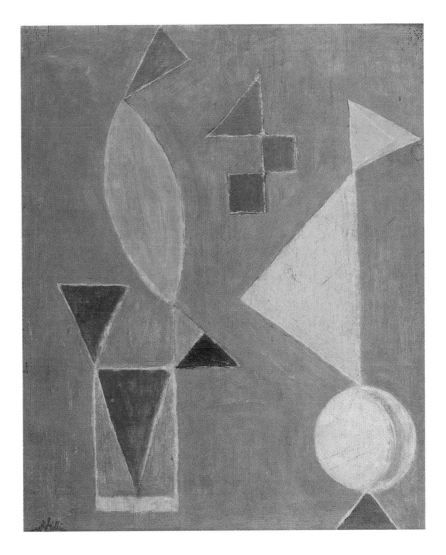

modern or a leg-pull.'[38] From comments such as this it is evident that his modernism was beyond the understanding of most of the Edinburgh gallery-going public of the time. A series of three paintings in the RSA collection survive from this most abstract of phases. *Flags and Bunting* [16], *Ascending* (1936) and *Untitled* [17] each reflect developments in Kandinsky's abstract work from about 1910 onwards. Significantly Gillies possessed a copy of *Kandinsky* by Will Grohmann[39] and he acknowledged a debt to that artist in an interview in 1960. However, this was as far down the path of abstraction as Gillies was prepared to go. In the same interview he explained: 'its not part of my make-up, I'm afraid. My kind of painting comes naturally to me. I need the contact with nature.'[40] Thereafter he was to concentrate on the representation and interpretation of nature – be it

17 W.G. Gillies, *Untitled*, c.1935
oil on board, 62.0 × 49.8cm, RSA

18 John Maxwell,
View from a Tent, 1933
oil on plywood, 76.2 × 91.5cm,
Scottish National Gallery of
Modern Art, Edinburgh

19 *below left* Camping at
Durisdeer, with Emma
Gillies and John Maxwell
(right), 1933
RSA

20 *below right*
Emma Gillies on Green
Lowther, 1933
RSA

portrait, landscape or still life – and by 1938 his work was finding a more appreciative audience: '*Society of Scottish Artists' Exhibition. Native Talent. A Gay and Continental Atmosphere ...* W.G. Gillies is perhaps this year's outstanding contributor. In 'Autumn Flowers' he gives a radiant rendering of the beauty and charm of flowers. Note the deep blue ... '[41]

Since he was a student Gillies had slipped happily into the pattern of making painting trips in the vacations. Sometimes he travelled with members of his family, sometimes with colleagues and sometimes with a mixture of the two. In fact these trips were some of the rare occasions when family life overlapped with painting and college life. Picture postcards to and from members of the Gillies family survive and reveal a web of journeys across Scotland – and also into France – from which stem many of his important paintings. In 1926 Gillies travelled to

Mallaig and Arisaig in the North-west Highlands, returning home via Tyndrum and Killin in Perthshire. Two summers later he returned to the Western Highlands. Throughout the 1930s he travelled all over Scotland. In 1931 he motored through Glencoe – 'They are making a fine new road from Tyndrum to Fort William, but the existing one is really terrible ... '[42] – and headed for Morar Sands and Mrs Macdougall's farm at Toigal. This excursion followed the usual pattern; Gillies and his companions would camp wherever they could, but would take their main meals at a local farm, and they would paint. Two years later he returned to the same spot with Maxwell [18]: 'We are down in Morar Bay, as usual ... However we are fairly high up and have a view both up to Morar River & down to the sea ... Johnny [Maxwell] is delighted with the place. Jim has toothache today.'[43] Another memorable holiday, on that occasion with Maxwell and Gillies's sister, Emma, was taken in September 1933 [19 and 20]. They camped at the village of Durisdeer in north Dumfriesshire, a place which offered great variety of scenery. The broad valley of the River Nith spreads out to the west and south with the Galloway Hills beyond. To the east and north rise the steep-sided, grass-covered Lowther Hills. Gillies wrote to his mother: 'Have found a rare camping site ... & intend to be here for some time. J. [Janet] would enjoy this place – plenty hills.'[44] The following summer Gillies took Geissler to the same place: 'Going out now with Bill to do a sketch. Durisdeer is looking lovely just now – heather just coming out – a lot of green everywhere.'[45]

Journeys in the far west and north of Scotland

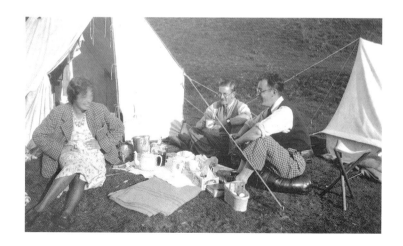

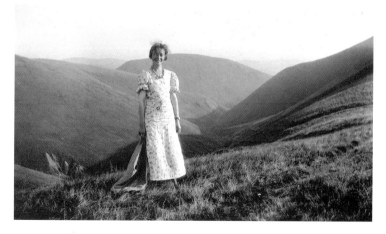

21 W.G. Gillies, *Beach at Laide*, 1937
pencil and watercolour, 47.9 × 63.0cm, RSA

22 *right* Laide, with D.M. Sutherland and
family, 1937–38
RSA

23 *below* W.G. Gillies in France with Bill
Logan (left) and John Maxwell (right), 1938
RSA

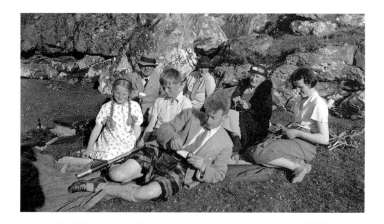

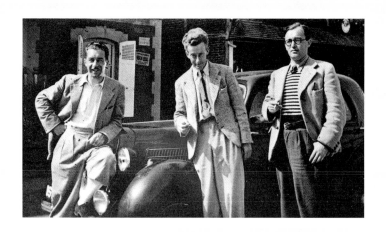

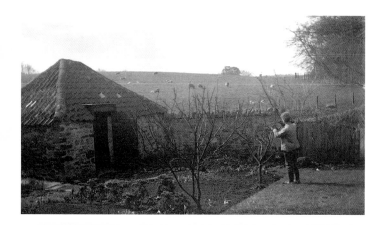

24 *left* Emma Gillies dressed as 'Pots', for a parade, Haddington, *c.*1928
RSA

25 *above centre* W.G. Gillies in the garden at Temple
RSA

26 *above* Having fun on a painting trip to Auchindoir, July 1939
RSA

followed: to Shinness in Sutherland in 1935, Achara-cle on the Ardnamurchan peninsula in 1936 and the tiny community of Laide on the edge of Gruinard Bay in Wester Ross in 1937 and 1938 [21]. One working holiday, taken in the mid 1930s, was with James Henderson.[46] The pair of young artists motored from Edinburgh north to Muir-of-Ord in Inverness-shire, and then a few days later they crossed over to the west coast and camped near Plockton. After a while they back-tracked to Muir-of-Ord, and from there journeyed east to Gillies's favoured sketching location of Gardenstown. Eventually they drove on to Aberdeen where 'we had a good meal' and then they went home. James Henderson remembers Gillies as always having an old car to drive, and that they crossed Scotland at an average speed of 20 miles an hour on quiet, narrow and rough roads. He re-members Gillies's ceaseless energy and urge to paint at all times. 'In the morning, you got up and cooked breakfast. Then you went out to paint. Then you came back to the tent and had something to eat – baked beans. Then you went out to paint again. You would come back for more baked beans, then go out again, and so on.'[47] Gillies and his travelling compan-ions met other Edinburgh painters during these working holidays. A.B. Thomson used a house at Fearnan on the north side of Loch Tay and D.M. Sutherland rented a house in Wester Ross near Plockton for many years. When camping nearby, the Gillies party would join the Sutherland family [22]. Gillies described the highs and lows of such a holi-day on a postcard to Emma: 'Johnny & I are delighted with the district. D.M. Sutherland & family are in Plockton, & we go down to see them at nights – play Lexicon. We are just beginning to get some work done – watercolours so far. Very bad storm last night, rain & wind – tent collapsed in middle of night but did not get wet. Fine again today ... '[48] In the summer of 1939 he travelled north with the landscape painter Robert Harold ('Tiny') Morton to Rhynie in Aber-deenshire and then as far north as Bonar Bridge in Ross & Cromarty. However the outbreak of the Second World War and the introduction of petrol rationing brought these painting forays to an abrupt close.

In addition to his exploration of Scotland in the 1920s and 1930s, Gillies made a series of journeys in France. Although almost all of his subject matter originated in Scotland, Gillies was constantly look-ing at and feeding off contemporary artistic move-ments further afield. In 1927, some four years after his student days in Paris, he returned to France with Robert Morris. A sketch map on the back of a post-card reveals a lengthy journey across France, first to Paris, on to Tours, and then to Dax in the far south-west where they found the weather so hot that they decided to turn north again. They headed for Brittany and places such as Tréboul and Concarneau, which had attracted other Scottish artists. From there they made their way home along the Norman-dy coast to the Channel ports.

In 1937 Gillies visited Paris again, on this occasion joining up with Maxwell and Morton. They visited Chartres, Versailles and St Cloud, but the main attraction was the *Exposition Universelle* in Paris. Un-doubtedly one of the highlights was Picasso's *Guerni-ca*, which was hanging in the Pavilion of the Spanish Republican Government. This painting made a lasting impression on Gillies and it was much talked about at Edinburgh College of Art in later years.[49] On a postcard written to his mother he accounted for his time: 'Have been to the exhibition 5 times & still only seen a little of it. Some fine shows in the smaller galleries. Got a very nice book & a huge box of pastels ... '[50] The following year he was back in France with Maxwell and Bill Logan [23]. After again spending time in Paris and Chartres, they motored north to Rouen and the Normandy coast, where they made a base at the resort town of St Valery-en-Caux. As always, the objective of the trip as far as Gillies was concerned was to work. A comment on a post-card to Janet reveals his constant energy and urge to get brush to paper: 'Charming place – done 6 water-colours & see quite a few more to do. Johnny [Maxwell] hasn't begun yet ... '[51]

Gillies paid his final visit to Paris in September 1946, this time with a party of twenty-four students from the College. In addition to what turned out to be the very onerous responsibility of keeping an eye on the students, Gillies visited exhibitions and bought books. His postcards home tell the story: 'Just to let you know I'm enjoying myself fine going

round old haunts in new company.' 'Spent yesterday going round the art shops buying books. Go to the Louvre today, again.'[52] Among the books he purchased were monographs on Utrillo, Vuillard, Picasso, Constantin Guys and James Ensor as well as general works on recent movements in French painting. On this occasion no paintings resulted directly from the visit. Gillies by now was focusing solely on his native environment as a source for his work.

In the 1930s a family trauma cast a dark shadow over Gillies's private life. His vivacious younger sister Emma had studied pottery at Edinburgh College of Art [24] and was accepted for a ceramics course at the Royal College of Art in London. She attended classes in 1932–33 and had started the next session, when her failing health caused her to return to Edinburgh. It appears that she suffered from a thyroid disorder, which resulted in great difficulty in breathing and also led to hyperactivity. In those days medical practice was not sufficiently advanced to allow an operation to cure the condition. During 1935 her health inexorably deteriorated. At first she was nursed at Vogrie House near Pathhead in Midlothian, a nursing home for the treatment of nervous disorders. A series of postcards from the autumn of 1935 poignantly reveal the family's desperate attempts to try to remain cheerful and optimistic. Eleven of Emma's pots were exhibited in the Annual Exhibition of the Society of Scottish Artists towards the very end of that year. Sadly she never regained her health and died on 18 March 1936, shortly after being admitted to Jordanburn Nerve Hospital in Edinburgh. Her tragic death – before her thirty-sixth birthday – was a devastating blow to the family. As with his dreadful experiences on the Western Front in the First World War, it seems that Gillies's method of coming to terms with this terrible loss was to bury it as deeply as possible. Indeed he did this so thoroughly that he wrongly recorded the year of her death in his *Biographical Notes*.[53] He treasured her personal effects: a white bead necklace which she wore in portraits he painted, photographs of her pots, her own notebooks and sketchbooks which she kept whilst working at the Royal College of Art, and even her collection of books on ceramics. A group portrait of himself, his mother and Janet, which he

painted at home later that year, demonstrates a brave closing of ranks in acceptance of the situation.

In the summer of 1939 the Gillies household moved back into the countryside to the small Midlothian village of Temple about thirteen miles south of Edinburgh. Consisting of little more than two single rows of cottages curving up the hillside from the steep gorge of the River South Esk, the village offered the quiet rural location that Gillies found so congenial for his work. Yet it was no more than a thirty minutes' drive to Edinburgh College of Art. Their new home was in fact three adjoining cottages linked by internal doors. The uppermost one became the family house, the middle one Gillies's studio and the lower one the garage. As in many Scottish villages, the front doors of the cottages open directly onto the road, but there are generous gardens at the rear. The Gillies family garden was enclosed by a mixture of stone walls and fences [25]. Beyond was a field and then a steep beech-wooded slope, which fell away into the South Esk gorge. The trees behind the cottage, like those beside the Tyne at Haddington, became an important focus for Gillies's work. In later years, when the local estate planned to cut down most of them, Gillies negotiated to save those on the knoll immediately behind the cottage by buying them as they stood. From the time the family settled in, the village, those trees, the garden with its pantiled shed and the cottage itself became the main focus of Gillies's attention. With the onset of the Second World War and petrol rationing recreational travel was severely restricted. As things stood, Gillies had to travel to the College daily in term-time. Although he was a fire warden for the village, his extra petrol allowance would not permit him to make sketching trips on the scale to which he had become accustomed. From 1940 onwards his work developed around certain themes close to hand: the garden from the cottage windows, the fields and the backs of the cottages and still life paintings done in his new studio.

The effect which the Second World War had on Gillies is not known. He remained at the College throughout and would have seen many students leave mid-way through their courses to serve in the armed forces, just as he had done a little over twenty

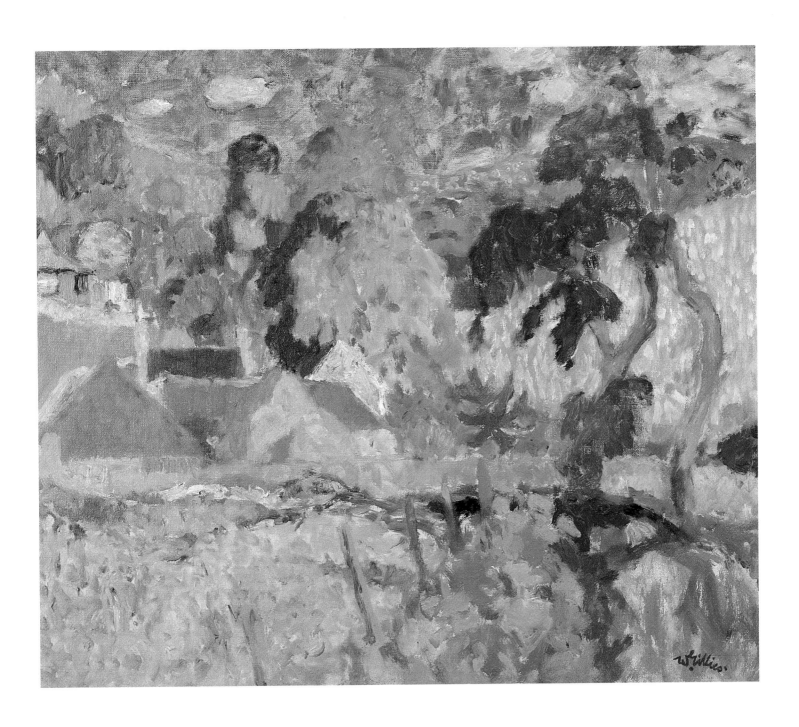

27 W.G. Gillies, *Near Borthwick*, c.1945–46
oil on board, 57.1 × 66.7cm, Private Collection

years before. Again the teachers and students who stayed behind were mostly women. Although the roll-call of the dead was not as dreadful as that of the First World War, the daily news reports must have acted as a stark reminder of his own experiences. Yet nothing of this is reflected in his paintings, which in the main are at their most light and impressionistic during this period [27].

From a cultural viewpoint one direct effect of the war was the creation of the Council for the Encouragement of Music and the Arts, known as CEMA, and the promotion of small-scale touring art exhibitions. The expansion of government-subsidised exhibitions both promoted the work of living artists and opened it up to a wider audience. In the thirties Gillies had exhibited with defined groups and societies. Occasionally his work had been hung in a dealer's exhibition and he had even shown paintings in shops such as Gordon Small's Gallery in Edinburgh's Princes Street. In the 1940s, however, his work was selected for inclusion in major exhibitions of the most advanced painting in Britain and abroad. For example in *Paintings and Drawings by British Artists*, an exhibition organised by CEMA, works by Gillies were hung alongside those of Mark Gertler, L.S. Lowry, Paul Nash, John Piper and Eric Ravilious. In 1946 Gillies was ranked on a level with his English contemporaries such as Ivon Hitchens, Paul Nash, Victor Pasmore, John Piper, Matthew Smith and Graham Sutherland in *British Painters 1939 to 1945*, a major exhibition organised by the newly formed Arts Council of Great Britain (ACGB). It was also at this period that Gillies's work was first exhibited abroad: in 1944 in Santiago, Chile, in *Exposicion de Arte Britannico Contemporaneo*, in 1946 in *Exposition Internationale d'Art Moderne* at the Musée d'Art Moderne in Paris and in Canada in 1948–49 in *Exhibition of Contemporary British Drawings*, organised by the British Council.

After the war Gillies was able to continue with the extended painting trips he had enjoyed in the 1930s. In 1947 he and Donald Moodie camped at Kellie Castle in Fife and worked in and around Anstruther. Gillies described their arrival to Janet: 'Arrived all safe. No Accommodation, so camping out at Hew Lorimer's. Kellie Castle, by Pittenweem. Food at Commercial Hotel, Anstruther – very good bkfast

this morning. Could you post Li-Lo – the newer one, but *not* the blower for it. Sleeping bag is not soft enough.' [26][54] The following year he was at Dalbeattie, close to the home of John Maxwell, and in 1949 he stayed at Fearnan on Loch Tay with William and Fanny MacTaggart. In the early 1950s he travelled repeatedly to the Banff and Buchan coast, making his base at Afforsk Farm at Gamrie near Gardenstown. By this time he was not always camping, yet the style of these excursions remained the same: 'Afforsk Farm, Gamrie … We have got a room in the farm, to sleep in, and are very comfortable, with a fire at nights. We do cooking in a large shed, & get lunch & tea out, often in Banff … We are now going down to Gardenstown to sketch.'[55] As well as these painting holidays he made shorter trips to the Borders. These were done by car or by motorbike (with two panniers for his painting equipment). Many of his landscape studies were done from handy roadside stopping places. However still life painting continued to be of equal importance. From small table arrangements he went on to complex interior views of the cottage. At other times he combined interior still life arrangements with views of the garden outside. The overriding impression in all these works, whether they be landscape or still life, is of a strong sense of place.

From 1940 onwards the art establishment accorded Gillies formal recognition, first in Scotland and then in England. In 1937 he had become a Professional Member of the Society of Scottish Artists. Whilst still regarded as a rebel in certain quarters, he was elected an Associate of the Royal Scottish Academy (ARSA) in 1940. Just seven years later, a year after he had been appointed Head of Drawing and Painting at Edinburgh College of Art, he was elected to the full status of Academician of the Royal Scottish Academy (RSA). Membership of the Academy brought duties and responsibilities. As well as taking his turn to sit on Council and other committees, he played his part in the preparations for the Academy's Annual Exhibitions [28]. In 1956 he was Convenor and thus had overall responsibility for the show that year. He worked hard to borrow for that exhibition paintings by Braque and Rouault, whom he greatly admired, but in the end he was unsuccessful. Instead

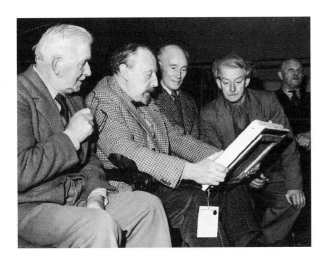

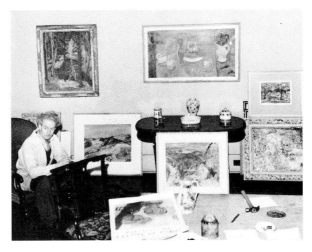

28 *left* Selection
Committee, at the Royal
Scottish Academy, 1955.
From the left: A. Graham
Henderson, W.O.
Hutchison, A.B. Thomson,
W.G. Gillies and Mr
Moncrieff (Administrative
Secretary)
RSA

29 *right* W.G. Gillies in
his studio at the
Edinburgh College of Art,
c.1952
RSA

a major Braque exhibition was mounted during the Edinburgh Festival later that year. Although water-colours were a very important part of Gillies's output, he was not elected a member of the Royal Scottish Society of Painters in Watercolours (RSW) until 1950. From 1963 to 1969 he served as its President. In a speech at the opening of the 1965 Annual Exhibition of the Society he commented on the value of such exhibiting societies:

I am sometimes told that the day of the big exhibition … is passed – that its usefulness has withered because of the growth of unnumerable [sic] small galleries, for one-man shows, or small group shows. These, I know, are important, but I, myself, think there's room for both. Where else than in the big exhibitions would the great majority of painters have any hope of a showing, and where else can the young man see his work and evaluate it, set among that of others, his elders as well as his own contemporaries? I remember David Foggie telling me, as a young man, that it took a good picture to get a place in the RSA and a *very* good one to make any kind of mark there. The big exhibition is a challenge, equally, to the young – to the amateur *and* to the mature artist. It is a fact, too, that in Scotland the big exhibitions are having a remarkable come-back, and in quality as well as popularity. The RSW is no exception.[56]

Honours from outside Scotland came when Gillies was awarded a CBE in 1957. He was elected an Associate of the Royal Academy in London in 1964 and an Academician in 1971. He received a Knighthood in 1970 'in recognition of his services to art in Scotland'.

When David Alison resigned as Head of Drawing and Painting at Edinburgh College of Art in 1945 Gillies was appointed in his place [29]. He remained in this post until his appointment as Principal of the College in 1960. The post-war period brought changes in teaching practices at the College, although Gillies continued to take life and composition classes. In the 1930s teaching was often by demonstration, whereby the tutor would paint over a student's work as a means of highlighting and correcting errors. This was evidently something Gillies found difficult, because he would very rarely do this, instead he would make corrections only down the side of a student's work. During the 1940s the practice of demonstration was increasingly supplanted by dialogue with the student. Gillies's approach was gentle yet firm: 'he would make you think about what you were doing by odd little remarks which you had to learn how to read, for example 'that's a funny looking toe' would mean that the whole foot was wrong.'[57] In his teaching, Gillies retained a natural humility. On his appointment as Head of Drawing and Painting he was entitled to a special studio of his own and a student of his remembers being invited there for tea and chocolate biscuits. However, on entering he discovered that the reason for this invitation was not simple hospitality but an excuse to be asked advice by the Head of Drawing and Painting as to how Gillies might resolve a difficult problem in his own current painting.[58] In this studio he not only painted but also stored his work and kept his ever-expanding collection of antiques. Many of these purchases

came from Mrs Humphrey's shop in the West Port. Although these items were used regularly in his still life paintings it was said around College that Gillies kept them there for fear of the tart comments his mother was sure to make if he took them home. Although the College was expanding during this period Gillies retained a sense of community and informality right up to his retiral as Principal in 1966. His senior position meant that much of his time was spent dealing with administrative matters. However, he always kept close to his staff and students. A draft of a speech written at the time of his retiral described the spirit he sought to foster:

There is something in the college atmosphere, in the very nature of our activities, that fosters this spirit. It is the spirit of the artist, in its widest sense, which permeates every section of our community, and affects every single individual who comes in contact with it. I'm glad I've been able to make a contribution to the creation of that spirit.[59]

30 Dr Robert A. Lillie and his cat
RSA

The post-war period brought an increasing measure of commercial success. In 1940 Dr R.A. Lillie bought his first picture by Gillies. Robert Alexander Lillie was born and raised in Aberdeen and studied philosophy at Edinburgh University. Although he lived modestly he enjoyed the freedom of a private income [30]. He was foremost a passionate musician and he began to collect art only when he reached his fifties. By the time of his death in 1977 his collection numbered many hundreds of Scottish paintings and drawings by living artists, crammed into his bungalow on the southern outskirts of Edinburgh. Works by Gillies far outnumbered the whole of the rest of the collection, as Lillie avidly made purchases every year. From surviving correspondence it appears that he bought not only from dealers' exhibitions all over the country, but also directly from the artist himself. He was an enthusiastic lender to exhibitions. It was through Lillie that Gillies had his first one-man show since his shop window display in Haddington back in 1920. In 1948 Aberdeen Art Gallery presented an exhibition of paintings by Gillies solely from Lillie's collection. This was followed by exhibitions of his work drawn from Lillie's collection at the Scottish National Gallery of Modern Art and in provincial galleries all over the country through the Scottish Arts Council's travelling exhibitions programme.

As his work became more widely known and appreciated, Gillies attracted the attention of other collectors. Foremost among these was Dr Harold Fletcher, Regius Keeper of the Royal Botanic Garden in Edinburgh, who became a close friend and supporter of both Maxwell and Gillies. Some of Gillies's most important paintings of the 1950s, such as *Interior at Temple* (1951) and *The Studio Table* (1951), entered Fletcher's collection. As wider recognition came (and his prices remained reasonable) Gillies's paintings and drawings were purchased for many private collections in Scotland and further afield. Later his works entered public collections, not only Scottish but also important British collections such as those of the Tate Gallery and the British Council.

Commercial success also went hand in hand with the fact that Gillies was exhibiting more widely. As well as having his works hung in the major open exhibitions such as the RSA and RSW, he was well

represented in dealers' shows throughout Scotland and the north of England. In 1949 Gillies had his first one-man exhibition in The Scottish Gallery in Edinburgh. Entitled *Watercolours: Scottish Landscapes*, it was well received and was a further mark of his acceptance by the art-buying public [32]. The Scottish Gallery regularly mounted one-man shows throughout the 1950s, 1960s and 1970s. In 1951 his major work *The Studio Table* was included in the 1951 *Festival of Britain* exhibition *Sixty Paintings for '51* and in 1954 the Arts Council of Great Britain mounted an exhibition of the work of Gillies and Maxwell in the New Burlington Galleries in London, for which his old friend R.H. Westwater wrote the catalogue. His paintings continued to be included in group exhibitions abroad.

However, apart from exhibitions drawn from the Lillie collection, Gillies did not have a major solo exhibition in a non-commercial gallery until 1970, when the Scottish Arts Council (SAC) mounted a large retrospective of 221 works in the RSA and SAC galleries in Edinburgh. From the start Gillies played a very active role in the whole project. He selected the entire exhibition, taking work from his own collection and from public and private sources. He arranged the complete hang, sketching little outline pictures on narrow strips of paper, which he kept rolled up in his jacket pocket. He drafted his own biography for the catalogue. For a man in his seventies it was a formidable task; eventually the Scottish Arts Council had to persuade him to have a telephone installed at home so that he did not have to rely on the public telephone box in the village! The exhibition and its subsequent tour were a notable success [31]. It was received with critical acclaim both in Scotland and further afield. In *The Daily Telegraph*, Terence Mullaly wrote 'That W.G. Gillies emerges triumphantly from the large retrospective exhibition of his work just opened in Edinburgh is the token of his power both to delight the senses, and to command the mind, and, at the same time, to weave a potent magic ... Truly this big exhibition, this confirmation of the stature of Gillies, is for the reputation of any man a formidable ordeal'.[60] Closer to home, Edward Gage in *The Scotsman* recognised the international significance of Gillies's painting

'We can now see his oeuvre outside the local setting of Scotland as part of a European heritage. His native sensibility, his love of the natural world and the traditional skills he learnt so well have all been strengthened in the forge of post-cubist formalisation, fired by colour explosions detonated by Gauguin, Pissarro, Matisse and Bonnard, and occasionally lit by the passionate intensities of expressionism'.[61] Gillies's popularity soared and he made many sales through the Scottish Gallery of both recent and earlier work as a result.

Home life in Temple had remained settled until Janet's death in November 1960. A local woman Mrs Cowan took over the housekeeping duties and helped his mother over the next three years. In 1963 Mrs Gillies died at the age of ninety-nine. Gillies remained at the cottage alone with only a black labrador, called Jet, for company. The early 1960s must have been a difficult time for him. Gillies lost not only his sister and mother, but also many of his closest colleagues and painting companions. Both Maxwell and Westwater died in 1962, followed by Donald Moodie in 1963. Gillies especially remembered John Maxwell:

... he came to college about the time I was given a very junior post there, and soon we were close friends, spending long spells of our summer holidays together, down in Dalbeattie with his parents and brothers, or wandering the length and breadth of Scotland in an old car I somehow contrived to keep running. Whenever I see a photo or picture of Morar, it conjures up our first trip together to the West and I see again that lovely painting of Morar Sands enclosed in the flaps of our tent ... [62]

31 W.G. Gillies and Sir Norman Reid, Director of the Tate Gallery, at the opening of the SAC Gillies Retrospective Exhibition, 1970

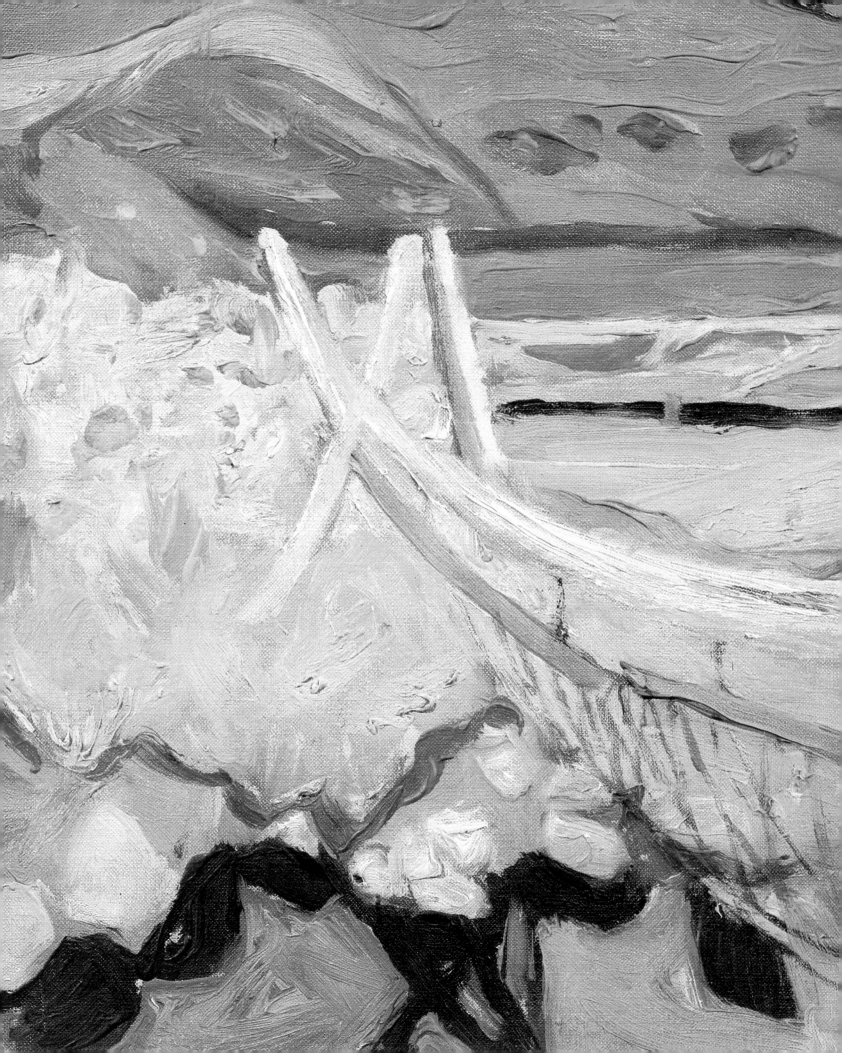

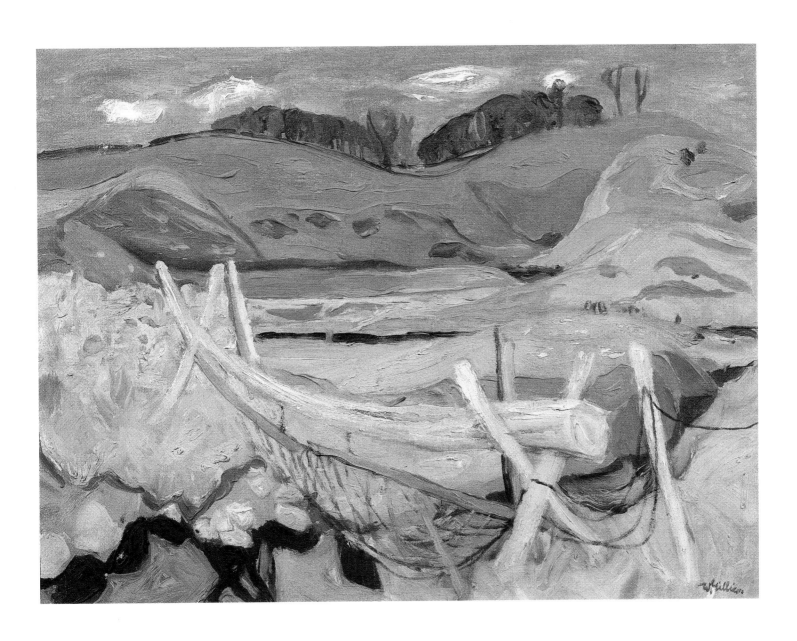

32 W.G. Gillies, *The Cattle Fence*, 1954
oil, 40.57 × 60.1cm, Robert Fleming Holdings Limited.

33 W.G. Gillies,
Early Spring, c.1964
oil, 90.65 × 121.9cm,
Robert Fleming Holdings Limited.

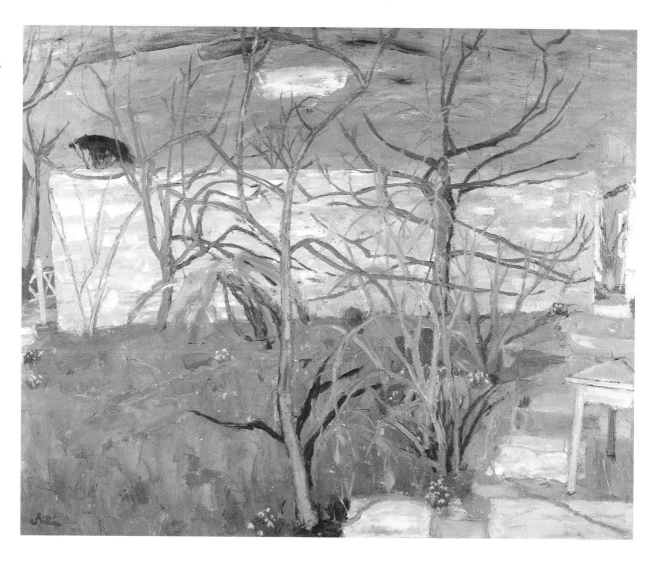

Another tremendous wrench, if not a bereavement, was Gillies's retiral as Principal of Edinburgh College of Art in 1966. During four unbroken decades of devoted service, the College had become a way of life and Gillies's influence on painting in Edinburgh was profound and long-lasting. However, it had also restricted his own freedom to paint. In 1961, the year after his appointment as Principal, he replied to an invitation to exhibit in France: 'Unfortunately, I have had practically to stop painting meantime. The work entailed in the College post is such that I have no time whatever in which to settle down and paint ... I shall not be active as a painter until I retire.'[63] [33]

The release from the day-to-day demands of the College gave Gillies the opportunity to spend time painting again and to move in new directions. This was something strongly evident in the big retrospective exhibition of 1970. Edward Gage in *The Scotsman* described well this renewed progression 'the development of his work continually reflects new ideas assimilated, fresh paths explored; and it is clear from his very latest pictures that he is even now in the grip of another exciting change. But with Gillies, change goes hand in hand with an improving and deepening vision.'[64]

After the upheavals of the early 1960s Gillies also began to turn his energies to his property. He employed John Winthrop, a young local man, to replace the pantile roof and to do further work on the cottage. From then on a very close relationship developed between Gillies and Winthrop. The latter helped Gillies to look after his assortment of cars

and motorbikes and advised him on any new pur-
chases (with the exception of a spur-of-the-moment
acquisition of a Bentley which, of course, was very
expensive to run). Winthrop also remembers help-
ing Gillies prepare stretchers for his oil paintings,
cutting mounts and working on picture frames,
which often entailed 'distressing' nineteenth-centu-
ry gilded wood and gesso frames in a manner that
was popular from the 1950s onwards. If there was an
exhibition deadline to meet, there would be a flurry
of activity, in fact 'a bit of a pantomime'. Although
Gillies was a natural hoarder, Winthrop remembers
him having a turn-out one day and throwing some
oil paintings on a bonfire. Aside from work, Gillies
had his evening meal with the young Winthrop
family every Sunday evening. He would arrive
armed with a bottle of sherry and a box of Terry's
Moonlight chocolates. Afterwards the whole family
would play Kan-U-Go. From about 1967 they also
went on summer holidays together [34]. A caravan
site beside the sandy beach at Nairn was a favourite
destination, although they went to other places
such as Mallaig or Carradale on the Mull of Kintyre.
Clearly Gillies and the Winthrops had 'adopted'
each other. Significantly, however, he never took his
sketchbooks and watercolours on these holidays.
Occasionally, outside the school holidays, he had
the opportunity to go to the caravan at Nairn on his
own and then he worked as before.[65]

Quite suddenly, on Sunday 15 April 1973, Gillies
died in his chair at the cottage. He was seventy-four
and had practised his art for sixty years without a
break. From a modest background he had risen to
become a notable figure in the art establishment in
Scotland. His paintings are hung in public and
private collections both at home and abroad. His
influence as a teacher at Edinburgh College of Art
was both profound and long-lasting. Taking his
work as a whole, Gillies is least known today as a
portrait and figure painter. Yet this was the disci-
pline he studied and taught throughout his years at
the College. He is remembered today for his still
life paintings and, above all, his landscapes. Howev-
er, all three areas help chart Gillies's progress from
precocious schoolboy to respected teacher and
painter. J.S.

34 W.G. Gillies on a camping trip,
with Leslie John and Anne Mary Winthrop, c.1966
RSA

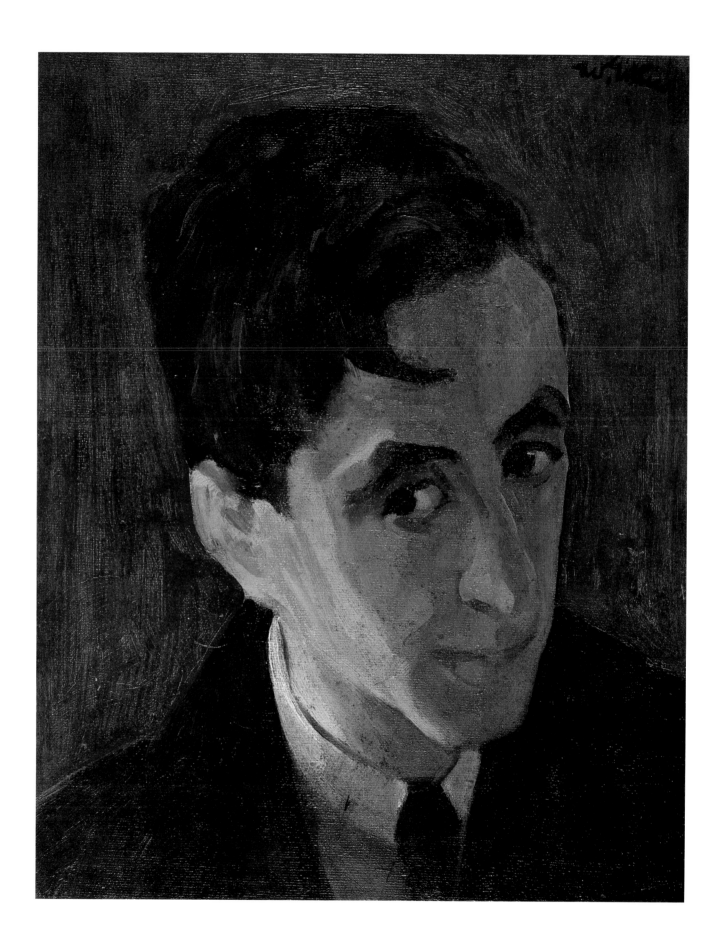

CHAPTER TWO

PAINTING THE FIGURE

The sculpture court at Edinburgh College of Art is an elegant, open space. At one time it was crowded with the great plaster casts of 'antique' and Italian Renaissance sculpture, which all licensed art schools were required to provide for their students to copy as part of their training in accordance with the terms of *Directions for establishing and conducting Schools of Art and promoting general education* issued by the Department of Science and Art in 1855. Today the court is empty, the space used periodically for temporary exhibitions. The casts themselves are tucked away along the College's long corridors[1] [36].

Learning to draw the human figure was at the very core of the College's curriculum, which was loosely based on training principles reaching back to Renaissance studio practices of the fifteenth century. When Gillies enrolled at the College in the autumn of 1916, it was necessary for all first-year students to study Elementary Drawing and demonstrate proficiency in that subject before being allowed to move on to the Diploma Course itself. This general preliminary course was still part of the syllabus when he joined the staff of the College in 1925. The prospectus for that year outlined the course new students would follow:

To begin with, students are set to draw from simple objects, from well-known casts, and details of the figure, leading on to a preparatory course in Drawing from the Antique, and simultaneously a simple course in Painting from Still Life either in oil or watercolour …

The syllabus remained much the same when Gillies retired as Principal some forty years later.

For the duration of his four years at art college

36 *left* Casts of sculpture in the Royal Institution, Edinburgh, c.1910, shortly before their transferral to Edinburgh College of Art
RSA

35 *opposite* W.G. Gillies, *Portrait of H. Harvey Wood*, 1922
oil on board, 36.8 × 29.1cm, RSA

(interrupted by his time in the trenches and in convalescence) Gillies was expected to draw. Beginning with the casts in the sculpture court and graduating in his second year to the male or female nude model (in segregated classes), the figure was the primary subject matter for study. Still life was very much a secondary subject. Landscape did not feature at all in the curriculum. Plant forms were covered in the elementary course, but only as part of an ornamental design class. If a student wanted to paint landscape, it had to be done outside college in his free time. Thus at Edinburgh College of Art Gillies learnt to draw the figure and eventually to paint portraits.

37 *left* Henry John Lintott,
Orange and Grey, c.1919
oil, 76.4 × 63.7cm, RSA

38 *right* David Foggie,
The Young Miner, 1926
oil, 76.2 × 64.0cm, RSA

39 W.G. Gillies,
Portrait of Emma, 1921
oil, 76.2 × 63.8cm, RSA

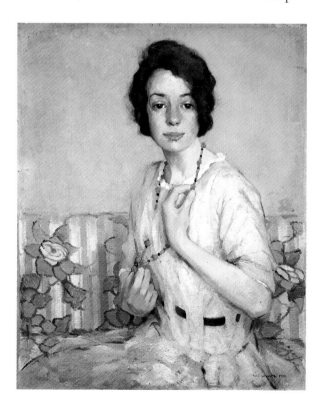

painters, they taught their students to draw and paint from the life and to study still life. All three were to become life-long friends of Gillies and companions on his landscape painting expeditions. The life painters on the staff whose teaching would have had the most immediate effect on a young student such as Gillies were Henry Lintott [37], who taught anatomy and who was at the College on Gillies's arrival in 1916, David Alison, Walter Grieve and David Foggie [38], the latter joining the staff in Gillies's third year.

Henry Lintott (1876–1963) and David Alison were both established portrait painters, commissioned by banks and universities to paint 'the great and the good'. Although they had their own individual style, Lintott's being more academic in approach than that of Alison, both tended towards a distinguished, elegant handling of paint. Lintott also painted pastoral scenes which, both in the use of paint and vague symbolism, are reminiscent of the work of the Italian symbolist Giovanni Segantini (1858–99), who was painting at the end of the nineteenth century. Foggie, apparently, was a great follower of Degas, both in his consummate handling of line and in the use of pastel. However his main teaching concern was with line, tone and light. Colour was of little importance.[2] Walter Grieve seems to have been the only member of staff at that time to be remembered for his use of colour.[3]

Gillies spent much time in Alison's evening life classes. An admirer of Henry Raeburn, Alison had a 'penchant for tonal harmony' and this influenced his student's initial development as a portrait painter.[4] Gillies's portrait of Harvey Wood, for example, is an exploration of tonal harmonies [35] and this development can be seen quite clearly in one of his earliest portraits of his sister Emma [39], which is dated 1921. The earliest portrait in Gillies's *oeuvre* is that of his mother, painted when he was still at school. Precocious though it is, its amorphous quality had by now given way to a more precise life drawing. The portrait of Emma is careful and certainly follows in the footsteps of his teachers, although he has caught the gentle prettiness of his younger sister, then aged twenty-one. The brushstrokes are squared, the paint texture rich and the delicate tonal harmonies much in keeping with the teaching of the period, when the

In the autumn of 1916 a number of members of staff who were to have a profound early effect on the young Gillies were away on active service. David Alison, D.M.Sutherland, Adam Bruce Thomson and Walter Grieve (1872–1937) would all have returned by the time Gillies re-entered the College in 1919, one of many such veterans of the Great War. David Alison was now Head of Drawing and Painting and Donald Moodie had just joined the staff. Although Sutherland, Thomson and Moodie were landscape

emphasis was on low-key colour harmonies and fine drawing; colour was expected to stay firmly in the background. The decorative use of textiles in the portrait, however, was soon abandoned for the more austere use of plain backgrounds favoured by his teachers.

A number of Gillies's nude life studies of women and men still survive from this time and show his development in confidence as well as the inevitable influence of his various teachers. In his final two years Gillies would have been expected to concentrate on gaining a likeness of his subject. His painting of the head and shoulders of the anonymous bearded model [40] – the broken brushstrokes very reminiscent of David Foggie's work – shows that he is mastering the craft. On graduating, each student was (and still is) required to present a Diploma Work to the College that demonstrates his or her competence. Gillies chose to mark the closing of this phase of his career with a full-scale painting of a male nude, sitting in an awkward, twisted pose (a very common feature in Alison's work) [41]. It is an academic, traditional painting, which appears to be saying: 'See, I can do it. Now may I move on?'

Although it was just a tentative step, that is exactly what he did in his postgraduate year. His portraits began to lose the strongly studied academicism of the life studies and his style became more relaxed as he sought his own way. In 1922 Gillies and William Geissler, whose names had already been linked the previous year when they received Minor Travelling Bursaries, were awarded their Diplomas. Both were also granted Maintenance Scholarships on which they were to live during their postgraduate year (which must have come as a relief to the Gillies family, who were still running the tobacconist shop in Haddington and waiting for the son and heir to take over as head of the family). The postgraduate students were very loosely supervised. They could follow their own preferences as long as they turned up for further life classes. Amongst Gillies's 'testimonies of study' were portraits, interiors, still lifes and a number of landscapes.[5]

The surviving portraits of that year are of his friends and fellow students with whom he shared accommodation and studios, such as R.H. Westwater [42], Arthur Couling and H. Harvey Wood [35]. There are also sketches of his mother [43] and sisters. The portrait of Westwater in particular shows the strong line and subdued tonal harmonies taught

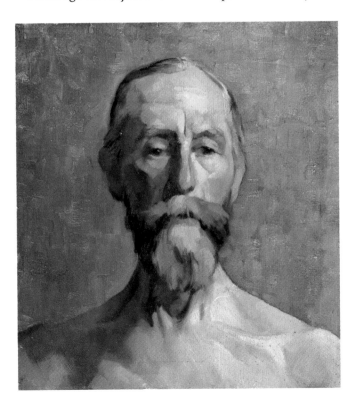

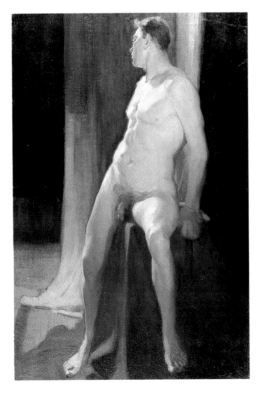

40 *left* W.G. Gillies, *Head and Shoulders of a Bearded Man*, c.1921–23
oil, 38.0 × 35.5cm, RSA

41 *right* W.G. Gillies, *Life Study*, 1922
oil, 91.5 × 61.2cm, RSA

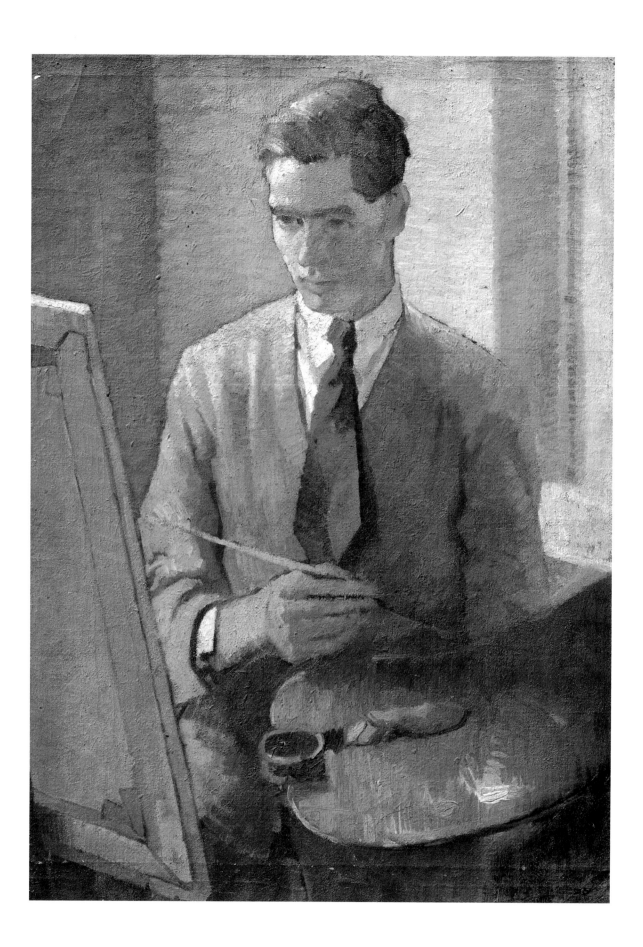

at the College, but there is a lightness of touch which is now more his own. A number of the portraits are of heads only, but in his portrait of Westwater, Gillies has concentrated on developing an interesting composition, depicting his friend at his easel with palette and brush in hand. The edges of planes have been sharpened, something which over the next few years he would accentuate following his encounter with Lhote and Cubism in Paris.

The College's Annual Report for 1922–23 records that Geissler and Gillies were highly commended. Their Diplomas were 'endorsed' (which means that they had spent their postgraduate year in a satisfactory fashion) and both were awarded travelling scholarships for the following academic year. The Principal of the College Frank Morley Fletcher, was 'full of enthusiasm for the Cubists'[6] and so Gillies and Geissler were persuaded to spend time in André Lhote's *atelier* in Paris.

Gillies may indeed have found Lhote's system too rigid, as has often been quoted, but he did study attentively, involving a very detailed attention to compositional structuring. Lhote had been a member of the *Section d'Or* group of artists, which had formulated a different version of Cubism from that of Picasso and Braque. Picasso's and Braque's development of Cubism was very monochrome, concentrating on the restructuring of an object using multiple planes and grid-locking it into a simple background.

The *Section d'Or* artists, who did not want to eschew colour, decided that a landscape or still life – a complex composition in its entirety – could be looked at also in terms of geometry. This led them to a decorative type of Cubism with either underlying or superimposed proportions and harmonised colour schemes. One of the best artists of this group was Robert Delaunay.[7] Lhote also encouraged a study of the Old Masters, teaching his students to look at paintings in the Louvre in terms of geometry.[8] The *Bathers* [44] is an exploration of Lhote's methods in which an Old Master formula is transformed by a Cubist re-structuring. The central figure indicates a study of Ingres' painting *The Valpinçon Bather* (Louvre, Paris). The use of counterbalancing figures and the dark and light rhythms are all part of traditional compositional practice. The landscape setting itself is dependent on a study of Claude. Gillies has filtered all this through Lhote's version of Cubism. However, formal study with Lhote did not stop him looking also at the work of Cézanne, Gauguin, Van Gogh, Degas, Renoir, Bonnard, Pissaro, Vuillard, Matisse, Braque and Picasso, amongst many others.[9]

The *Bathers* can be seen also as part of the new traditionalism in European painting of the early 1920s. Gillies was in Paris in the spring of 1924, when contemporary artists such as Picasso were exploring a new mode of expression that has been called the 'Return to Order' or the 'Call to Order'. This new

42 *opposite* W.G. Gillies, *Portrait of Westwater*, 1923
oil, 88.6 × 61.0cm,
Private Collection

43 *left* W.G. Gillies, *Portrait of the Artist's Mother*, 1923
pencil, 22.5 × 17.5cm, RSA

44 *right* W.G. Gillies, *Bathers*, c.1924
oil, 58.9 × 73.8cm, RSA

philosophy was very much in evidence amongst contemporary artists in Spain, France and Italy throughout the 1920s. The 'Return to Order' is seen by some as a reaction to pre-war *avant-garde* art, which was thought to have contributed to the breakdown of the social order. Many of the artists with this approach looked for their inspiration to the Italian Renaissance, often to the early fifteenth century or even earlier to 'primitives' such as Giotto. The subject matter, such as 'Mother and Child', was deeply attrac-

not exact copies, but are an attempt to catch the spirit of a composition. With Lhote's personal brand of Cubism still very fresh in his mind, the planes of the faces are crisper. However, because they were intended as studies of other artists' work, Gillies did not subject them to the full impact of his newly acquired Cubist handling, as he did with some of his own paintings of Florence itself. The figure paintings that show him coming to grips with this new way of looking at things came when he was back in

 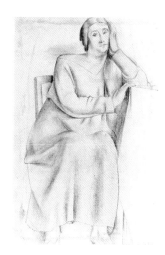

45 left W.G. Gillies, *Detail from Giotto's 'Nativity of the Virgin' (S. Maria Novella, Florence)*, 1924 pencil and watercolour, 20.0 × 25.2cm, RSA

46 centre W.G. Gillies, *Detail from an Annunciation (Master of the Strauss Madonna, Accademia, Florence)*, 1924 pencil and watercolour, 30.0 × 36.5cm, RSA

47 right W.G. Gillies, *Woman Seated, c.1925–26* pencil, 30.5 × 19.9cm, RSA

tive to these artists, as was the simplicity and often monumental nature of the figures. However the aim was not to copy the art of the past, but to attempt to paint modern life using the past as a guide.

Having spent several months assimilating Lhote's methods and looking at art in Paris, Gillies and Geissler left for Italy, where they would spend the next several months, based mainly in Florence. It is hard for us, in an age of good colour reproduction in books and a multitude of high-quality television programmes to grasp how totally overwhelming it must have been to see Florence and its treasures at first hand. Anne Redpath before them and John Maxwell after them were bowled over, particularly by the Italian 'primitives', and Gillies was no exception. It was a requirement that students on travelling scholarships returned with evidence of their studies, such as copies of Titians or Raphaels in the Uffizi or the Pitti Palace. Some of Gillies's copies survive – frescoes by Giotto in the cloister of S. Maria Novella [45] and panel paintings by early fifteenth-century Siennese painters in the Accademia [46]. They are

Scotland and had had more time to think.

After his return to Haddington in the late spring of 1924, Gillies produced a number of drawings and a double portrait, which demonstrate the influence of Lhote's teaching as well as the assimilation of his Italian experiences. The Giotto-esque *Woman Seated* [47] combines an acknowledgement of Lhote's Cubism with the extreme solidity of Giotto's figures in the frescoes in Florence. In the double portrait of his sisters Emma and Janet [48], for which preparatory drawings exist, Gillies has leaned more towards the Siennese panel painting he copied in the Accademia, but the influence of Lhote's Cubist structuring is still very evident. The faces, their ovals tightly encompassed by the composition, tilt in the gentle, slightly quizzical fashion common to early fifteenth-century Italian madonnas, yet the whole effect is very contemporary. Gillies was not alone in combining this interest in Cubism with an interest in early fifteenth-century Italian art. Indeed there was a vogue for it in the 1920s, particularly in Italy itself, which can be seen, for example, in the work of

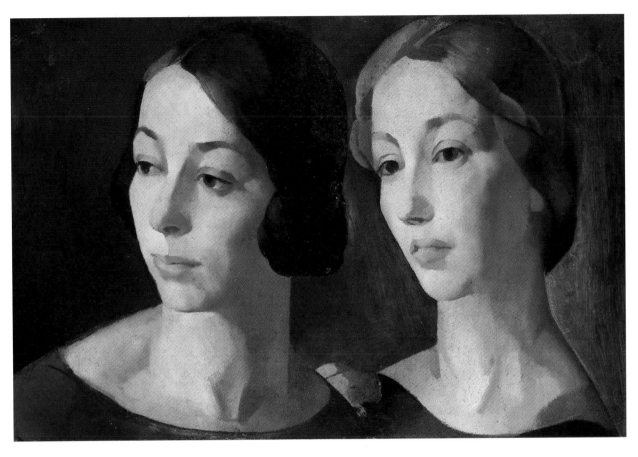

48 W.G. Gillies, *Portrait of Emma and Janet*, c.1925
oil, 33.4 × 50.4cm, RSA

artists such as the former Futurist Carlo Carrà and Mario Sironi.[10] It was only to be expected that a young artist would experiment in this manner.

In 1925, after a year as Assistant Art Master at Inverness Royal Academy, Gillies joined the staff of Edinburgh College of Art in a part-time capacity. Gerald Moira had taken over as Principal from Morley Fletcher. David Alison was still Head of Drawing and Painting and would remain so until his retirement in 1945. The College's Prospectus for 1925–26 had been revamped from previous years and now included illustrations by recent students of the various disciplines. Two works by Gillies were featured that year. One was his impressive Diploma Work of the male nude [41] and the other a rather curious figure composition, depicting two female nudes kneeling grief-stricken on either side of a prostrate male nude [49]. This is the only post-war work by Gillies which could be construed as a reference to the sorrows of war, although its 'dying warrior' theme is also an exercise in looking at 'antique' sculpture. John Duncan (1866–1945) was a Royal Scottish Academy

'visitor' in Gillies's final years as a student at the College and was a member of staff on Gillies's return in 1925. The figures in this composition – their delicate outlines and symbolist content – are very reminiscent of Duncan's work, as well as of other Edinburgh Group artists of the period. The two illustrations – their emphasis on the figure both literally and imaginatively – demonstrate well the different aspects of one student's work.

FIGURE COMPOSITION by W. G. GILLIES.

49 W.G. Gillies, *Figure Composition*, c.1922
reproduced in the *Edinburgh College of Art Prospectus 1925–26*, location of original unknown

Gillies's responsibilities at the College were to teach still life and life drawing. As a very junior member of staff he was probably teaching at elementary level, but over the years he moved on to teach life drawing at the more advanced levels. The staff and students felt honoured when in 1933 S.J. Peploe, by then a distinguished artist, agreed to teach at the College. Unfortunately illness cut short his time there during the session 1934–35 and Gillies took over Peploe's life painting classes in addition to his own. On Peploe's death in October 1935 Gillies lost not only a friend, but also a fellow artist who had encouraged him in his youth and whose work had been an inspiration to him.

Gillies is listed as a teacher of still life, life drawing and life painting [50] until he became Acting Head of Drawing and Painting in 1945 on the retirement of David Alison, when his role became more supervisory. It was during the 1930s that he produced the greatest number of portraits, both single figures and group compositions. Along with his landscape and still life paintings, this is just one aspect of what would be for him the most richly productive and innovative period of his entire career.

The College was employing as teachers artists who had begun to travel regularly to Paris, still recognised as the centre of the art world. Thus it is not surprising that their students were faced by a veritable avalanche of new ideas circulating throughout the art world. When Gillies had been a student, all the staff were knowledgeable about Impressionism and Post-Impressionism.[11] Now newer members of

staff such as Gillies himself, who had travelled more recently, were even more conversant with current trends in the wider art world. In its Annual Report for 1926–27 (Gillies's second year on the staff) the College drew attention to this trend. The Report on the School of Drawing and Painting states rather defensively:

… The student is perhaps inclined to be too experimental in this very important branch of study [composition], but this must not be allowed to reflect on the instruction given in this subject; it is simply a sign of the times. With so many new theories of composition and painting continually under review in the best of our Art magazines, it is not surprising that the student is somewhat confused and frequently impatient with the more orthodox or academic.

Although Gillies was required to teach in the academic manner, in his own work he felt free to explore new trends whenever he wanted to do so. This began to show itself in a tentative fashion in the figures in his landscape paintings. Though sometimes recognisable as his mother or sisters, their role is as part of the overall composition, rather than mere portraiture. The Gillies family had moved from Haddington to Willowbrae Road in Edinburgh in 1929 and many of his paintings around this time are of the streets and vistas on that side of the city. His style is deliberately naïve, a way of looking at things which was being explored at the time by many seemingly diverse artists at home and abroad, such as Ben Nicholson, Christopher Wood, Georges Braque and

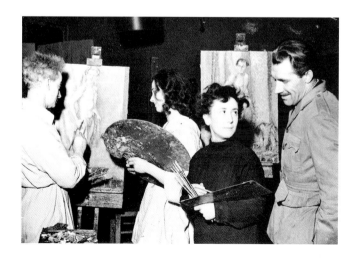

50 *left* W.G. Gillies teaching a Life Class, Edinburgh College of Art, *c.*1948
with Mary Thomson, Mamie Parker and a student who had served with the Polish forces

51 *right* W.G. Gillies, *Landscape with House and Two Heads*, *c.*1930
oil, 63.9 × 77.0cm, RSA

Marc Chagall, as well as by Gillies's own friends like John Maxwell. The simplistic figure-shapes with their child-like round heads, which appear in Gillies's street scenes, occasionally fade out altogether into stick figures. Gouache studies for larger paintings explore the relationship between these simple figures and their settings. The figures are not meant to be identifiable, but, if they are, it is because a study of his work leads to the ready recognition of his family at every turn; he frequently used his own surroundings as inspiration [51].

However the earliest portraits and drawings of the 1930s are not part of the trend towards deliberate naivity seen in some of his landscape paintings. In the area of portraiture he was moving more slowly towards a liberated style. Old academic habits were hard to shake off. The *Portrait of Emma* [54] and the unfinished portrait of William MacTaggart [52], with whom Gillies was now sharing a studio in Frederick Street, are studies in close tonal harmonies and very elegant handling.

Emma was a frequent model for her brother in the early 1930s. Around 1932 Gillies drew her as a vulnerable, fragile woman [53]. Her hair is coiled on either side of her head, giving her a top-heavy look.

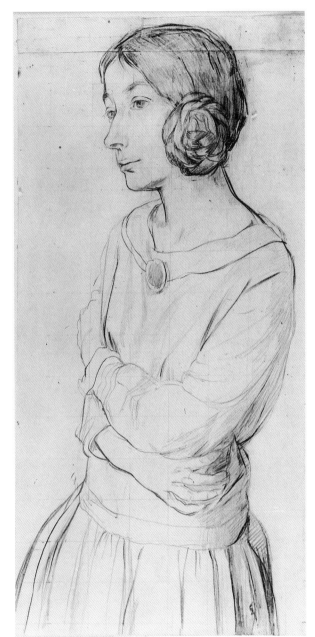

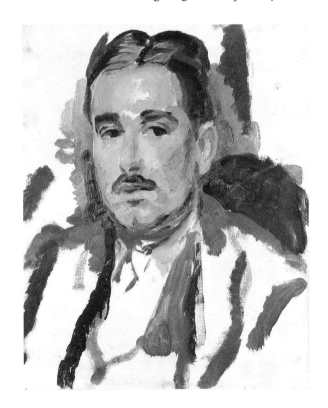

She is wearing a blouse with a low, broad collar; a brooch is pinned to the front of the collar. Her arms are clutched across her middle, as she looks dreamily into the distance. It is a touching likeness, as are all Gillies's pictures of his sisters, especially Emma with whom he was particularly close. The drawing encapsulates what Gillies had learnt as a student in Life Drawing and what he tried to pass on to his own students. However the double portrait [55], for which this pencil drawing was a preparatory work, was not the sort of thing which would have found a

52 *below left* W.G. Gillies, *Portrait of William MacTaggart*, c.1935
oil, 51.2 × 40.6cm, Scottish National Portrait Gallery, Edinburgh

53 *left* W.G. Gillies, *Emma Gillies*, c.1932
pencil, 36.7 × 18.5cm, RSA

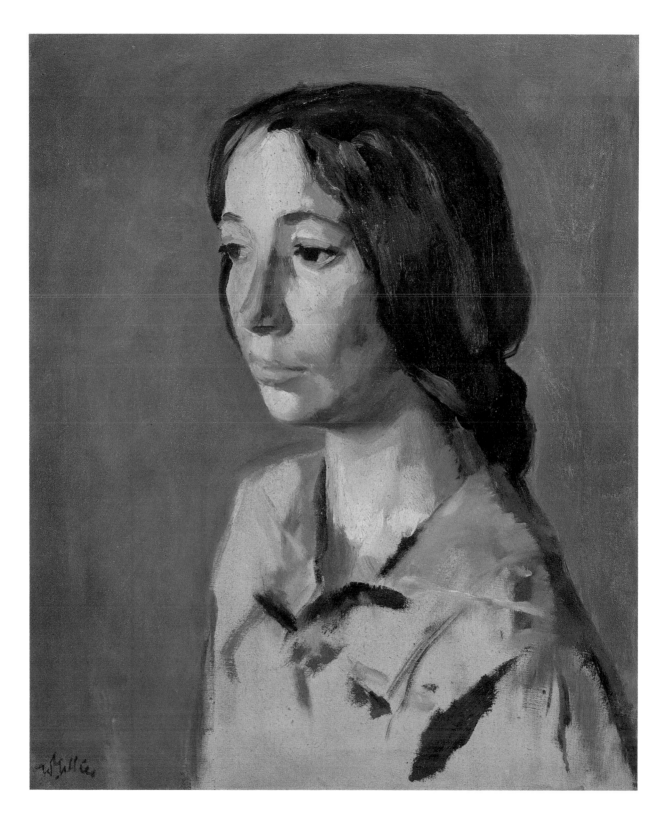

54 W.G. Gillies, *Portrait of Emma*, 1931

oil, 61.0 × 53.3cm, Fletcher Collection on loan to the City Art Centre, Edinburgh

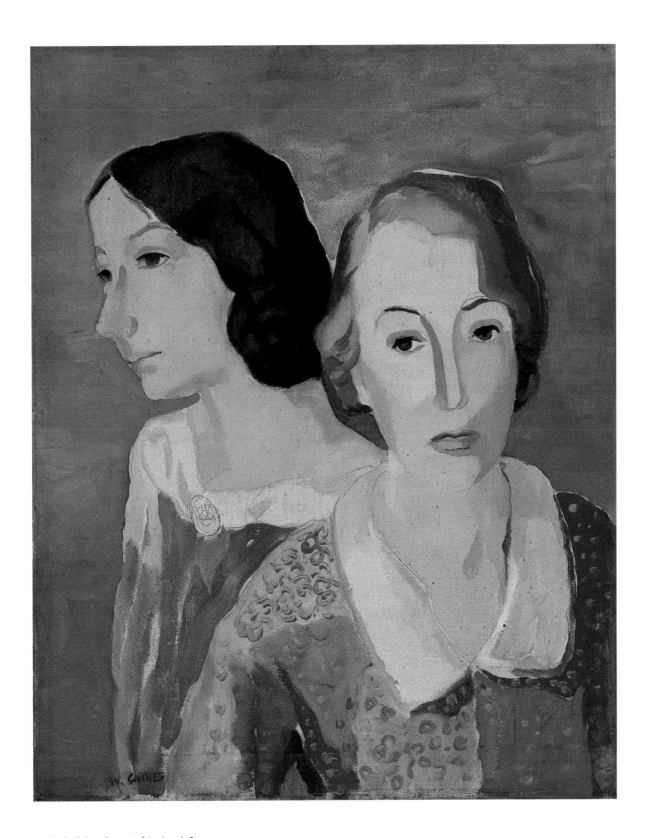

55 W.G. Gillies, *Portrait of the Artist's Sisters*, 1932

oil, 76.1 × 61.0cm, Fletcher Collection on loan to the City Art Centre, Edinburgh

56 *right* W.G. Gillies,
*Portrait of Emma, Mrs
Gillies* and Janet, c.1933
oil, 172.8 × 177.8cm, location
unknown

57 *far right* W.G. Gillies,
Portrait, c.1933–34
oil, size unknown, reproduced
in *The Listener* 17.1.34, location
of original unknown

58 *opposite* W.G. Gillies,
Portrait of Jenny, c.1933–34
oil, 114.9 × 90.2cm, Private
Collection

place in the College's syllabus. Gillies has placed
Emma at the back and Janet to the fore. The two
sisters look as if they have no connection with each
other, as if they are not even sharing the same space.
Probably this is because the painting was construct-
ed using preparatory drawings of separate poses. As a
composition it does not quite come together. How-
ever, what is of interest is the loosening-up of Gillies's
handling of paint. He is moving the medium around
in a much bolder fashion than formerly. Also he has
abandoned any desire to capture a firm likeness in
the painting. The colour is still subdued, although
over the next few years that too would change radi-
cally.

This change in style may be explained by two
items in the College's Annual Report for 1932–33. The
first noted that Professor Herbert Read, who had
been appointed in 1931 as Watson Gordon Professor
of Fine Art at the University of Edinburgh, had lec-
tured in the first and second terms on 'Modern
German Art'. This would have included *Die Brücke*
artists such as Kirchner and *Der Blaue Reiter* artists
such as Kandinsky and Franz Marc. No doubt Read's
lectures would have fired up Gillies just as much as
his students. The second item is a passage from the
Report on the School of Drawing and Painting:

Interest in this School is keen, and there is a vitality and
courage of attack about the work which is exhilarating. In
the present highly interesting but chaotic state of the Art
of Painting, students in this School more than any other
must depend on innate personal gifts and personal convic-
tions. Experiments by some of the most gifted students in
the direction of an expressive use of colour passed over
occasionally into violence, but should be valuable when
controlled by experience. This, I think, was in the mind of
Mr Philip Connard, R.A., who was Assessor for Diplomas,
when in his report he says 'The painting is strong and
vigorous, but I would point out that vigorous painting is
not always the best' …

The image conjured up is of students occasionally
being fed on powerful ideas and then, as they tried to
implement what they had seen and heard, being held
back on a sort of choke-chain by the constraints of
the academic training system.

Other forces were at work to bring exciting new
imagery to Scottish artists and their students. By the
late 1920s Gillies had made two further visits to
France. Although these were painting trips, on which
he managed to do a lot of work, there would have
been opportunities to see what was happening in
contemporary French painting. In their annual
exhibition in 1929 the Society of Scottish Artists
showed work by Derain, Dunoyer de Segonzac and
Matisse amongst others. The Society followed this in
1931 by exhibiting twelve paintings by Edvard Munch,
selected by the artist himself. Munch, with his broad
handling and intense psychological content, was a
great revelation to many of the younger Scottish
artists. Gillies visited the exhibition a number of
times[12] and made a trip to Oslo the following year.[13]
Also in 1931 Gillies was invited to join The Society of
Eight, many of whose members – such as Peploe –
had for some time used a higher-keyed palette and
vigorous handling of paint.

It is a measure of how important it was to Gillies
to have a period of contemplation and assimilation
of such external influences that he held himself back
for as long as he did in the use of colour in a high key.
Thus it comes as a shock when in 1934 colour erupts
in his paintings, slashed on to the canvas with the
palette knife or large brushes. This is apparent prin-
cipally in his landscape paintings, because by this
time that was his preferred choice of subject matter.
Unfortunately several portraits of the period have
disappeared and are known only from black and
white reference photographs taken by the artist.
They include a triple portrait of his mother and
sisters [56] and a portrait of Emma [57], which was
reproduced in *The Listener* of 17 January 1934 along
with work by three other artists exhibiting with The

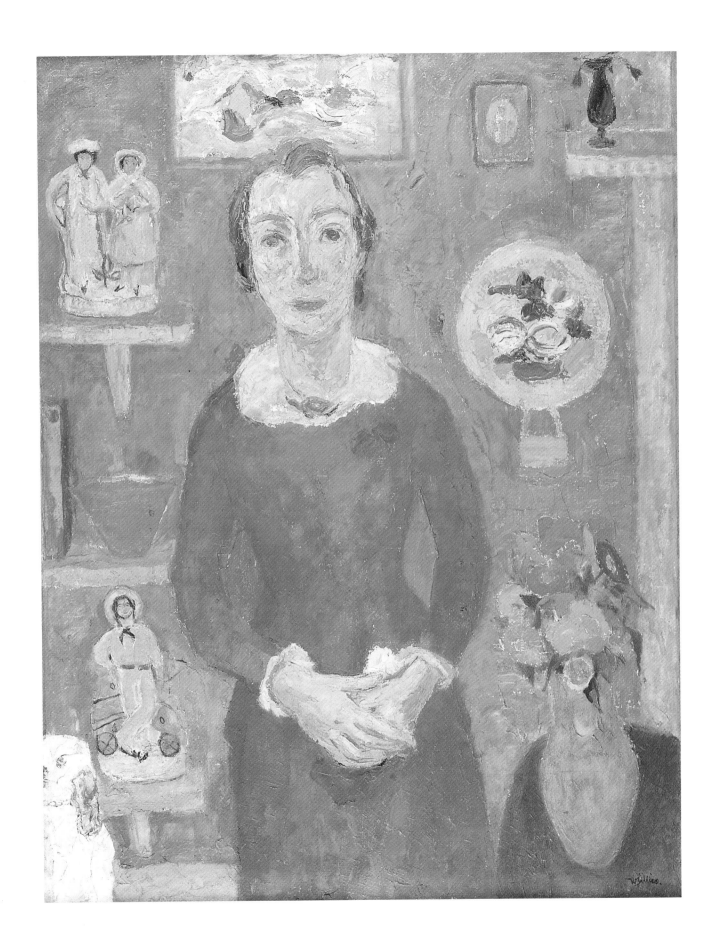

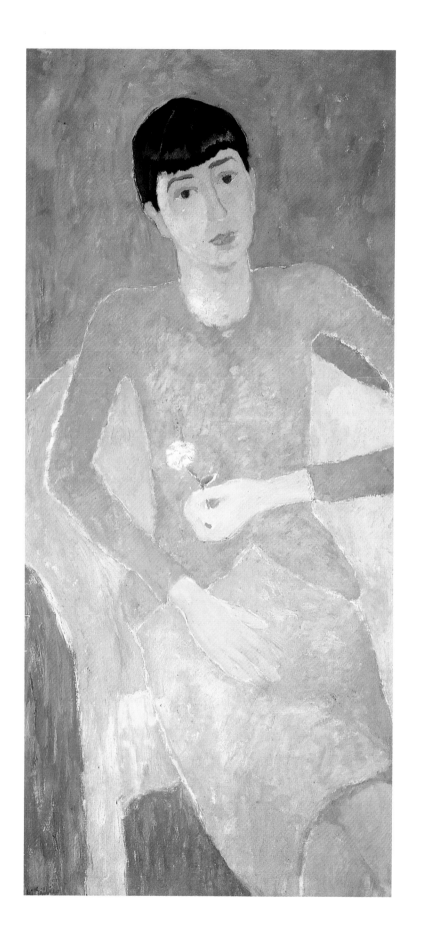

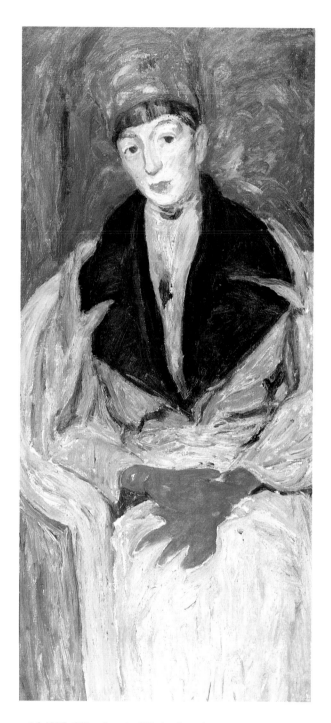

59 *left* W.G. Gillies, *Portrait of Marjory Porter I*, 1934
oil, 129.0 × 58.5cm, RSA

60 *above* W.G. Gillies, *Portrait of Marjory Porter II*, 1935
oil, 129.0 × 58.7cm, RSA

Society of Eight that year: Peploe, Alison and Archibald McGlashan.[14] However what evidence there is indicates that these missing paintings form part of his whole-hearted adoption of high-keyed colour and vigorous handling. A reviewer of that exhibition wrote:

… The most recent recruit is W.G. Gillies, and the inclusion of his work in this year's exhibition, which has just opened, is likely to provoke a public, already insulted and enraged by the current exhibition of the Society of Scottish Artists, to further expressions of horror. But there can be no doubt that the public that now accepts Peploe and Cadell will some day accept Gillies – as true a son of his generation as they are of theirs – and we can only commend the courage of the Society in including him in their number. He has been given a wall to himself and his display is very impressive; his landscapes are the most personal things in the exhibition, and his 'Portrait' (reproduced on another page) has the dignity and impressiveness of early Florentine painting … [15]

Even though the caption is vague, we know it is Emma, because contemporary photos show her wearing the blouse and the necklace. The richness of the paint, the obvious strong contrasts and the overall power of the painting is impressive. Strength of handling and colour is evident in his landscape and still life paintings of this period and there is no reason to doubt that that was also the case in this portrait. It is obvious that Gillies was keeping up with the times. This is an artist who has looked at Derain and Matisse's fauvist period and who was aware of Alexei Jawlensky's portraits[16] with their broad handling and bold use of colour.

In the same exhibition Gillies exhibited another portrait, that of his elder sister Janet, whom the family called 'Jenny' [58]. In this intensely intimate portrait Janet is shown surrounded by various household objects and bric-a-brac which were important to her. Another reviewer commented: 'His large portrait follows the convention of the medieval designer in its centrally placed figure surrounded by unrelated, though possibly symbolic objects'.[17] In treating Janet's things in such an iconographic way, Gillies has made this portrait into a celebration of Janet and her importance to the family. The handling

of the paint is not as exuberant as in the portrait of Emma (but by all accounts Janet was not as lively a character as Emma). The colours are soft and gentle and use of the palette knife is very pronounced. The still life objects close in around Janet as if she were a medieval Virgin Mary surrounded by her attributes.

Another portrait from around 1934 [59], the first of three portraits of Marjory Porter, also relies heavily on soft colours and the use of the palette knife. As was mentioned in the previous chapter, the sitter was the daughter of Dr Frederick Porter and his wife, whose house in Edinburgh's Morningside was the regular venue for many Sunday evening discussions on art and other matters between Gillies and John Maxwell and the Porter family and friends. In each of the paintings Gillies has portrayed Marjory as a very chic young woman. She must also have been a good friend. Gillies's known portraits from the 1920s and 1930s are of family and friends, most frequently his sisters. Surely it must be a sign of an important friendship for Gillies to have painted *three* such handsome pictures.

Marjory Porter I is a tall, narrow painting, in which the sitter's left arm is deliberately cropped and the legs are cut off just below the knee. It is a sinuous picture, full of curves and complex spaces. The colour is rich, yet at the same time subdued – all pinks and grey. His handling of paint is broad; it is chalky, not oily and luscious as in many of the landscapes of this period. Had Gillies himself not dated this portrait to as early as 1934 in the catalogue of his 1970 Scottish Arts Council Retrospective Exhibition, it would be tempting to place it closer to 1940 and the painting entitled *The Blue Window* [see 76], with which it shares a certain stylistic affinity.

There is an interesting symbolism in this painting that is rare in Gillies's work. Marjory is holding a pink, a symbol of betrothal. The way in which she is holding the flower suggests a deliberate reference to late fifteenth-century Netherlandish portraits, such as that of Petrus Christus, in which almond-eyed sitters, their arms akimbo, hold symbolic objects between their thumb and forefinger. It is known that Gillies was interested also in the work of the French painter Marie Laurencin,[18] whose pared-down simplicity of approach towards figure painting is echoed

here. Whether there was any romantic attachment between Gillies and Marjory Porter at this time is not known, but the reference can hardly be accidental. Gillies was too well educated an artist to lightly make a throwaway statement.

The other two pictures of Marjory [60] are also three-quarter length, sitting in the same chair, but there the similarity ends. In these portraits Gillies has turned to the expressively handled brushwork and strong colour that is the hallmark of his landscape painting of the period. The sitter's stylish winter coat and jaunty red gloves, hat and lips dominate the compositions. The intimacy of the early picture, communicated as much by its brushwork and colour as by its composition, has been abandoned. In 1935 *Petit Patissier* by Chaim Soutine (1893–1943) was exhibited at the Society of Scottish Artists' annual exhibition. Building on an existing interest in Soutine (he owned several illustrated booklets on the artist), Gillies explores in the second and third portraits of Marjory that artist's strongly expressionist vision of his sitters. This very much suited Gillies's already vigorous handling of the period.

Gillies and his family suffered greatly from Emma's death in 1935. His 1937 painting *Family Group* [61] is as much a statement as any of his more detailed portraits. Deeply shattered by their loss, it appears that the family, close-knit already, turned in on itself even more. The surviving sketches make it clear that Gillies was searching for a way to paint the remaining members of the family without being heavy-handed and traditionalist. The rather 'primitive' manner of some of the sketches [62] for the painting refers back to the naïve style seen in his work around 1930. Gillies was an admirer of the intimate interiors of artists such as Matisse, Vuillard and Bonnard with their exploration of interior–exterior spaces, often using windows and doors as compositional devices. Here Gillies has embarked on an intimate subject set within a complex interior arrangement, which rather disturbingly depicts the remaining members of the family isolated in their own worlds, yet still held together. Mrs Gillies is seated on the left, a lonely figure gazing thoughtfully away from the artist, who is standing in a hallway between the two rooms. Janet, who is brushing her

hair, stands further back in the right hand room. Gillies looms large, directly facing the viewer as in a self-portrait using a mirror. The powerful verticals of the artist and the walls on either side of him are only marginally softened by the horizontals of pictures, carpets and shelving. This painting was first exhibited at the Society of Scottish Artists in 1937 and was never to leave the artist's possession. Curiously, Gillies cut off the right hand side of the painting (Janet's side) at some point in the 1960s and exhibited the picture in London.[19] However he was persuaded to have it reattached in time for his 1970 Scottish Arts Council Retrospective Exhibition. It is obvious that at some point family sentiment was overcome by artistic dissatisfaction with the composition, which indeed is rather uncomfortable both literally and psychologically. This is hardly surprising, when one considers that it was probably part of a grieving process, which was never actually put into words.

The years during which Gillies felt the need to express himself through portraiture were swiftly drawing to a close by the time he painted his self-portrait in 1940. By then the family had been settled in the village of Temple for nearly a year, Gillies had recently been elected an Associate of the Royal Scottish Academy, he was now a senior member of staff at the College, and Britain was at war with Germany. Indeed there was doubt about whether the College would open for the 1939–40 session. The Annual Report for the academic year expressed those doubts, which had by then been overcome. It went on to note that air raid shelters had been prepared in the basement and store rooms, that teaching had been made more awkward by an enforced black-out of the skylights and that there were stringent restrictions regarding the other massive windows. However the session did commence, Gillies teaching Life Painting, Life Drawing and Still Life. He was now David Alison's principal assistant, teaching his students (mostly women in those years) the finer points of life drawing and painting. With the exception of a few drawings, to all intents and purposes he executed no more portraits other than the very self-assured oil painting now in the Scottish National Portrait Gallery.[20]

In his self-portrait [63] Gillies gazes steadily at the

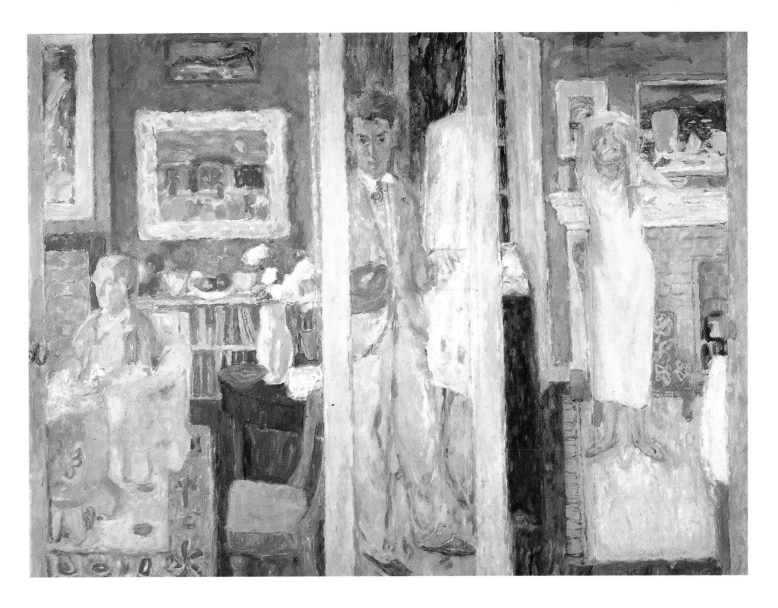

61 W.G. Gillies, *Family Group*, 1937
oil, 127.0 × 173.5cm, RSA

62 W.G. Gillies, *Compositional sketch for Family Group*, 1937
pencil, 20.7 × 16.9cm, RSA

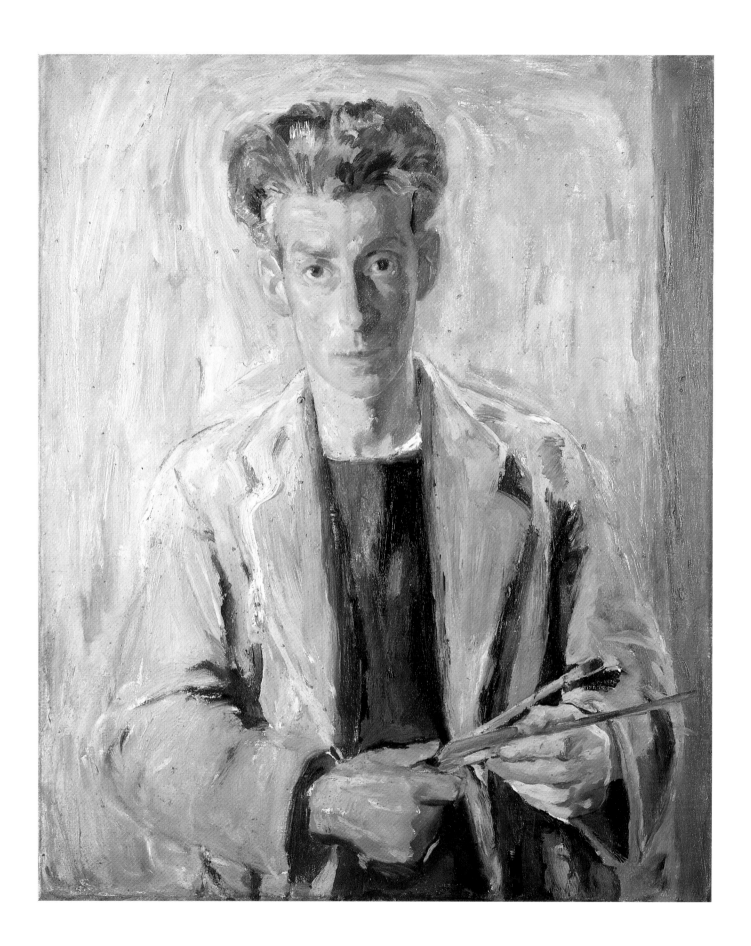

viewer with the slightly quizzical tilt of the head that from the evidence of family photos was quite typical of him. He has captured himself very much as his students saw him – full of energy, hair standing straight up, the edges slightly tinged with nicotine from his constant smoking (he would always keep a cigarette tucked over one ear). Very fluid brush-strokes delineate his strongly defined hands in a few broad outlines, as if he were drawing with the brush. Like so much of his painting of the period there are touches of thick impasto as well as tiny areas where the primed surface of the canvas shows through, both techniques used to give a touch more defini-tion. The very strong pink-red strip on the right is the perfect painterly device to counterbalance his own quizzical tilting pose. It is a successful figure painting, the last of such paintings that he was to do and a worthy testament to his skills in this area.

From now on when figures appear in his paint-ings, as they do occasionally, they are not portraits. They serve the same purpose as the sometimes crude, frequently naïve, figures that appear in some of his landscapes of the late 1920s and early 1930s – there to complement the overall composition. Even in a setting as identifiable as *Interior, Temple Cottage* [65], dating from 1951, Janet and his mother are included. They are necessary – the space would be empty without them – but this is not a portrait. Indeed the preparatory drawing for this painting does indicate a different purpose altogether [64]. It was to be another version – though less mannered – of the 1937 painting *Family Group*, on this occasion with the artist in the foreground and his mother and sister carefully posed together at the back of the room. Somewhere along the line, however, Gillies changed his mind and his approach, making the

63 *opposite* W.G. Gillies, *Self Portrait*, 1940
oil, 86.9 × 71.4cm, Scottish National Portrait Gallery, Edinburgh

64 *left* W.G. Gillies, *Study for Interior, Temple Cottage*, 1951
pencil and watercolour, 24.7 × 31.7cm, RSA

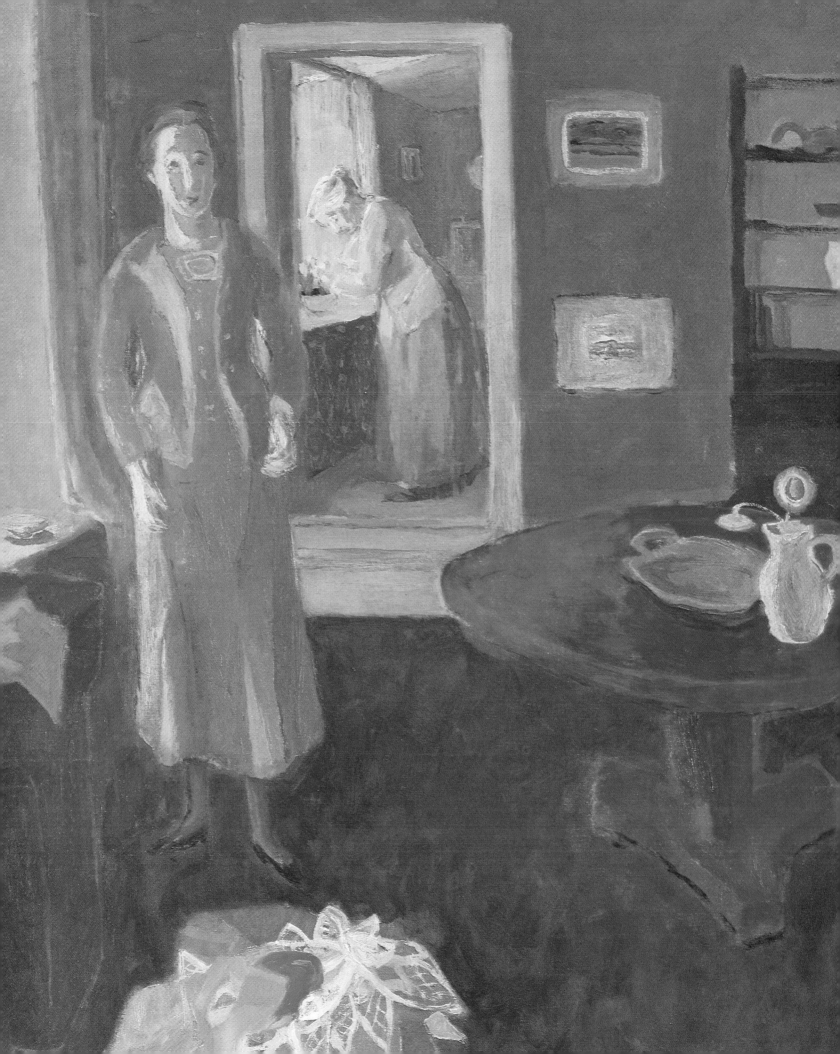

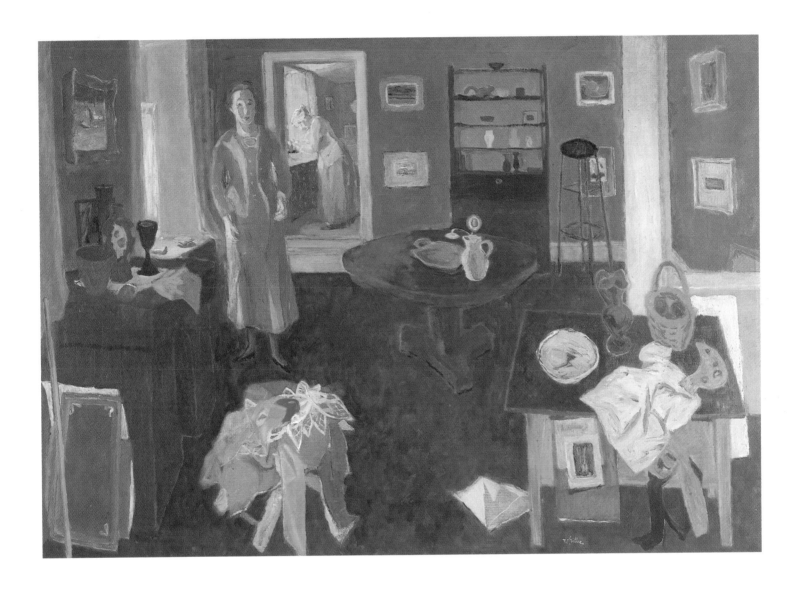

65 W.G. Gillies, *Interior, Temple Cottage*, 1951
oil, 119.4 × 170.2cm, Fletcher Collection on loan to the City Art Centre, Edinburgh

sense of place more important than any one person or object (although they are still identifiable). The painting belongs to the series of interiors with still life, which he painted in the 1950s and 1960s, rather than within the realm of portraiture.

After this time paintings with figures are virtually non-existent. However, in the 1960s, after his retirement as Principal of Edinburgh College of Art, he was prevailed upon to accept a commission from the University of Edinburgh to paint a portrait of Lord Cameron.[21] Gillies was always loathe to accept commissions and generally managed to avoid them, even when he was asked by friends.[22] Neither he nor Lord Cameron were happy with his efforts, which he fretted over for some time, making many preparatory drawings and several attempts at the painting. Eventually Alberto Morrocco, then Head of Drawing and Painting at Duncan of Jordanstone College of Art in Dundee, was commissioned to paint the portrait, which was finished in 1974, the year after Gillies's death.

Unlike Morrocco, who at one time painted many commissioned portraits, Gillies never attempted to earn a living in this way. Though thoroughly trained in this skill, he only used it to portray very close friends and family with some superb results during the years between the wars. Probably he was unable – or unwilling – to develop this side of his work commercially. Portrait painting requires an intense interaction between sitter and artist, which Gillies, by all accounts a shy man, would have found gruelling. The teacher–student interaction was quite different in its demands and by most accounts he was very successful in that respect. The portraits he did paint were affirmations of friendships or confirmations of family relationships. By the early 1940s he was established in his work, had made many friends and, as a confirmed bachelor, had settled into a home life based around his mother and elder sister. He had little need – or indeed time, considering his College commitments – for more portraiture as such. It had served its purpose. From now on he was to concentrate on still life and landscape painting, which was his true love.

In his second year as Principal of the College the following passage appears in the Report on the School of Drawing and Painting. It makes clear Gillies's own commitment to the Life Class as a preparation for whatever a painter was to do eventually with his art:

The current avant-garde view is that the traditional disciplines of the life room are out of touch with the modern spirit and have now little relevance to art training. On the other hand, a large body of teachers like ourselves hold resolutely to the belief that a sound academic training in life drawing and life painting is fundamental to the training of the artist and cannot, without detrimental results, be replaced by the relatively easy disciplines implied in the study of abstract form. With few exceptions most of the distinguished painters of today have had the advantage of a thorough academic training; they have learned from experience that there are no short cuts to high creative achievement … [23]

The last words on the subject should be those of the artist himself. In 1970 a film was made to coincide with his Retrospective Exhibition. It is a gentle affair, the artist shown at his home in Temple, reminiscing about his days at Edinburgh College of Art, recalling his contemporaries and making remarks about his painting. This is what he had to say about portraiture:

In the latter part of my training at college, I had made a great many portraits. I had a flair for catching a likeness and I seemed well on the way to becoming a portrait painter. My experience in France, under Lhote, however, was rather against this development and when, very soon after coming back to teach in college I was put in charge of still life painting, the fascination of this subject quickly gripped me and it has remained, along with landscape, my subject to the exclusion of figure work.

I heard just the other day of the opinion of one of my fellow students to the effect that Gillies had taken the wrong step when he gave up portraiture and took a teaching job in college. This I would warmly dispute. Portrait painting is, after all, in itself, a narrowish field and I maintain that I was extremely fortunate as an artist to be given the chance to continue my own growth as a painter in the propitious, adventurous atmosphere of a great school. To share the hopes and enthusiasms of the young folk in my charge and at the same time to have

enough leisure to develop my own talent.

Far from being a burden, my teaching has been a real delight to me during my long connection with college. I would not have chosen any other way of life and would willingly, if it were possible, do it all over again. I feel that my contact with the attitudes and aspirations of so many young enthusiastic and idealistic students has prevented me from becoming the old fossil you might expect me to

grow into. Teaching in a college of art like Edinburgh is an inspiration.

The portraits I have done have been mostly family ones and are not just straightforward likenesses. They have occurred rather as personal mementos of some rapport of members of a very close knit family life. In them my aim has been to hint at relationships, to whisper rather than to state.[24] V.K.

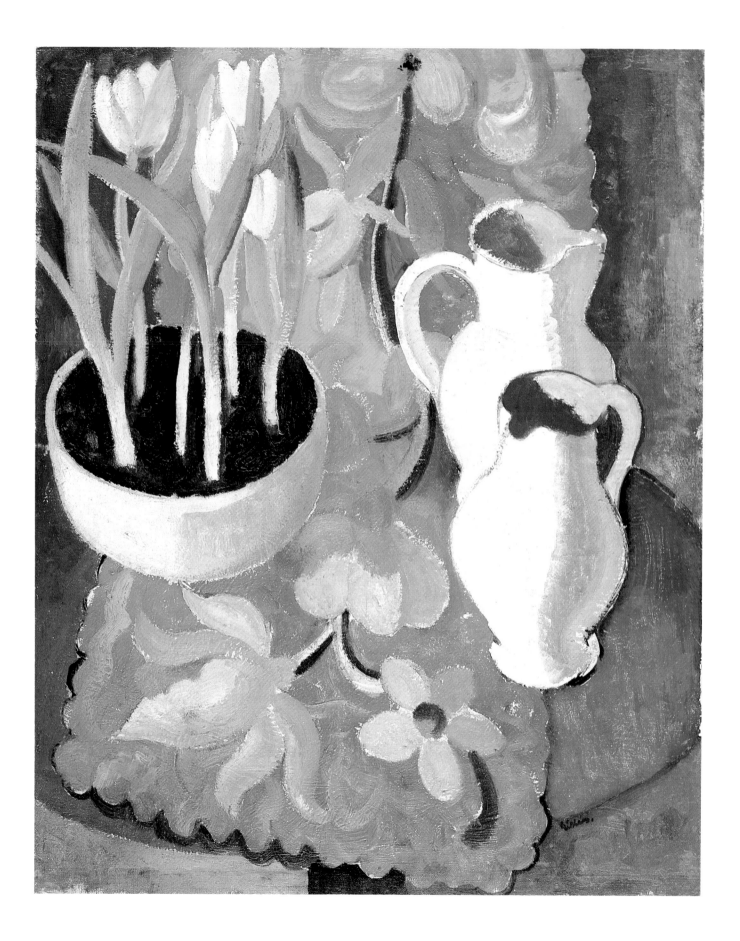

—

THE STILL LIFE

—

My house is absolutely full of still life objects which I've collected over the years and often now I merely start off with a notion, a symbol of one or two of these objects. They seem to group themselves in my mind automatically and my picture is really an extension of this notion … [1]

Spoken in 1970, these words sum up the attitude of Gillies towards his still life painting: to use and reuse familiar objects as an exploration of ideas. He was always greatly interested in the work of other artists. Using the genre of still life painting, he would distil the ideas and methods of other artists into his own thoughts and styles, adding much of himself as he went along. Then, only when they were thoroughly sifted through this process, these ideas, usually dealing with composition, would find their way into the more intuitive side of his painting, landscape.

When Gillies was a student at Edinburgh College of Art, still life was on the curriculum, but none of his principal teachers were regarded as still life painters. David Alison, David Foggie, Henry Lintott and Walter Grieve were known as painters of portraits or allegorical scenes, pictures that told of emotions, specific events or related stories. Still life was considered part of a process, a useful tool in learning how to construct compositions. Unlike the life model, it remained motionless, so that it could be drawn or painted at a slower, more considered pace. Like landscape painting, which students were encouraged to pursue in their free time, still life was considered something that could be part of a painting, but not its whole purpose. In his *Discourses* delivered between 1769 and 1790 as first president of the Royal Academy, Sir Joshua Reynolds (1723–92) laid

down ideas about the relative merits of various subject matters, which then influenced the training and exhibiting practices of artists in Britain during the next hundred years. Uplifting subject matter was at the top of that list and still life, although acknowledged as worthwhile, was at the bottom:

Even the painter of still life, whose highest ambition is to give a minute representation of every part of those low objects which he sets before him, deserves praise in proportion to his attainment; because no part of this excellent art, so much the ornament of polished life, is destitute of value and use. These, however, are by no means the views to which the mind of the student ought to be primarily directed … [2]

This opinion became thoroughly entrenched in attitudes towards art in Britain in the nineteenth century and discouraged professional artists from pursuing still life painting on its own. Still life, particularly flower painting, was considered appropriate for women painters and for gifted amateurs, but not for the professional male artist. It is not totally surprising, therefore, that by the beginning of the twentieth century there was no tradition of still life painting in Scotland. S.J. Peploe changed all that.

Samuel John Peploe was born in Edinburgh in 1871, where he trained at the Royal Institution and the RSA Life School, before going on to Paris to study at L'Académie Julien and L'Académie Colarossi.[3] His early still lifes and landscapes were influenced by the textural richness of the paintings of Frans Hals. As Peploe's sojourns in France continued into the early years of the twentieth century, his painting adopted the vivid colours prevalent in contemporary French

66 *opposite* W.G. Gillies, *Still Life, Tulips and Jugs,* c.1928
oil, 68.8 × 56.1cm, RSA

art. He produced many still lifes in those years, a genre with a long and rich tradition in France, flourishing at the end of the century with Cézanne and carried on into the twentieth century with fervour by the many and diverse artists under the banners of Fauvism and Cubism. Peploe's French-influenced still life was slow to catch on with the Scottish art-buying public, but was already much admired by art college students of the early 1920s.

The other great influence on students of Gillies's generation was the repercussions of Roger Fry's 'Post-Impressionist' exhibitions in London in 1910 and 1912. These and several other exhibitions of avant-garde continental art, together with Fry's own writings, established the 'English' and English-language understanding of modern French art. Clive Bell, who had assisted Fry in the second exhibition, wrote the highly persuasive 'Art', first published in 1914, which, based on his enthusiastic response to French contemporary art, influenced the attitudes of several generations of painters towards their art. At the root of Bell's essay was the idea of 'significant form':

… What quality is common to Sta. Sophia and the windows at Chartres, Mexican sculpture, a Persian bowl, Chinese carpets, Giotto's frescoes at Padua and the masterpieces of Poussin, Piero della Francesca, and Cézanne? Only one answer seems possible – significant form. In each, lines and colours combined in a particular way, certain forms and relations of forms, stir our aesthetic emotions. These relations and combinations of lines and colours, these aesthetically moving forms, I call 'Significant Form'; and 'Significant Form' is the one quality common to all works of visual art.[4]

With handling of paint reminiscent of his teacher David Foggie, the tilted table-top and use of citrus fruits in Gillies's postgraduate still life painting [67] is a foray into the realms of French Post-Impressionism. As well as benefiting from the example of Peploe, Gillies was able to glean ideas from the available art magazines of the day. These illustrated the work of Cézanne, Gauguin, Van Gogh, Derain and Matisse. The best known still life in Scottish painting before Peploe is *The Vegetable Stall* by W.Y. Macgregor, executed in 1884. Very much in the Dutch-Flemish tradition of still life, this is a spectacular representa-

tion of Scottish-grown produce such as leeks and root vegetables with not an orange or a lemon in sight. French painting is full of the colours and forms of the Mediterranean and Peploe's work showed young Scottish artists that it could be acceptable in Scotland to be influenced by modern French painting. However, this did not happen without some struggle on the part of those young Scottish artists.

While Peploe's very early still lifes, such as *The Black Bottle* (c.1905, Scottish National Gallery of Modern Art), are indebted to Chardin and Manet, the work he showed at exhibitions in Edinburgh in the early 1920s were paintings which used much heightened colour and simplified shapes outlined in black. When Peploe exhibited in London in 1912 as a member of the Rhythm group (others included Jessica Dismorr, J.D. Fergusson, Anne Estelle Rice and Ethel Wright), it was already noticeable that the group's strong Fauve-like colours were encompassed by heavy outlines, initially influenced by Cézanne. This decorative use of line was very much frowned upon by the traditionalist teachers at Edinburgh College of Art, where the importance of tonal relationships, that careful balance of light and dark, was emphasised. If a student attempted to introduce a more daring approach, it was swiftly discouraged. Gillies himself commented 'I can remember as a student being warned not to be influenced by Peploe – he put black lines round things, and no black lines existed in nature.'[5]

The French use of still life allowed artists to approach material in a 'formal' way. Subject matter can be controlled in ways that are difficult in the case of portraits and landscapes, which are living, breathing and constantly changing. Light levels can be set to suit the artist. The models do not require a break every fifteen minutes. This absence of the need to address swift changes in nature and the mood of the sitter allows the artist the freedom to study a subject from all angles, to contemplate it at leisure and perhaps to change the attitude towards it throughout many pictures. Emotion, such as Van Gogh's attitude towards sunflowers, is the artist's overlay. It does not have its origin in the subject matter. It is no accident that the vast majority of Cubist paintings by Braque and Picasso are still life. It is a useful vehicle for intellectual exercises, a way to explore new ideas.

All the Cubists acknowledged their debt to Cézanne. However Picasso and Braque took Cézanne's style of painting landscapes and still lifes with short broken brushwork and developed it into a stylistic framework for viewing objects from many different angles at one time, which did not deny the two-dimensional nature of the picture surface. The avant-garde painter of still life in the early twentieth century refused to treat the picture surface as a window on to a three-dimensional space. Artists such as the Cubists insisted that a picture was not about copying reality, it was concerned with conveying viewpoints about reality. Still life was the primary vehicle of this concept, on which ideas could be tested. It was an acceptance that painting could be quite openly approached conceptually, not perceptually. Although certainly not a 'conceptual artist' in today's terms, Peploe was amongst the first to make this approach known to a wider Scottish public, opening up new avenues for younger artists.

Early on in his own career Gillies began to use still life as a proving ground, in which he tried out ideas gleaned from the work of other artists. In the years following his graduation his still lifes move from a strongly traditional, perceptual approach to that of a Post-Impressionist viewpoint. *Still Life, Tulips and Jugs* (c.1928) [66] may be viewed as an elegant acknowledgment of the influence of Peploe. When the painting was exhibited in London in 1928, the critic of *The Times* wrote:

Mr W. Gillies, who shows landscapes and still-life subjects in oil and water-colour, is intelligently adapting Continental principles of design to his native impulse – most of his landscapes being in the Highlands. As usual with English – and still more Scottish – painters who sit at the feet of Frenchmen, his difficulty is to tame his colour sufficiently for the formal scheme. Every now and then it 'erupts'. But *Still Life, Tulips and Jugs and Patterned Fabrics* is an excellent decorative composition … [6]

Gillies had been away from college for five years, so the painting, in spite of its Peploe-like subject matter, is not a slavish mimicking of Peploe's handling. It illustrates the path Gillies's still lifes were taking compositionally. The two white jugs are placed contrapuntally to balance each other. The impasto is not only important for the texture it gives, but also as a line to indicate the edge of shadows. This is not a descriptive use of paint; it is a decorative one. With the acceptance of the idea that the image is two-dimensional, not pretending to be three-dimensional, using paint decoratively, not descriptively, came into its own. The contrapuntal use of dark-light, light-dark is a compositional device that was part of Gillies's early training. It is blatantly evident in many of his very early works, such as *Inverness* (1925) [see 11], in which it is combined with strongly cubist overtones. This sort of device would become more subtly handled as he grew older and more experienced. Colour is not overly exuberant in this picture of tulips, but certainly there are 'black lines round things'.

The rich, but not gaudy, colour of *Still Life, Tulips and Jugs* was to be put on hold for a few years around the end of the 1920s and early 1930s, as Gillies for the first, but not the last, time came under the spell of Georges Braque. It was not the Braque of the days of early Cubism, when he worked in tandem with Picasso, but the post-war Braque of dark, sombre still lifes. Braque's work was well known and his exhibiting career quite successful by the time Gillies made his first trip to Paris in 1924. Much of Braque's work throughout the 1920s, which Gillies easily

could have seen in French commercial galleries in 1924 and on his second trip in 1927, was characterised by the use of a black primed canvas and a black background, which pushes objects into the viewer's face. Gillies's *Still Life with Black Jug* (1933) [68] is almost monochrome and very sombre. The objects, many of which recur in his work throughout the rest of his life, are very carefully arranged on a tipped-up table top and push out towards the viewer with great vigour. It is a careful, yet powerful, study of space, using strong light–dark contrasts. The outlines that occur in *Still Life, Tulips and Jugs* have become a more subtle and schematic element in themselves, particularly in the aura-like shadowy shapes surrounding the black jug of the title. There is a series of these pictures, all from the very early 1930s, which share this schematic, forward-pushing approach and long horizontal format.

The early thirties was a time when Gillies's use of impasto became very rich. The flatness of the subtle handling of *Still Life with Black Jug*, influenced as it is by Braque, gave way to a more tactile approach in the small but intense *Two Pots, Saucer and Fruit* [69]. The space is simplified, being divided into unequal light and dark rectangles. All is balanced, however, by the intensity of the lemon on its dish of white with a black edge, pushed almost to the edge of the picture surface. The jug to the left looks as if it has been sculpted out of paint, but its gaping darkness is not allowed to dominate the painting, being balanced by

a section of shadowy cloth to the upper left and the white top of the vase on the right of the picture. This is the first of a series of tautly constructed still lifes that Gillies was to paint from now until late in his life, which are amongst his most successful. *Two Pots, Saucer and Fruit* looks back to Braque and forward to Matisse, another consummate still life painter, who also painted a number of simple, stark still lifes dominated by black with intense touches of lemon yellow. Like the still life paintings of the Italian Giorgio Morandi (1890–1964), whom Gillies came to admire, Gillies has taken a small number of items, often the same things from picture to picture, no more perhaps than four or five, pushed them close to the front of the picture plane and then explored the relationships between the objects and the space they are set in, often using tonal balance as an important compositional device.

Gillies painted many still lifes throughout a long career, of which only a few can be said to be truly outstanding. It was in landscape painting that he always felt most at ease and where his intuitive powers were at their strongest. In still life he felt his way with a great deal more caution. The nature of still life painting allows the artist more time to contemplate and forces him to think his ideas through, encouraging him to keep trying to get it right. In his own teaching Gillies encouraged his students to learn when to stop working on a picture. His landscape painting, which often began with drawings,

68 W.G. Gillies, *Still Life with Black Jug*, 1933
oil, 56.5 × 127.1cm, RSA

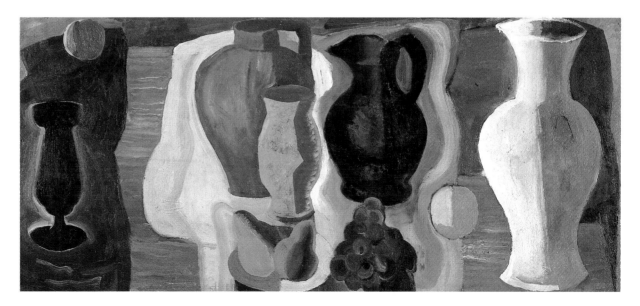

then progressed to watercolours painted *in situ* with the oils painted later in the studio based on those watercolours, shows that he knew when to stop in this genre. The working procedure alone encouraged this, as a watercolour refuses to be overworked. Gillies did not use this procedure with still life. The large collection of drawings in the RSA Archive contains only a very small number of preparatory drawings for still life and even fewer preliminary watercolours. For Gillies, still life was something to be worked straight on to the canvas and reworked on the canvas. Apparently it was much more difficult for him to know when to stop.

Still life was a cerebral exercise, whilst landscape was intuitive. However, the working out of spatial ideas in his still lifes was of vital importance to his landscape painting. The abstraction of form found in many of his best landscape watercolours of the 1930s, such as *Achgarve* [see 128], could not have been achieved so easily without the concentrated thought he devoted to still life. Indeed it can be said that throughout his life many of his best landscape compositions in oil have been treated as if they had been still lifes. The piling up on the canvas of shapes in an abstract fashion derived from his responses to still life. This can be seen in such examples as *The Red House, Durisdeer* (c.1933) [see 116], *Harbour, St Monans* (c.1935) [see 110] and *Garden Temple, Winter Moon* (1968) [see 143].

Much has been made of the keying-up of colour in the early 1930s, but this happened more gradually with Gillies's still lifes than his landscapes, which were exploding with colour by this time (*The Red House, Durisdeer* is a case in point). *Still Life with Apples and Grapes* (private collection) contains the grapes found in *Still Life with Black Jug* paired with the jug found in *Two Pots, Saucer and Fruit*. The paint handling has the richness of the latter, but the colours are no longer sombre and subdued. The background is a gentle peach-pink, the grapes are luscious swirls of intense purple. There is a scattering of cut-open green apples across the picture with shadows of a rich red. The picture is on the same scale as *Two Pots, Saucer and Fruit* with the same approach to space and handling. However, the colour now takes on a decorative quality that was to stay in Gillies's still lifes for many years.

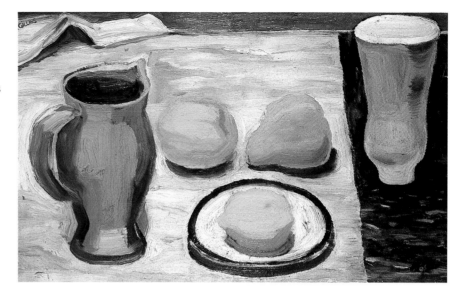

69 W.G. Gillies, *Two Pots, Saucer and Fruit*, 1933
oil, 31.3 × 50.7cm, RSA

The early 1930s must have been exhilarating years for Gillies. His part-time teaching post at Edinburgh College of Art was growing into a full-time job, which gave him great pleasure. In 1931 the Society of Scottish Artists invited Edvard Munch to exhibit twelve of his paintings at their annual exhibition. Cadell and Peploe sponsored Gillies's election to the prestigious Society of Eight in December the same year. There was a great deal to interest him on the international and national scenes, as well as influences much closer to home.

In 1931 Herbert Read published his book *The Meaning of Art*.[7] An art critic for *The Listener* and Watson Gordon Professor of Fine Art at the University of Edinburgh, he was by then an advocate of modernism in European art. Before leaving Edinburgh for London in 1933, he lectured in the 1932–33 session at Edinburgh College of Art on modern German art.[8] Read went on to become the principal spokesman for the English avant-garde throughout the rest of the 1930s. In 1933, when Gillies was involved in his second exhibition with The Society of Eight and considered something of a rebel on the Edinburgh art scene, *Unit One* – the most contemporary English art group of its day – was arranging its first exhibition in London. It counted among its members Paul Nash, Ben Nicholson, Henry Moore, Barbara Hepworth, Edward Burra and Edward Wadsworth. Nicholson was four years older than Gillies and over the 1920s and into the 1930s their artistic concerns, as

was the case with so many of their contemporaries, ran roughly parallel. However Nicholson's work was at the forefront of modern art in Britain, while that of Gillies was not.

On the broader stage in Britain the search for 'significant form' throughout the 1920s often took the shape of a child-like simplicity. This went hand in hand with an interest in Post-Impressionism amongst the more traditionally minded and in Cubism amongst the more avant-garde. Nicholson, and later Gillies, would have counted themselves among the latter camp. By the 1930s modern art in Britain was veering towards a polarisation with those interested in taking Cubism further into the realms of abstraction in opposition to those who saw the dream worlds of Surrealism beckoning.

When William Crozier died in 1930, Gillies lost a colleague and friend, with whom he had shared notebooks on their visit to Italy only six years before. Gillies's friendship with William MacTaggart secured him Crozier's space in MacTaggart's studio in Frederick Street, where artistic ideas could be exchanged and problems discussed. Two women artists, Agnes Falconer and Lily McDougall,[9] shared the studio next door. The latter was to become a life-long friend[10] and was also to have an impact on his painting. She had occupied her studio since before the First World War. Trained in Edinburgh and abroad, widely travelled and by all accounts endowed with a forceful personality, this was a woman of some consequence when Gillies arrived at the Frederick Street studios in 1930. Nevertheless in those days it was still difficult for women artists to get their work exhibited, however talented they might be. It was McDougall's father William who took the step of setting up the Scottish Society of Women Artists in 1924, of which his daughter became the first president.[11] Gillies was to learn from Lily McDougall and be encouraged by her. In return he imparted to her something of his own enthusiasms.

Flower pieces dominate McDougall's painting, although surviving examples of her portraiture show that she excelled at this branch of art. Gillies owned three of her still lifes which demonstrate that her handling of the foreground is very vigorous. Great

slabs and slashes of paint encourage the flowers to erupt from the picture surface in vibrant colour, often with some primed canvas showing through. The background of all her work is much more subtle. Paint is heavily applied in consistent vertical strokes. In contrast to the foreground the brush-marks are of delicate colour, overlapping but not allowed to blend with each other. A kind of shimmering veil is thus achieved, the hallmark of many of her paintings.

With so much to excite his interest it is not surprising that influences close to home and further afield begin to appear in Gillies's own painting. Two pictures from the early to mid 1930s incorporate many ideas new to his work. *Still Life with Chagall Print* (1933) [70] and *Still Life with Portrait Postcards* (c.1934–5) [71] contain similar elements, such as reproductions of other artists' work as well as the black vase and other pots. There are similarities in handling: lush, rich brushstrokes and a heightening of colour. Compositionally, however, they differ strikingly. The former, with all its explosive quality of paint, is linked to the more sombre *Still Life with Black Jug* [68], that ubiquitous black vase pushing itself out at the viewer in an extremely aggressive manner. In the latter work Chagall's imagery still persists, but now in a smaller postcard form, and the black vase has been carefully relegated to the mantelpiece at the upper right of the painting. The middle and foreground is dominated by a French coffee pot with a shiny glaze, a vase of flowers and the scattering of postcards.

Gillies made few preparatory drawings for his still lifes, but there are at least two small sketches that indicate that he was feeling his way into new territory with *Still Life with Portrait Postcards*. One of the drawings contains some of the same elements, but includes a jug as well as two books. In a very similar painting the postcards are replaced with books, which it is actually possible to identify, because they were part of his library, which he bequeathed to the RSA. Both books are on the French artist Henri Matisse. One of them, written in German and published in Leipzig in 1924, was bought by him in Paris in 1927. The other small monograph was published in London in 1930. It is to Matisse that these new still

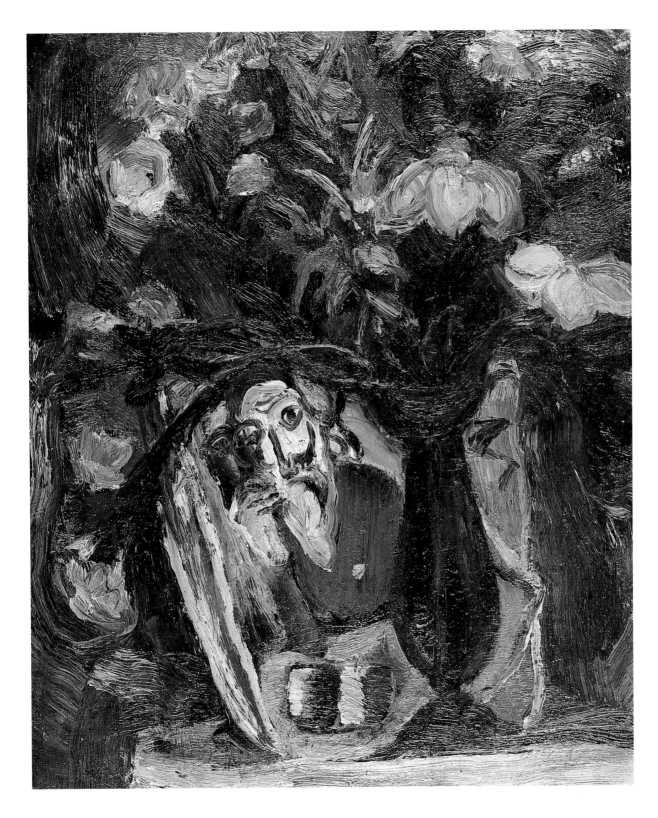

70 W.G. Gillies, *Still Life with Chagall Print*, 1933
oil on plywood, 56.0 × 45.5cm, RSA

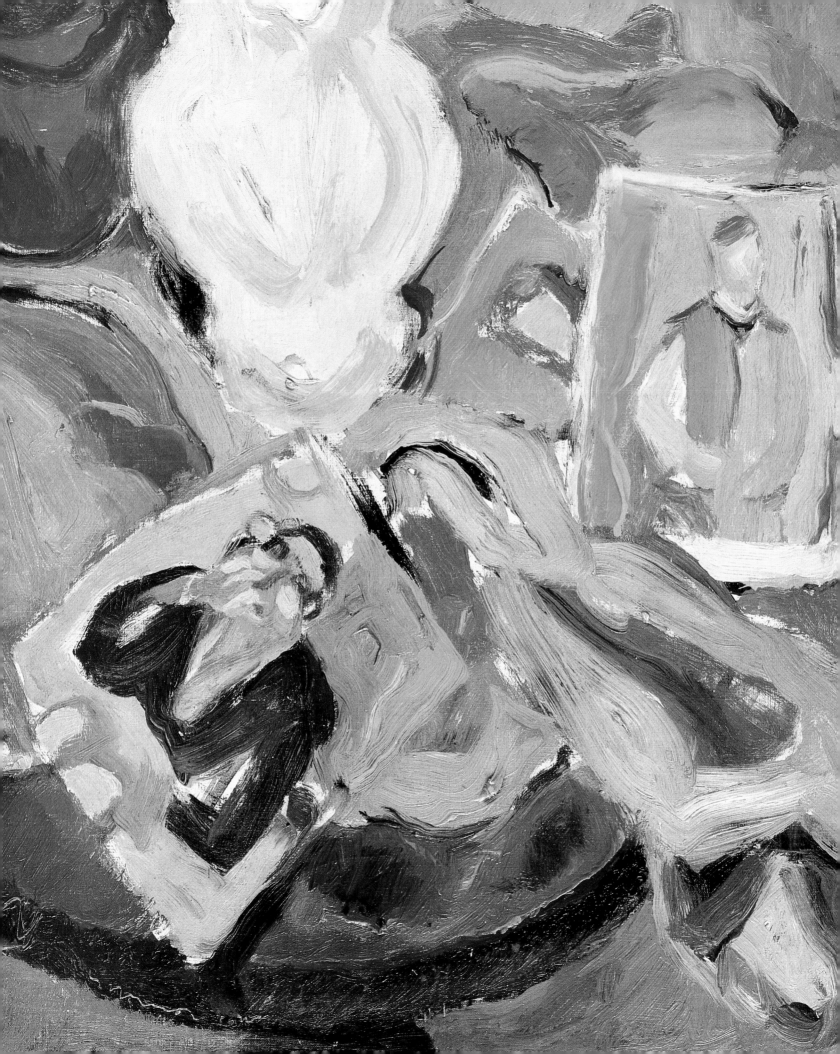

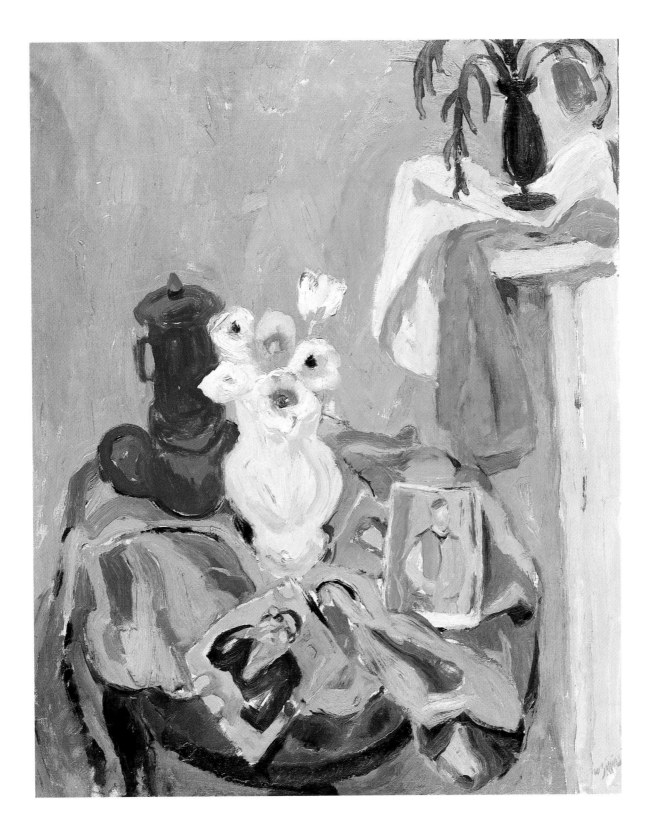

71 W.G. Gillies, *Still Life with Portrait Postcards*, c.1934
oil, 82.6 × 65.9cm, RSA

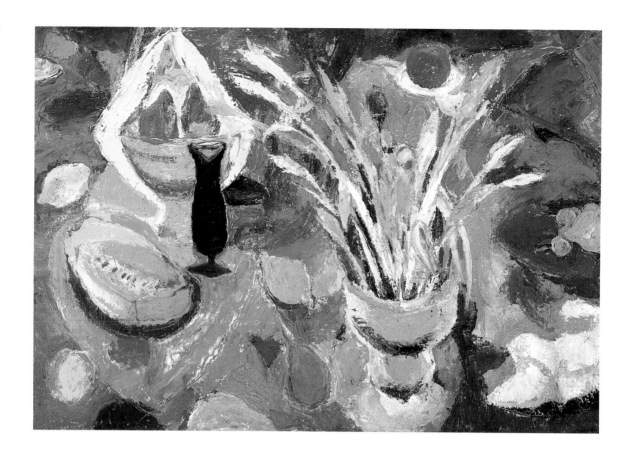

72 W.G. Gillies, *Still Life with Scattered Fruit and Grasses*, c.1937
oil, 75.8 × 110.5cm, RSA

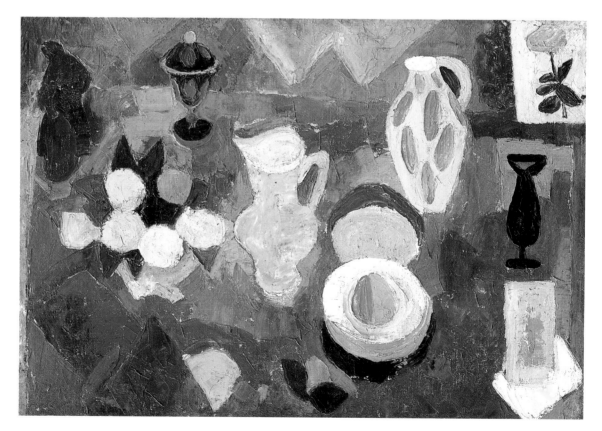

73 W.G. Gillies, *Westwater's Marriage Present*, c.1936
oil, 76.2 × 111.8cm, Private Collection

lifes initially look for guidance. They begin to inhabit a domestic space that is quite new to Gillies's painting, but which Matisse had established in his work of the 1920s, where compactly painted flower arrangements glow quietly amid the scattered debris on a table in the corner of a room. The little table in *Still Life with Portrait Postcards* is heavily burdened with objects on a crumpled cloth which appears to float over the tipped-up table. The whole effect is rather monochromatic with flashes of colour from the flowers and postcards. The colour is very different from the exuberance of his contemporaneous landscapes. Here the emphasis is more on composition and its resolution and less on the sensuous aspects of colour.

During this period Gillies was doing more and more teaching at Edinburgh College of Art. Over the next two or three years Gillies turned away from the construction of intimate corner-of-the-room compositions and returned to concentrating on long horizontal table-tops like those of the early thirties. On this occasion, however, his attitude has less to do with focusing the viewer's eye on objects marching fiercely across the front of the picture surface and more with ideas linked by abstraction. Now the objects seem to be cast like handfuls of grain to chickens across the whole of the picture surface with no sense of recession, a fundamentally decorative concept in which it is possible to do without shadows altogether. Both *Still Life with Scattered Fruit and Grasses* [72] and *Westwater's Marriage Present* [73] were preceded by careful compositional studies, that of the latter being executed in gouache [74]. One of a small group of such studies – primarily for still lifes or views out of windows – it is characterised by a simplicity not found in Gillies's pencil sketches. It is more akin to the bravura nature of his 1930s watercolours. The shapes of the still life objects (which include the ever-present black vase) have been simplified down to basic formulae.

The texture of the *Westwater Marriage Present* is very similar to *Still Life with Scattered Fruit and Grasses*. However, it is a much more successful painting in that the objects seem to relate more to one another. The lovely patchwork nature of the table-top is very similar to that in a number of Gillies's landscapes of

the period, particularly noticeable in a series of Fife fishing village paintings of the late 1930s. Interestingly, Gillies decided to exchange the wine bottle in the study for a lidded dish, not such a tall dominating presence compositionally. The print of a flower – in this case a rose – is a favourite motif which recurs in his still lifes up to the late 1960s.

Abstract painting was very much on Gillies's mind when he worked on these pictures. He set himself an exercise of painting a series of three completely abstract works at about this time, two of which are illustrated in Chapter One [see 16 and 17]. He even allowed himself in the 1930s to push some of his landscape paintings to the edge of abstraction [see 125]. However he viewed still life as the appropriate arena for such activity. He later remarked 'In still life I felt able to go into almost pure abstraction; in landscape there is a limit beyond which content vanishes altogether.'[12] In *Still Life with Scattered Fruit and Grasses* he plays with a painterly, textural vagueness, where shadows become more like auras around the dish of pears, and fruits float around the picture surface like so many celestial bodies. This seems to have been as far as Gillies was prepared to take abstraction, at least for the time being.

Now his pictures tighten up. He does away with so much vagueness and brings back strong decorative passages of paintwork, which indicate more than a passing interest in the work of Bonnard. *Flowers in a Blue and White Vase* (c.1938) [75] is the first painting to show his great fondness for Bonnard's work, which was so strong that his students from the 1940s and 1950s acknowledge that Bonnard had taken on god-

74 W.G. Gillies,
*Study for Westwater's
Marriage Present*, c.1936
pencil and watercolour,
26.2 × 37.6cm, RSA

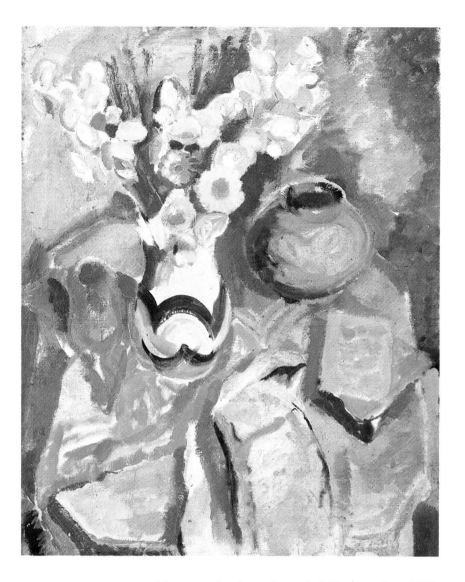

75 *above* W.G. Gillies,
*Flowers in a Blue and White
Vase, c.1938*
oil, 85.2 × 69.7cm, RSA

76 *opposite* W.G. Gillies,
The Blue Window, c.1940
oil, 122.1 × 91.3cm, RSA

like status for them through Gillies's teaching.[13] The possibility of creating, like Bonnard, veils of colour across the picture surface fascinated Gillies in the late 1930s. He was very taken with paintings of intimate spaces – occasionally peopled, sometimes with windows opening up on to the outside world – by Bonnard and Vuillard as well as by Matisse. The opportunity to develop compositions using seemingly simple, yet often highly complex, spatial arrangements and non-representational colours had taken Gillies a long way from the *Still Life, Tulips and Jugs* of 1928. All these ideas are played with in the *Family Group* (1937) [see 61], in which entire rooms have been painted like a still life. Painted shortly after the death of his younger sister Emma, this painting shows Gillies, his mother and his elder

sister placed apart, compartmentalised emotionally, but linked together by the warm veils of colour.

The family moved to Temple in 1939 where the ferment in Gillies's still life painting from the 1930s gives way to the elegant formality of *The Blue Window* [76], the first work he completed at Temple.[14] He later remarked 'On coming to Temple I began to cope with my new material by relying on simple planning and tonal relationships as subtle and evocative as I could make them.'[15] The almost frantic stylistic casting-about is gone, at least for the moment, and in its coolness and solemnity he has achieved that almost abstract balance of form and colour which is the hallmark of his best work. Many of the same objects recur, as in earlier work, but he has left out the prints and books, rectangular shapes which could help open out space. Here spatial interest has been created by the substantial opening of the window with its view of a confusing density of garden walls and shrubs. The extreme delicacy of all the objects on the table contributes to an almost oriental quality in the picture. It works because of the subtlety of the use of colour in the composition, which relies for its anchor on the blue and red at the bottom and the hectic riot of spring outside the window.

Later, probably late in 1940 or very early in 1941, Gillies painted a winter version of this still life. The cool blue tones of the walls remain, but now the window is closed. There is snow outside, which simplifies the garden and makes it easier to read the landmarks. A blue light plays over all the objects on the table. Many of these are the same as in the first work, but the jug has been replaced by a more vertical vase with dried grasses lined up directly in front of the window's central glazing bar. These two paintings act as a very substantial coda to the decade of the 1930s and as a supremely elegant introduction to the still lifes of the 1940s.

Wartime restrictions affected both the work of the College and travel. In addition Gillies's full-time role as a member of staff and his local responsibilities to his mother and sister and as a fire officer in Temple placed considerable constraints on his painting. Landscape painting, certainly in the manner to which he had become accustomed before the war,

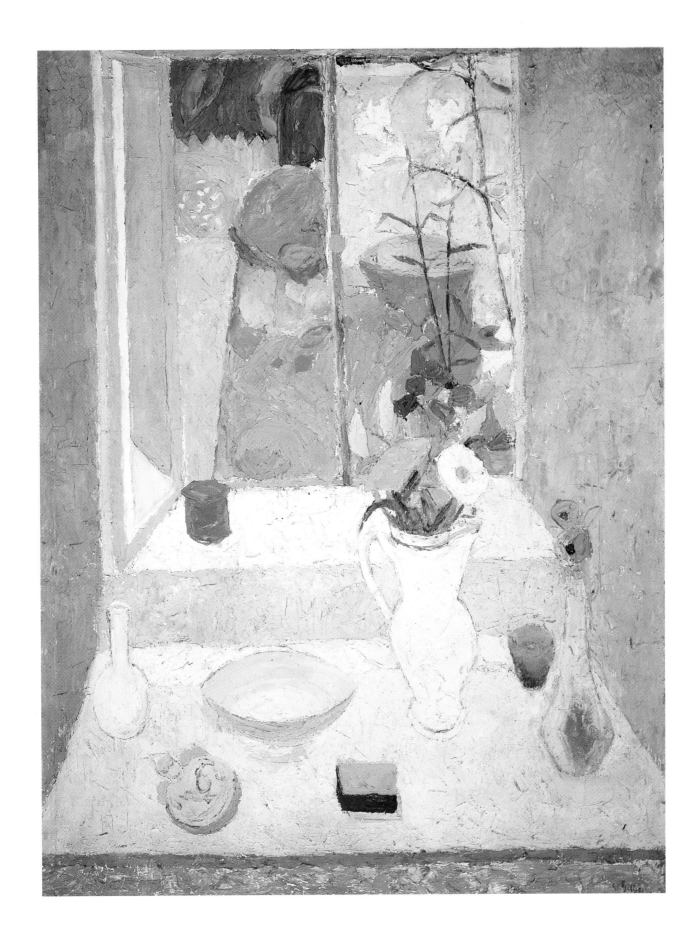

was no longer possible. After executing his self-portrait, painted at about this time, he gave up portraiture. The 1940s, therefore, were the years when he explored his immediate environment around Temple. Still life assumed a more central role.

The still lifes of the 1940s can be divided into three categories, epitomised by *The Red Squirrel* (1941) [77], *Still Life, the Doyley* (c.1947) [78] and *Flowerpiece* (c.1948) [79]. The first work reflects the artist's on-going love for the sort of decorative patterns found in the work of Vuillard, Bonnard and Matisse. The eye of the viewer is almost overwhelmed by the delightful variety of colours and patterns of fabrics, so much so that the ceramics, fruit and red squirrel are almost lost in the exuberant riot across the picture surface. Shadows are almost non-existent, because they would interfere with the flat, two-dimensional nature of the patterns themselves.

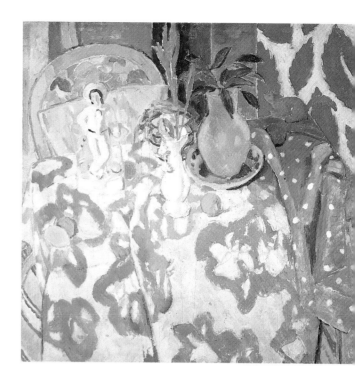

Still Life, the Doyley exemplifies the use of strong shadows, which are the hallmark of a large group of pictures begun in the 1940s and continued into the 1950s. He said of these works 'The move to Temple had its effect, too, on my still life painting. We'd exchanged electricity in town for Tilly paraffin lamps in Temple. I had always done a lot of work by artificial light and I continued to do so, fascinated by the shadowy effects I got with these lamps.'[16] The painting has the same tipped-up table-top as *The Red Squirrel*, but, other than a delight for the feel of the paint surface, that is about all the two pictures have in common. The pigment looks as if it has been chiselled rather than laid on with a brush or a palette knife, and the shadows cast by the objects play dramatically across the table and against the back wall. The desire to show the still life (and its shadows) from different angles at the same time echoes his earlier Cubist essays, but the landscape created by the shadow on the wall is pure Gillies.

Flowerpiece is an example of *bravura* painting, contemporary not only with paintings such as *Still Life, the Doyley*, but also with the very impressionistic landscape paintings and his work in the Fife fishing villages of the later 1940s. The paint has been handled at extreme speed,[17] in the more relaxed, intuitive way he painted watercolour landscapes, the large whirling brushmarks of the flowers almost

overwhelming the pretty ceramic jug in which they have been stuffed. The handling is not far removed from one of Lily McDougall's flower pictures owned by Gillies. There are a number of such pictures from this period, painted almost as a cathartic release from the careful structuring of space demonstrated in works such as *Still Life, the Doyley*. Gillies was in Paris in 1946 and the rich paint handling he indulged in throughout the period, especially in the late 1940s, can be viewed as one with the work of certain contemporaneous School of Paris artists, such as Nicolas de Staël (1914–55), who revelled in expressive abstraction.[18]

Gillies's college work was building up steadily throughout the 1940s. He remarked 'The late forties and early fifties were strenuous ones for me in college as Head of Painting, and I didn't have much leisure except of course during the long vacation and during this period in term time I concentrated mostly on still life ... '[19] David Alison resigned as Head of Drawing and Painting during the session 1944–45 and Gillies was appointed to supervise the work of the school pending the appointment of a successor.[20] The following year he became acting Head.[21] As well as coping with his new administrative duties, he taught life drawing, life painting and

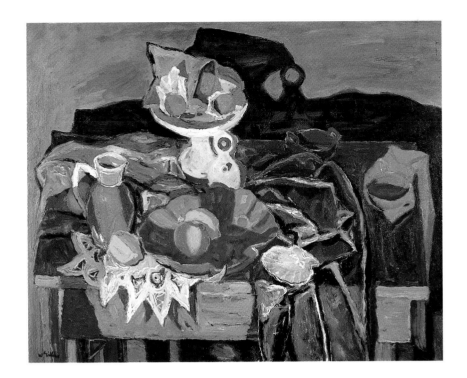

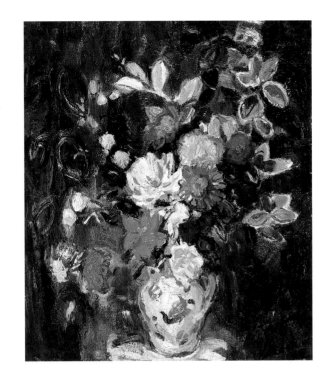

composition,[22] and accompanied a group of students to Paris that summer (during which most of them suffered from stomach upsets). The many postcards he sent from Paris to his mother and sister indicate that Gillies took the opportunity not only to visit the Louvre, but also to visit dealers' shows, buy art books and revisit old haunts: 'Saturday. Still enjoying ourselves. Weather lovely. Having an easy day today a saunter round the little art exhibitions. Will go to Chartres to see the glass on Monday ... We may go up Eiffel Tower today. Have got some very nice art books. Food lasting very well.'[23] His appointment as Head of the School of Drawing and Painting was confirmed during the 1946–47 session, when he was also elected an Academician of the Royal Scottish Academy. This was the year in which the College was so overwhelmed by student appplications that entrance tests had to be introduced for the first time,[24] which resulted in even more administration for Gillies. However, staff had their own studios in the College and, as Head of Drawing and Painting Gillies had one of the finest, of which he is reported to have made good use, painting when he could and occasionally inviting students in to ask their opinions of the work in hand.[25] Not only did he keep some of his antiques and various other pieces of bric-a-brac

there, but he also hung two kilims on the walls.[26] Occasionally these appear as decorative backgrounds in some of his late still lifes such as *Still Life on a Cupboard* (1966, Royal Academy, London).

In 1951 Gillies was one of a number of artists asked to contribute a painting to an exhibition held in London to celebrate the Festival of Britain. Organised by the Arts Council and entitled *60 Paintings for '51*, other exhibitors included Francis Bacon, Lucian Freud and Patrick Heron. The painting which Gillies sent was *The Studio Table*[27] (1951) [80]. It is a very large canvas, the culmination of a number of smaller still life paintings of the late 1940s. The more lighthearted overall decorative side of his art, exemplified by *The Red Squirrel* of 1941, has been shed, although it lingers on faintly in the design on the ceramic jug and the delicate passages of blue and pink. The shadows thrown by the Tilly lamp are still there, but they no longer dominate the picture surface, but lend the legs of the stool a certain schematic strength. There is evidence of an interest in Braque's series of paintings of studio interiors begun in the 1940s, in which all surfaces, whether walls or table-tops, are conceived as a series of interconnecting planes against which is placed a still life arrangement.

Braque was not the only artist on the internation-

al stage who held Gillies's attention in the early 1950s. From the late 1940s to the present day, Scottish artists have been fascinated by the 'very still' still life paintings of Giorgio Morandi.[28] Morandi was born in Bologna and spent his entire working life there. Although in his youth he had been an early follower of Giorgio de Chirico's Metaphysical Painting, he turned to painting still life arrangements early in his career. Using the same bottles and vases over and over again, all lined up at the very front of the picture plane, Morandi's quiet authority of placement, and the almost monochrome, often rather silvery tones and frequent quite rich handling of pigment, have impressed a wide range of artists. Gillies's acknowledgement of the Italian artist lies not only in the way he arranges his still life material, but also in the 'scrubbed' fashion he sometimes employs in depicting it, which is a hallmark of Morandi's later handling.

The Studio Table of 1951 is followed by a number of small-scale canvases, such as *Still Life with Fruit* (c.1952) [81]. The organisation of the picture plane and the subdued yet rich handling of the colour in these pictures suggest a very tangible appreciation of Morandi. They concentrate on what is very clearly a corner of a table in Gillies's studio with a small number of familiar objects arranged and re-arranged from painting to painting. The corner of the table is important, because it is a rectangular surface that is frequently divided from picture to picture into two unequal halves. The narrower right hand side, cut off by the picture's edge, is the dark side. The larger left hand side, showing the edge of the table, is the light side. Around the top and left side are other rectangles that may or may not be parts of the wall or floor – ambiguity is quite important. Frequently there is a source of light so that the objects can be shown with strong contrasts of dark–light. This paring down of objects into abstract essentials was to return very strongly in pictures painted nearly a decade later in the 1960s after his retirement from the College.

This preoccupation with showing an interior space as a succession of shifting squares and rectangles is very elegantly handled in two quite different paintings dating from 1955 and 1957. *Still Life – Yellow Jug and Striped Cloth* [82] is his Diploma work, painted and deposited with the Royal Scottish Academy in 1955. It is not unusual for new Academicians to take some time in depositing a painting for acceptance into the Diploma Collection, but it had taken Gillies nearly eight years after his election to decide what seemed appropriate. Surprisingly it was not a landscape, the better known and appreciated side of his work, but this very striking composition. However he very deliberately refers to the other areas of his work at the time through a drawing of boats and a glimpse of the garden through a window. The still life elements are almost an excuse for painting a picture predicated on the square and rectangle. Table tops, pictures leaning against the wall, the floor, the walls, bits of carpet, all these form the main elements of the work. Colour is used to pace the

80 W.G. Gillies, *The Studio Table*, c.1951
oil, 116.8 × 213.4cm, The Fletcher Collection, on loan to the City Art Centre, Edinburgh

81 W.G. Gillies, *Still Life with Fruit*, c.1952
oil, 48.5 × 64.8cm, Paisley Museum and Art Galleries

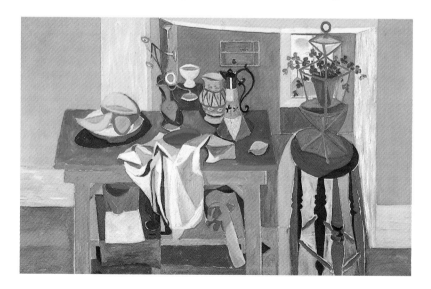

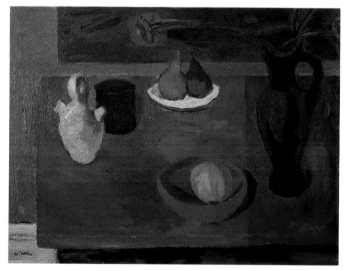

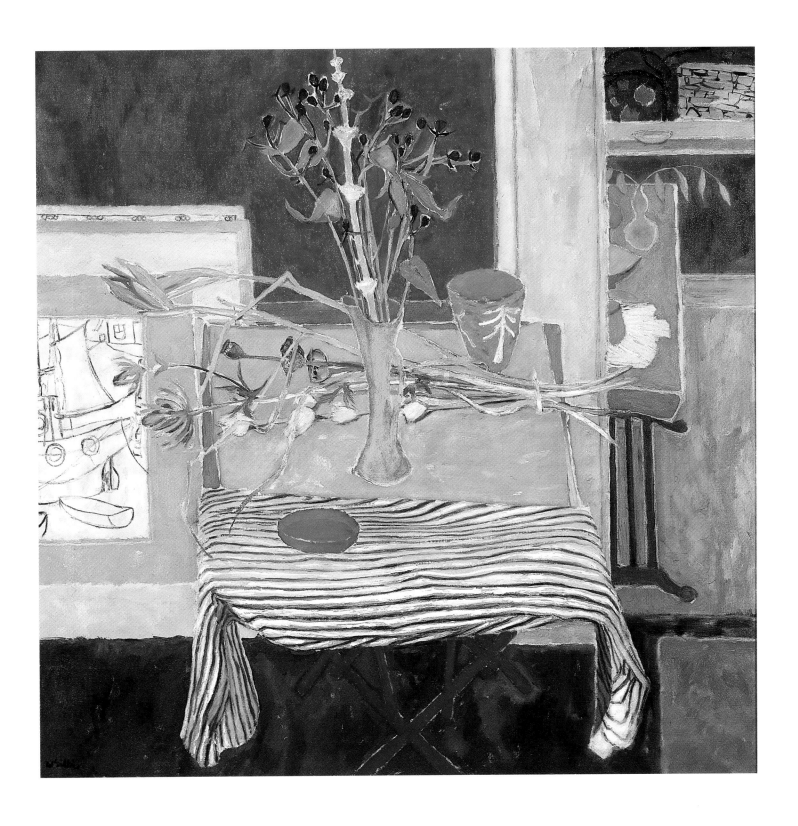

82 W.G. Gillies, *Still Life – Yellow Jug and Striped Cloth*, 1955

oil, 112.0 × 114.9cm, RSA (Diploma Collection)

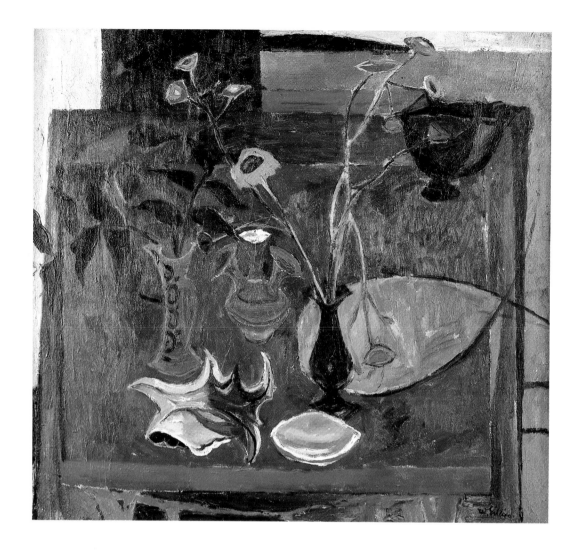

83 W.G. Gillies,
Still Life, Blue and Red, 1957
oil, 91.5 × 99.0cm, Private Collection

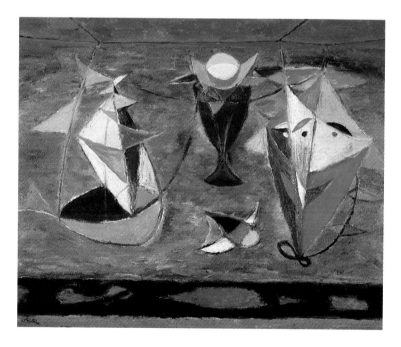

84 W.G. Gillies, *Still Life with Toy Boat and Kite,* 1958
oil, 76.3 × 93.8cm, RSA

exercise, the red dish placed precisely across the undulating vertical stripes of the cloth, a focus for the eye so that it will not be daunted by the geometry of the picture. Shadows have been completely omitted from this complex equation.

Still Life, Blue and Red (1957) [83] retreats from the severity of the earlier Diploma work. The picture surface has become more painterly again. Impasto is used to give the surface a strong textural quality. The shifting squares and rectangles of the picture planes are more subtly handled, but are even more ambiguous. It looks as if landscape elements are included in the distance and some of the still life objects are wittily metamorphosing into totally abstract shapes, such as the fish-shaped dish that connects the ubiquitous black vase to the background via its schematised tail-fins.

The fish dish reappears in a new guise in the painting *Still Life with Toy Boat and Kite* (1958) [84]. The horizontal table-top has reappeared as a setting for the abstraction of familiar objects in a playful vein. After his experiments of the 1930s Gillies never seriously pushed his still lifes beyond this sort of abstraction. The more successful and certainly more sombre *Still Life, Black Table* (1960) [85] also has a dominant horizontal table-top. It too employs shifting background verticals with a formal still life arrangement pinned in suspended animation across the table suface. The black table, painted with powerful strokes of the palette-knife, stands out against the black brush-painted background horizontal. As in *Garden, Temple, Winter Moon* (1961) [see 143], Gillies uses the texture of black or grey paint, which covers the majority of the surface, to give life and surface interest to the painting, rather than using the subtle changes of colour seen in the earlier *Still Life, Blue and Red*. The fish has metamorphosed into a placemat or a print, and the tulip print, which appeared in paintings of the 1930s, contributes further rectangles to the overall composition. In order to enliven the rectilinearity of the composition, Gillies has also played with curves – the spider plant, the handle of the sweet-dish, the leaves of the foreground plant and the bit of cloth draped over the goblet, which crosses the boundaries of the rectangles and softens the overall line.

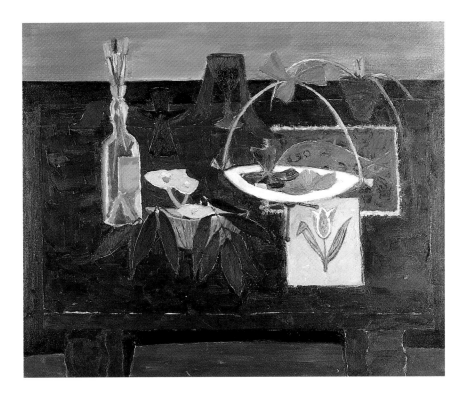

85 W.G. Gillies, *Still Life, Black Table*, 1960 oil, 81.3 × 99.0cm, Perth Museum and Art Gallery

1960 was a difficult year for Gillies, both personally and professionally. His sister Janet died that year after a number of years of declining health and his mother was becoming increasingly frail as she entered her ninety-sixth year. He was now the rather reluctant Principal of the College with all the extra administration that that entailed. There was a loss of contact with the students, which previously he had enjoyed. He had even less time to paint. Pictures of substance – still life and landscape – are few and far between in the early years of the decade. Those that are successful are almost without exception very dark, saved from grimness by passages of lyrical colour.

Winter Dusk [86], started in 1961 and completed in 1963, the year his mother died, combines still life and landscape in an interior–exterior composition, imposing the rectilinear structure of the window and table on the whole picture. It is cool in tone, as befits a winter composition, and looks back to the winter version of *The Blue Window*, which he had painted twenty years previously. In place of the shifting spaces of abstract rectangles in the paintings of the 1950s, Gillies has manipulated the natural scene beyond the window to give ambiguity to the fore-

86 W.G. Gillies, *Winter Dusk*, 1961–63

oil, 114.3 × 152.4cm, Hunterian Art Gallery, University of Glasgow

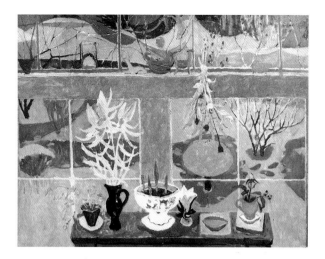

ground. The little animals on the upper ledge of the window frame appear to want to move out into the background.

After retirement in 1966 Gillies's painting, both landscape and still life, took on a new lease of life. The early sixties had been stressful both at work and at home and by 1966 he was only too ready to be able to concentrate on his painting. Two exhibitions held at the Scottish National Gallery of Modern Art in the summer of 1965 were a great encouragement to his artistic thought processes over the next several years. The exhibitions of work by Giorgio Morandi and Julius Bissier (1893–1965) made a profound impact, not only on Gillies, but on many other, often much younger, artists.[29] While Morandi's work was already known and much admired in Scotland by the mid-1960s, Bissier's painting was relatively unknown; there are artists working today who remember this exhibition with great enthusiasm.[30] Bissier came from Freiburg-in-Breisgau in Germany. A few years older than Gillies, he began his artistic studies just before the war in 1914 and resumed them afterwards. He turned to abstraction in the 1930s with a particular interest in Eastern culture and art, developing a calligraphic style with rich colour combinations. Later in his life he produced the paintings which gained him the widest recognition. Small in format and utilising pieces of canvas that had been cut or torn, they are executed in egg tempera and finished with an oil glaze, which gives the colour a beautifully transparent quality. The work, seemingly of abstracted still life subjects, has an almost ethereal quality

that can best be understood in terms of the most deftly handled, limpid watercolour.

Now that he had time to paint, fresh ideas gave new impetus to his work. Gillies's still lifes and studio interiors from the mid 1960s are very complex developments of compositional devices he had used in earlier paintings, adding a new twist in the area of colour. Two striking examples of this were painted in 1965 and 1968: *Interior of Studio, Temple* [88] and *Still Life – Study in Grey* [87]. They both play with a multitude of rectangular shapes, creating shifting planes across the picture surface. The former employs windows, other pictures, the floor and table-tops as the basis for its compositional structure, very much in the same vein as *Still Life – Yellow Jug and Striped Cloth* of 1955. Although the composition seems to be interlocking in its geometry, Gillies's use of colour liberates what could have been purely a play of abstract shapes. Lime greens, acid yellow, orange and passages of intense blue run riot. This exuberant colour is applied rather flatly, so that in reproduction *Interior of Studio, Temple* could be mistaken for a watercolour.

Still Life – Study in Grey is placed across a table-top pushed flat against the picture plane. The only thing that keeps this work from abstraction is the pedestal the table sits on. The paint is so chalk-like in appearance that it resembles fresco painting, a conceit encouraged by the Etruscan nature of the pots. The composition recalls an image of Morandi's paintings of a few pots arranged at the front of the picture plane, while the 'fresco-like' handling is reminiscent of the work of Massimo Campigli (1895–1971), another Italian artist whose work had been interesting Scottish artists since the 1950s.

After he had seen the Bissier exhibition, Gillies purchased a book on the artist.[31] He cut out the colour reproductions and pasted them on to mounting board, placing them around his studio so that he could see them while he worked.[32] A number of Gillies's late still lifes are a direct homage to Bissier. The most impressive of these is *Still Life with Blue Gloves* (1968) [89], executed in watercolour. Never before had Gillies produced such supremely confident still life paintings in this medium. Watercolour had long been reserved primarily for landscape. Those still lifes that he had done in watercolour do

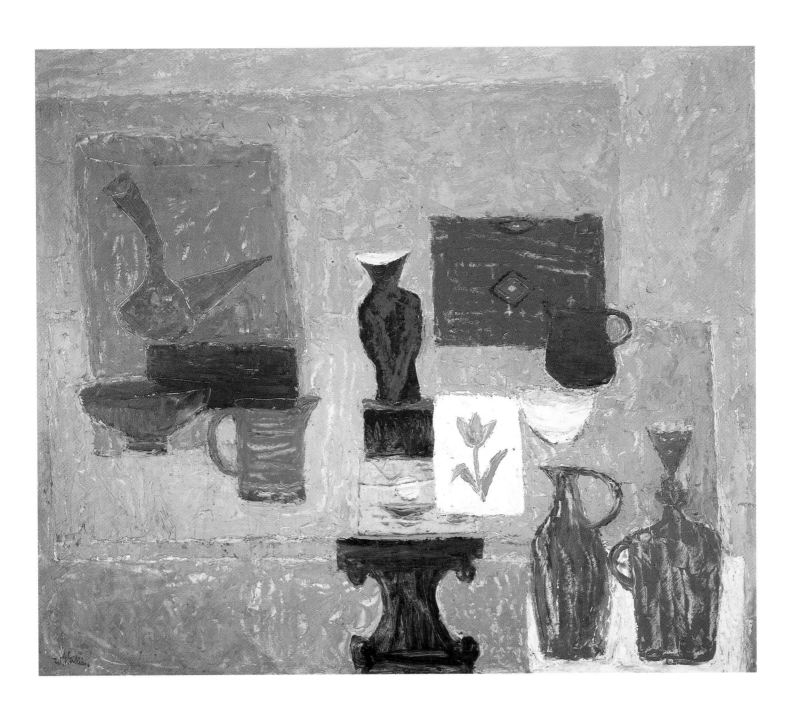

87 W.G. Gillies, *Still Life – Study in Grey*, 1968
oil, 81.2 × 97.8cm, Private Collection

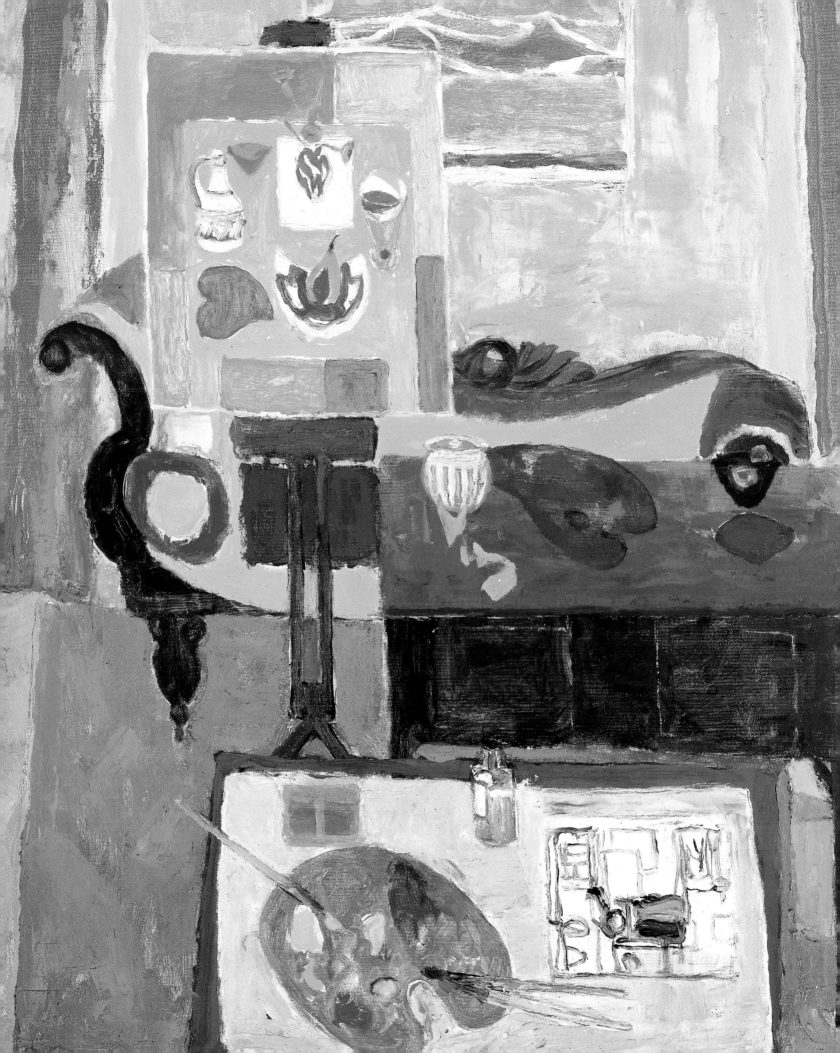

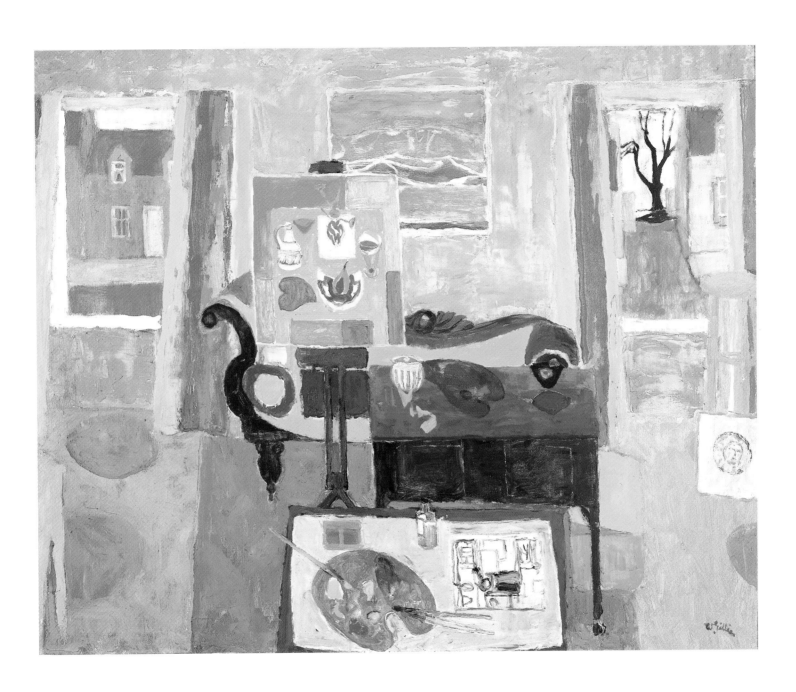

88 W.G. Gillies,
Interior of Studio, Temple, c.1965
oil, 96.5 × 121.9cm, Private Collection

89 W.G. Gillies,
Still Life with Blue Gloves,
1968
watercolour, 65.4 × 91.4cm,
Tate Gallery, London

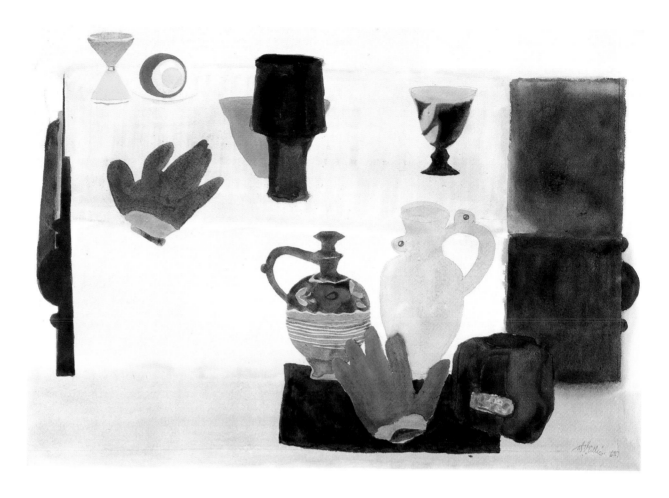

tend to look rather stilted and uncomfortable, as if he had thought about them rather too long. Oil was his primary medium for still life, for which deliberation was acceptable. Inspired by Bissier, Gillies had made a breakthrough. In *Still Life with Blue Gloves* Gillies has turned the pedestal-top table, only just recognisable at the edges, into a field which is defined as three broad washes of colour. The brilliant blue gloves dominate the central and lower field while a lemon yellow object holds the upper left corner. Diagonally at the bottom right are oriental ceramics painted in sombre tones with edges that bleed into the paper. It is interesting to note that his landscape watercolours of the late 1960s were beginning to return to the freedom expressed in his grand paintings of the 1930s, in which visions of sky and water were at the very heart. The large freely brushed landscapes – now of Border subjects rather than the Highlands – show a renewed interest in bold handling of watercolour, which may have

sprung from the Bissier-inspired *Still Life with Blue Gloves*. There are several other still life watercolours in this vein, such as *Still Life with Colour Box* of 1967 (private collection) and *Still Life with Christmas Paper* (1967, private collection), which show that the Tate Gallery's picture was not just a happy accident.

The late 1960s and early 1970s were busy years for Gillies. Although no longer teaching, he still had commitments to various professional exhibition societies, such as the RSA and RSW, as well as occasionally adjudicating for amateur societies. His attention was sought and his work requested by various commercial galleries at the same time as the Scottish Arts Council was organising his retrospective exhibition in 1970. The retrospective, which included oil paintings, watercolours and drawings, all selected by himself,[33] was an enormous success. He did not neglect his painting, however, which was achieving a lightness, a delicacy of touch within a rigorous organisation which he had always attempt-

ed to impose on his still lifes. *Vase of Honesty, Full Moon* (c.1969–70) [90] and *Shells and Wandering Sailor* (c.1971) [91] are both late reflections of ideas that preoccupied him throughout the 1960s and before. The first, with its rectangular scaffolding, looks back again to *The Blue Window* of 1940. Although geometry dominates, the bareness of stark branches, the shimmer of the moon and the honesty keep the picture from being swamped by its own structure. That shimmering quality is also evident in *Shells and Wandering Sailor*. The pedestal table has now been cropped radically on both sides and the still life objects grouped tightly together. There are no shadows, but the objects are shown reflected in the surface of the table-top with such delicacy that it is scarcely noticeable.

It is perhaps trite to say that these pictures have an elegiac mood. Gillies's very late landscapes, such as *Nairn Beach* [see 148], share a similar feeling. There is a fragile, transparent quality to the paintwork, which makes some of the pictures look unfinished. On the other hand he is also exploring new territory, a fresh regard for the characteristics of light on surface textures, which shows up in the late still lifes. This constant exploration of new ideas, searching for fresh effects and backtracking to former styles, has left Gillies open to the criticism of an inconsistency of approach. However it also kept him from fossilising, which was of the utmost importance to him as an artist. He remarked in 1970:

I believe I am now achieving a simplicity I have striven for, for a long long time, but nothing is static and I am free, in fact I am apt, to change direction without notice. But this is part of the fascination of the job of painting.[34]

V.K.

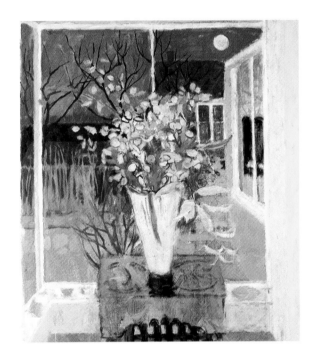

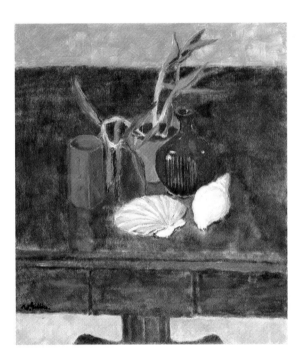

90 *left* W.G. Gillies,
Vase of Honesty, Full Moon,
c.1969
oil, 111.3 × 101.4cm, RSA

91 *right* W.G. Gillies,
*Shells and Wandering
Sailor,* c.1971
oil, 66.3 × 58.3cm, RSA

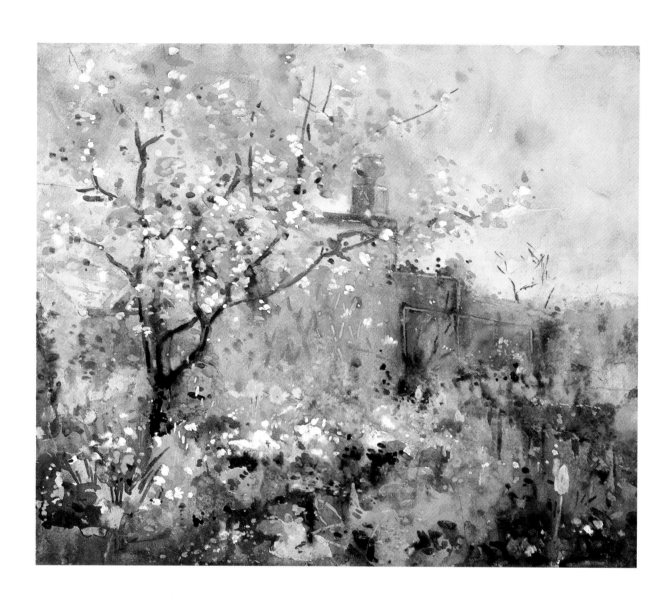

92 W.G. Gillies, *Dakers' Garden*, c.1916

watercolour, 23.7 × 29.2cm, RSA

LANDSCAPES

As has been discussed in previous chapters, Gillies studied figure drawing and painting at Edinburgh College of Art and later taught these subjects at the College. He also taught still life, using this discipline himself to explore artistic problems. However it was landscape painting that came instinctively to him and that served as a life-blood throughout his career.

Gillies's first experiments in landscape were studies of the East Lothian countryside which he made as a schoolboy. As an art student he escaped from the restrictions of the formal classes to go further afield on painting trips with his friends. Thereafter he regularly travelled the length and breadth of Scotland (and also to parts of the North of England and of France), making numerous sketches and painting with watercolours and oils *en plein air*. The material gathered on these trips fuelled him throughout his life with subjects to develop into oil paintings.

BEGINNINGS

It was around 1910 that 'Uncle Will' (William Ryle Smith) from Broughty Ferry first permitted Gillies, then a boy of about twelve, to join him on his holiday sketching trips around the East Lothian town of Haddington. Gillies remembered his uncle's paintings as being 'delicate watercolours', recalling that this was the beginning of his life-long fascination with the medium.[1] *A Corner of Kirrie* (1912) [see 4], which is initialled by both Gillies and his uncle, marks a tentative start. This small watercolour depicts a street scene in Kirriemuir, in Angus, where Gillies's mother was born.

From this beginning Gillies was exposed to a more robust way of painting in oils by Robert Alex-ander Dakers, editor of *The Haddingtonshire Courier*. A local man and an amateur painter, he 'painted landscape very sensitively with a palette knife.'[2] He took the young Gillies under his wing. The influence of Dakers can be seen in *Dakers' Garden* [92], another of Gillies's very early watercolours. In it he has built up a dense and rich texture with gouache over watercolour washes, creating a jewel-like image of the colours and textures of a richly flowering garden.

Gillies's school, the Knox Institute in Haddington, had no art department, so he was encouraged to work on his own for his Higher Art examination. That gave him the opportunity to develop his landscape painting, because, instead of being forced to work indoors to a rigid curriculum, he was permitted to ride his bicycle into the East Lothian countryside and work from nature. An album assembled by him in his final year at school contains little other than landscapes, some of the locality and others done in the school holidays at Broughty Ferry and on the Fife coast.

Even as a schoolboy Gillies was able to adapt his work to current styles in painting. He was fortunate in having access to the art magazine *The Studio* and thus had an opportunity to study both black and white and colour reproductions representing current artistic trends. The bold graphic style of the Beggarstaff Brothers and of Japanese colour woodcuts led to a series of stylised paintings and linocuts. *Nungate Bridge, Haddington* (1916) [93] combines the strong, bold lines and shapes of William Nicholson's linocuts with a nocturnal colouring reminiscent of Whistler. Other early landscapes demonstrate an easy naturalism and an interest in recording the

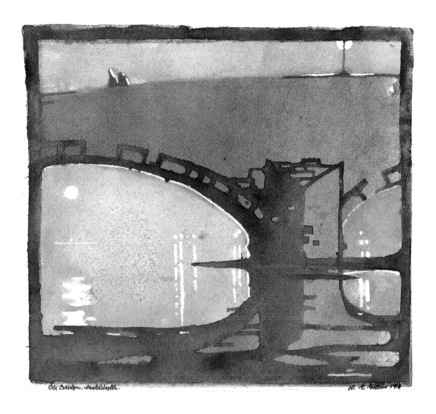

93 W.G. Gillies, *Nungate Bridge, Haddington*, 1916
coloured linocut, 18.7 × 20.4cm, RSA

The oil paintings which survive from Gillies's college years show him feeling his way, looking at the work of earlier generations. A series of views of his home town of Haddington are painted in the bold, chunky manner reminiscent of the painting of John Guthrie Spence Smith RSA (1880–1951) [94], who was working in the early 1920s in East Lothian, especially around East Linton and Haddington itself. It is very likely that Gillies not only knew his work, but also knew the artist himself. However, as Spence Smith was both deaf and dumb following a childhood illness, communication must have been difficult. Yet Gillies's adoption of four-square brushstrokes and his success in capturing both the fleeting effects of weather and the bold patterns of sunlight falling on masonry come close to the work of the older artist.

Other oils give hints of different interests. *Red Roofs* (*c.*1922–23, RSA) combines a formal, four-square composition made up of buildings and roofs with delicate hints of light and movement in the billowing washing and wisp of smoke. The overall effect is more decorative than impressionistic. *East Lothian Upland* (1923) [95], a landscape from his postgraduate year, looks forward to later work in its evocation of the transient effects of clouds and light over the Lammermuir Hills. Although the actual painting is quite flat, Gillies stresses the decorative qualities of the shapes of the scudding clouds. In this work he communicates his close attachment to the countryside of his birth. This is a feature of Gillies's painting which above all else marks his work throughout his career.

transient effects of light and weather. These can be seen in *Decorative Scene based upon Beeches, Letham* (1915, RSA), which proves that Gillies was able to handle watercolour with relative ease. In other watercolours, such as *Beeches, Letham* (1915) [see 5], Gillies tried his hand at the cursive patterns of Art Nouveau. On other occasions he experimented with the free 'blottesque' watercolour technique of the Angus painter James Watterston Herald, whose work he had the chance to study in his uncle's house in Broughty Ferry.[3]

STUDENT YEARS

94 John Guthrie Spence Smith, *Canongate Kirk*, nd
oil on board, 72.9 × 76.5cm, RSA (Diploma Collection)

With this body of work behind him, Gillies entered Edinburgh College of Art in the autumn of 1916. Landscape painting was not on the curriculum, but he continued to work in this discipline at weekends and in the holidays. The artist remembered one such working holiday in the summer of 1920:

Alan Ronald, with two friends, George Watson and I, hired a bell tent and went to Comrie for a month's sketching. I can remember glorious weather, a water shortage, a milk shortage and much enjoyment, and a great pile of sketches at the end.[4]

95 W.G. Gillies, *East Lothian Upland*, 1923
oil, 60.2 × 91.5cm, RSA

In addition to visiting exhibitions in Edinburgh and studying the illustrated magazines in the College library, Gillies was exposed to a wider range of painting when in 1921 he spent his Easter vacation in London. Although in those days the Tate Gallery was in effect a gallery of British art, he would have had an opportunity to see contemporary British and foreign work in the galleries of London's art dealers. A number of paintings were executed as a result of his visit. *St Paul's and the River Thames* (1921) [see 8] demonstrates Gillies working in a Post-Impressionist manner, which must have been inspired by what he had seen in London. From the days of Monet, the Thames has been an important subject for French artists working in London, either looking towards the Houses of Parliament or from across the river towards St Paul's Cathedral. The latter view was the one selected by Gillies, a spot almost identical to that from which André Derain painted his fauvist *Blackfriars Bridge, London* (c.1906–07, GMAG).[5] However Gillies does not use the strong Fauve palette, but rather breaks up his colours into their constituent parts in the manner of, for example, Paul Signac. Thus form is dissolved into a vivid harmony of blues and pinks; shadows are created with the use of complementary colours. As this painting was done on a scholarship, it must have been presented for inspection on Gillies's return to the College. Sadly there is no record of what his teachers thought of it. As nothing else quite like this survives, it must be presumed that Gillies was not encouraged to develop in this direction.

It was not until Gillies settled to work at the

Académie Montparnasse, André Lhote's studio in Paris, that he was encouraged to work in a modernist way. Although Lhote's teaching was founded on the study of the figure and the work of the Old Masters, his Synthetic Cubism was reflected in Gillies's landscape painting once Gillies had moved on to Italy in the spring of 1924. Both his watercolours and oil paintings show an interpretation of the towns and countryside of Italy based upon the principles he had studied in France.

The watercolour *Florence* (1924) [98] presents a view of the skyline of the city from across the River Arno with the Ponte alle Grazie forming a link between foreground and background. This spot was very close to Gillies's lodgings and the watercolour may well have been painted *in situ*. However he kept a postcard of exactly this view and also took a photograph of it [96]. The positioning of the buildings in the painting is very close to their layout in these images, so that this may be a rare example of Gillies basing a painting on a photographic reference. Certainly he was accustomed to copying and working from Old Master paintings and it is noted that Lhote used postcards in his classes.[6] The watercolour, however, is far from a flat monochrome photographic image. The strident colours suggest that Gillies had seen the work of the Fauves in Paris. Its free, fluid handling is an absolute joy. It is hard to credit that Gillies's months in Paris were the 'dismal cul-de-sac' that much later he claimed them to be. The same view is repeated in a much larger oil painting *Florence* (1924) [97]. This may have been painted on Gillies's return to Scotland, but it is closely based on the watercolour. However he has developed the counterpoint of dark and light in the buildings, river and sky. Indeed the sky is now heavily brooding, its threatening aspect reflected in the still river. Although this stylisation is derived from the lessons of Lhote, the painting as a whole is far from the dry, academic products of his studio.

Gillies painted smaller oils whilst in Italy. These include views of hill villages and the unfinished oil *View from the Pitti Palace* (RSA). The latter reveals the artist's pencil drawing underneath, the strong horizontal and vertical lines marking out the vertiginous perspective of the scene. Gillies's bold pencil drawing

96 The Ponte alle Grazie, Florence, 1924
RSA

97 W.G. Gillies, *Florence*, 1924
oil, 66.0 × 91.4cm, RSA

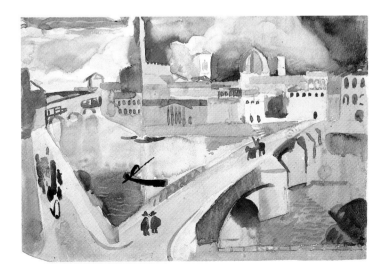

98 W.G. Gillies, *Florence*, 1924
watercolour, 24.4 × 35.3cm, RSA

99 W.G. Gillies, *A Study of a Canal in Ravenna*, 1924
pencil, 19.4 × 24.2cm, RSA

is also evident in his sketchbooks, contrasting strongly with the more delicate, intricate work of his travelling companion William Crozier. Already there is a confidence and immediacy in Gillies's work as, for example, in *A Study of a Canal in Ravenna* [99]. His quick, sure line picks up the decorative qualities of the masts of the boats against the solid masses of the buildings behind. In its boldness and assurance this drawing looks forward to his harbour paintings of the 1930s, 1940s and even 1950s.

On the Road to San Miniato, Florence (1924) [see 10], a much more delicate pencil drawing, also looks forward, but this time to paintings done later in the 1920s. Gillies has utilised the tight hairpin bend in the road as the basis of a dramatic perspective leading down towards the city of Florence. The treatment of the masses and the soft shading with its counterpoint of light and dark still echo the lessons of Cubism. However Gillies's interpretation of the landscape is a lyrical one, far removed from the academism taught in Lhote's classes. In this drawing he is instinctively responding to the countryside around him.

On his return to Scotland in May 1924 Gillies had the summer to digest his experiences of France and

Italy before taking up a teaching post in Inverness. Then he had little time for painting; the only traced work[7] from this period is the watercolour *Inverness* (1925) [see 11]. This more than any other painting proves that Gillies could not break the shackles of Lhote's teaching immediately. A recognisable aspect of the Moray Firth has been broken into segments, with blocks of colour emphasising gable ends and heavy skies, and surface patterns articulating foliage and swaying grass. Within a year Gillies was back in Haddington and preparing to take up a part-time teaching post at Edinburgh College of Art.

EARLY YEARS OF EXPERIMENT

There are many drawings and paintings from the 1920s and 1930s, but very few can be identified or dated precisely. It must be presumed that a good number were exhibited at The 1922 Group shows in Edinburgh, but relatively few sales were made. The unsold work was returned to the artist. Many of the oil paintings were put aside or painted over. Others were removed from their stretchers, so that the wood could be recycled, and the canvasses safely stowed away out of sight, apparently under the floor coverings in the house. As a result of this much has remained unseen and forgotten until recent conservation. Because these paintings were removed from their frames and stretchers some time ago, any ancillary information, other than a signature and perhaps a date, has now been lost. Many of the works must be the ones described by the critics in their accounts of the exhibitions of the period. It is sometimes possible to tie such a reference to an individual painting, but in general this is now a hopeless task. However the overall picture that these works present is one of an experimental phase, which began on Gillies's return to Scotland in the summer of 1924. The earliest paintings show him trying his hand at the kind of work he must have seen in Paris the previous winter. It is from these rather didactic experiments that he begins to find his artistic feet.

The River Tyne meanders past mature trees in a public space known as The Long Cram, a mere five minutes' walk from the family home in Haddington. As a schoolboy Gillies had sketched along this

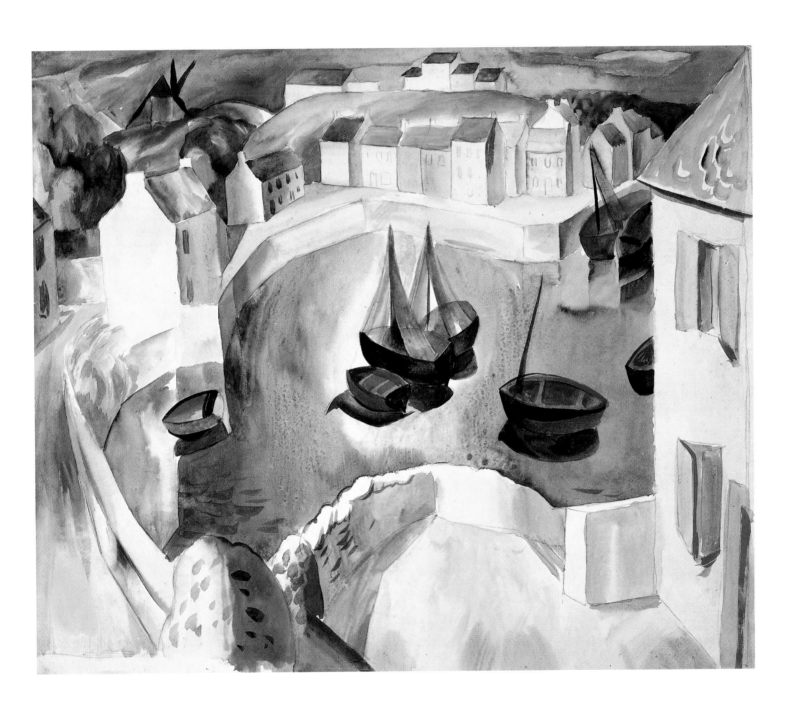

100 W.G. Gillies, *Tréboul*, 1927
pencil and watercolour, 46.1 × 54.5cm, RSA

stretch of river and he was to return there in the mid-1920s. *Trees on the Tyne, Haddington* [see 14], which the artist later removed from its stretcher, breaks the pattern of paths, tree trunks, foliage and river into highly coloured facets. It shows Gillies working through Lhote's more decorative brand of Cubism. Other paintings of the same subject matter (RSA) interpret the riverside walk in a dramatically naturalistic way, echoing the landscape paintings of Maurice Vlaminck. Here the brushwork is much freer and the build-up of colour contrasts gives texture to the paint surface. Between these two examples lie careful, naturalistic pencil drawings and paintings reminiscent of the cooler, formal paintings of Derain in his post-Fauve period. Other works such as *The White Lodge* (1926)[8] prove that Gillies had not yet dropped the influence of Cubism. These experimental paintings were received with scepticism when they were exhibited in Edinburgh. A critic reviewing the 1927 exhibition of The 1922 Group noted ' ... Some of his other work shows modern French influence.' [9]

In contrast to these careful exercises in oil, Gillies's watercolours are much freer. They were painted on the spot (in all weathers) and were the artist's direct response to his surroundings. For example *The Moor* (1927, private collection), a study of the Lammermuirs, vividly recalls the dark wintry colours of heather and a wild and cold scudding sky. Others capture landscape forms and weather in monochrome washes, such as *Inverlochy* (RSA), leading R.R. Tatlock in *The Daily Telegraph* to comment:

… Inverlochy, in which he has caught, in a typically Northern way, the gloom and glamour of an ancient and austere castle with frowning hills behind and an angry canopy of cloud overhead. The rest of the pictures are all strongly influenced by the art of modern Paris.[10]

Gillies's strong interest in contemporary French painting persuaded him to make a lengthy tour of France with two painting companions in July and August 1927.[11] Their intention may have been to travel as far as Spain. However, being fair-skinned Scots, they found the summer heat of south-west France too oppressive and instead headed north again for Brittany. This Celtic corner of France had been attracting artists of all nationalities for the previous fifty years. Not only did Gauguin and the Pont Aven group work there,[12] but it also attracted the more traditionalist artists of the day. Scottish painters such as Robert McGregor RSA (1847–1922) and William Marshall Brown RSA (1863–1936) relied heavily on Breton subjects for their paintings. Some of the Edinburgh painters of the next generation, colleagues of Gillies at Edinburgh College of Art, had recently discovered the region as well. D.M. Sutherland painted some of his best work as a result of his visits to Brittany and Donald Moodie had even made a ciné film of his travels.[13] These artists, who were also friends, must have encouraged Gillies's party to visit Brittany.

That summer Gillies worked in Quimper, Audierne and the neighbouring harbour towns of Tréboul and Douarenez in the far west of Brittany. There were many other painters in those towns that summer. For example Frances Hodgkins (1869–1947) and Cedric Morris (1889–1982)[14] were both working in Tréboul, but there is nothing to suggest that their paths crossed with Gillies's. However their paintings show that each artist was moving in a similar direction. Morris's paintings of the period have a simplicity which anticipates the primitivism of Christopher Wood's work in Tréboul in 1929.[15] Indeed these two artists were already friends. A watercolour by Gillies, *Tréboul* (1927) [100], combines his acquired Cubist mannerisms with a deliberate naïvety. The steep perspective leading down into the harbour with its little up-tilted boats and the houses ranged like children's building blocks has a directness and simplicity. Added to this are the little decorative touches of masonry, tiles and lapping water, which are found both in Lhote's painting and in naïve art. This painting demonstrates that Gillies had adopted a feeling for the primitive, which was common to many British painters at the time. Indeed Gillies was to return to this deliberate primitivism again and again over the next ten years.

An oil painting of Tréboul (unlocated) was exhibited at the St George's Gallery in London in 1928 alongside other Scottish subjects. It attracted the attention of E.H. Furst, writing in the magazine *Apollo*:

Mr W. Gillies has a good deal of power, but it seems the watercolour medium does not impose sufficient restraint on his impetuous hand – his oil paintings, notably the views of 'Mallaig' (4) and 'Tréboul' (6), seem perforce restrained and more impressive on that account.[16]

Mallaig [101] was probably painted in 1928 and, like the watercolour of Tréboul, it too shows a move away from the artifice of André Lhote's Cubism to a simpler, almost naïve approach. Yet the overall clarity and structure of the painting could not have been achieved without Gillies's period of study in Paris. In addition to its formal qualities Gillies has once again powerfully evoked a storm-filled sky, which is echoed in the decorative 'white horses' in the foreground waves. In the watercolour *Loch Morar* (1928) [104] Gillies again turns to stylisation to portray the

drama of a stormy Highland sunset. In a review of the exhibition at the St George's Gallery the art critic of *The Daily Mail* hinted as early as 1928 that Gillies's watercolours would find a readier audience than his oil paintings:

Whether the artist found Mallaig a stark and depressing place or not is difficult to say, for so many things might account for his somewhat brutal treatment which has endowed his painting of that place with a very ungracious atmosphere. Mr Gillies seems to pipe a livelier and more pleasant tune in water-colour. Loch Morar is but a drive from Mallaig, yet it seems to have pleased the artist better. [17]

Back home Gillies returned to the sketching grounds of his schooldays. On the western outskirts of Haddington the Letham Burn flows eastwards to

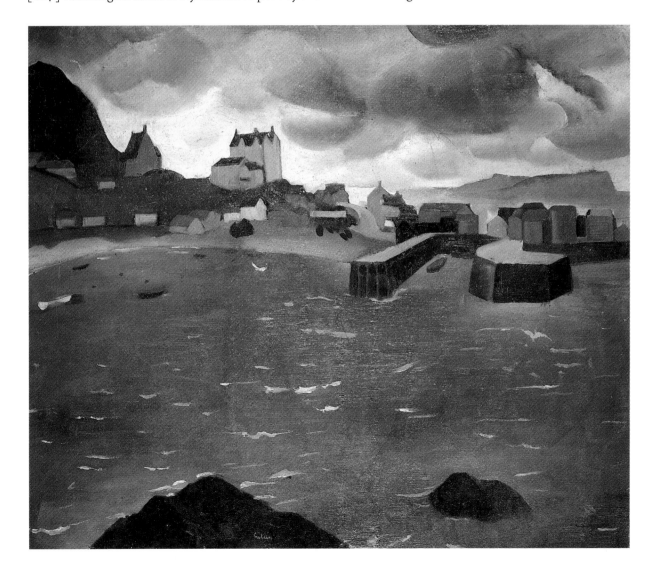

101 W.G. Gillies, *Mallaig*, 1928
oil, 55.9 × 65.7cm, RSA

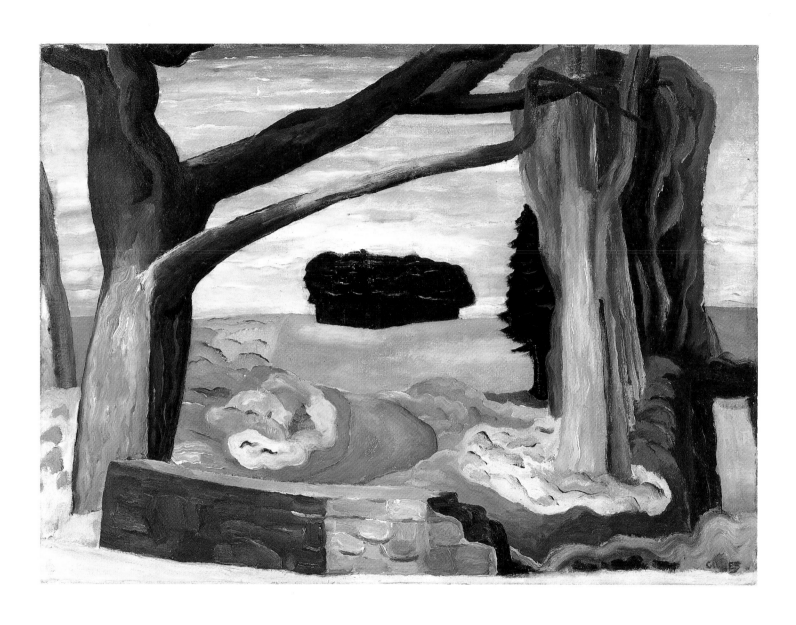

102 W.G. Gillies, *Trees and Coppice*, 1928

oil, 89.0 × 124.0cm, Aberdeen Art Gallery and Museums Collections

join the River Tyne. Flanking this narrow stream are the tall, smooth trunks of majestic beech trees, which had first attracted the young Gillies in 1915 [see 5]. In the late 1920s he worked at this subject again. Numerous pencil studies survive, as well as watercolours and experimental oil paintings. The forms are simplified, the colours muted and there is subtle play of light and dark. Related to them is the only known dated oil painting from the end of this decade. *Trees and Coppice* (1928) [102] demands attention. Here the artist has achieved an astounding clarity of vision. Although he has enlivened the picture by the use of varying painterly textures, Gillies has pared down the shapes in the picture to a minimum. The strong vertical and horizontal lines give the composition a surreal stillness and the

removed from the Englishman's technique, yet the colouring and the clump of trees with its powerful reflection in the foreground water echo the dense shapes and shades of Nash's woods. This closeness to the work of Nash and his English associates may be seen not only in Gillies's oil paintings, but also in his watercolours and pencil drawings of the period. For example *Loch Through a Wood 1933–34* [105] is a lyrical exploration of the counterpoint between light and dark in dense woodland. It brings to mind the work of the English book illustrators of this period, but especially Nash's woodcuts of 1921 and 1922.[18]

The coastline near the town of North Berwick was another favoured local spot for sketching. About a mile and a half to the east lie the majestic ruins of Tantallon Castle and beyond a fine, sandy beach with

103 *below* Paul Nash, *Wood on the Downs*, 1930
oil, 71.1 × 91.5cm, Aberdeen Art Gallery and Museums Collections

104 *right* W.G. Gillies, *Loch Morar*, 1928
pencil and watercolour, 42.3 × 60.0cm, RSA

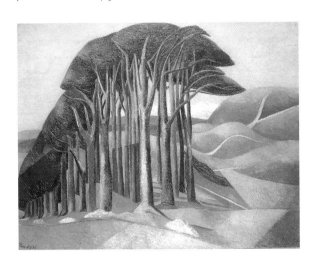

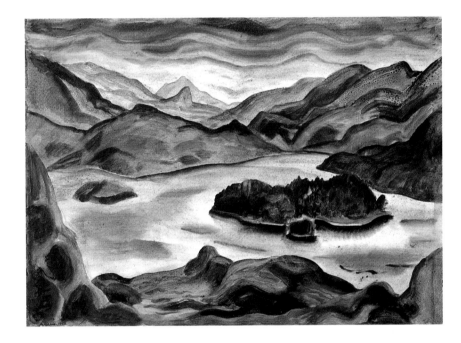

spectator's eye is drawn through the outer framework into the dark, mysterious coppice on the horizon.

The formal qualities of *Trees and Coppice* draw immediate comparison with the downland landscapes of Paul Nash (1889–1946), for example his fine *Wood on the Downs* (1930) [103]. Yet Gillies's work actually predates the Nash. *Beech Tree Reflections* (RSA), another, slightly later, experimental oil painting by Gillies, also has parallels with Nash's work, but in a different way. Here Gillies's style is loose and free, far

views out to the Bass Rock. A group of drawings and paintings dated between 1927 and 1931 show Gillies moving away from the careful structure of his earlier work. The watercolour *Shore and Bass Rock* (1931) [106] has an eerie stillness reminiscent of the beach subjects of the English Surrealists. In contrast a pencil drawing of exactly the same view is boldly shaded in with strength and immediacy. An oil painting *The Bass Rock from Seacliff* (RSA) also has a vigour not yet seen in other oils. It is a direct response to waves, wind and weather. Gillies has allowed the priming of

105 W.G. Gillies, *Loch Through a Wood*, 1933–34
pencil, 50.6 × 35.2cm, RSA

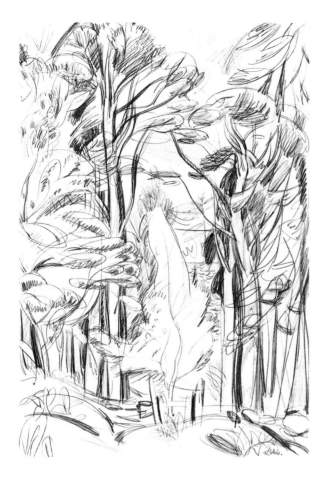

active sky. Gillies painted the same scene again two years later [108]. In the meantime the Society of Scottish Artists had included twelve paintings by Edvard Munch in its annual exhibition. Gillies readily admitted that he – like many of his contemporaries – was greatly influenced by what he saw. In later years Gillies described the effect of the works by Munch as 'an event which ... "shook" him ... '[20]. He returned repeatedly to the show, recalling the impact on him as a 'naked, thinking heart'. His response to Munch is evident in both his urban and wilderness paintings. For, although the subject of the second Gardenstown painting is the same as the first, its treatment is quite different. Gone are the clearly defined planes and lines of structure, dating back to André Lhote's classes. Instead the painting is created out of an intricate web of vigorous brushwork. The contrasts in tone and variations of colour defy the solid masses of the rocks and buildings before him. The colours have become richer and play an important role in the painting. The energy of this second *Gardenstown* marks a change in Gillies's treatment of his landscape subjects. It looks forward to the wonderful essays of the following years.

the canvas to serve as part of the finished work. He was to use this to great effect in later years.

Gillies's oil paintings dating from the end of the 1920s are characterised by the clearly articulated masses of trees, rocks and buildings and by an overriding sombre mood. In July 1929 his sister Janet spent a holiday with relatives in Macduff on the Buchan coast. From there she visited the little harbour town of Gardenstown, where the houses rise in step fashion up the sides of the cliffs to the high, open grassland above. At one end, above the rooflines, the buttressed four-square kirk of the Church of Scotland makes a striking landmark. Janet wrote back to her brother 'You would like Gardenstown'.[19] Sensibly Gillies took her advice and paid the first of many working visits to the area. *Gardenstown* (c.1930) [107], one of the earliest of the village, is painted with a feeling for the solid masses of masonry before him and for the brilliant northern light reflecting off a white, harled wall. Beyond the buildings is a hint of the harbour far below, a cold North Sea and a wildly

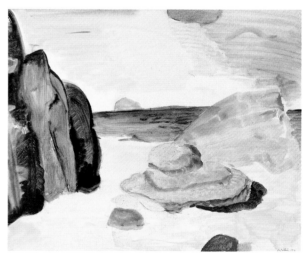

106 W.G. Gillies, *Shore and Bass Rock*, 1931
watercolour, 44.0 × 56.0cm, RSA

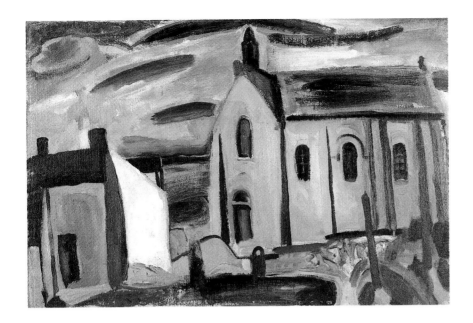

107 W.G. Gillies, *Gardenstown*, c.1930
oil, 61.2 × 92.0cm, RSA

108 W.G. Gillies, *Gardenstown*, c.1932
oil, 76.0 × 90.8cm, RSA

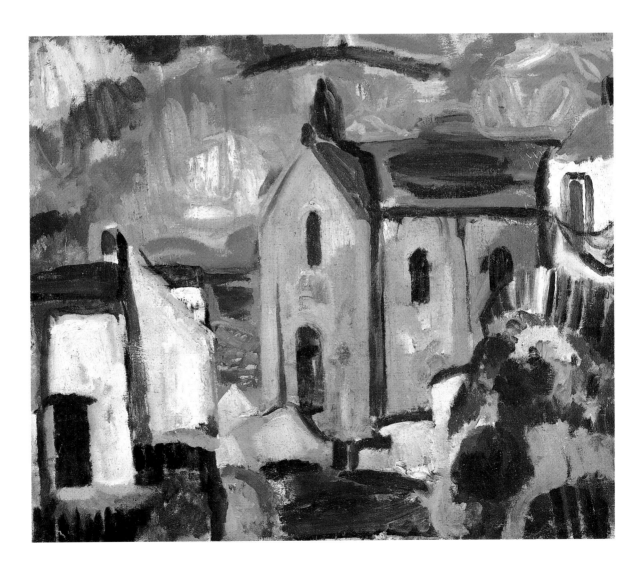

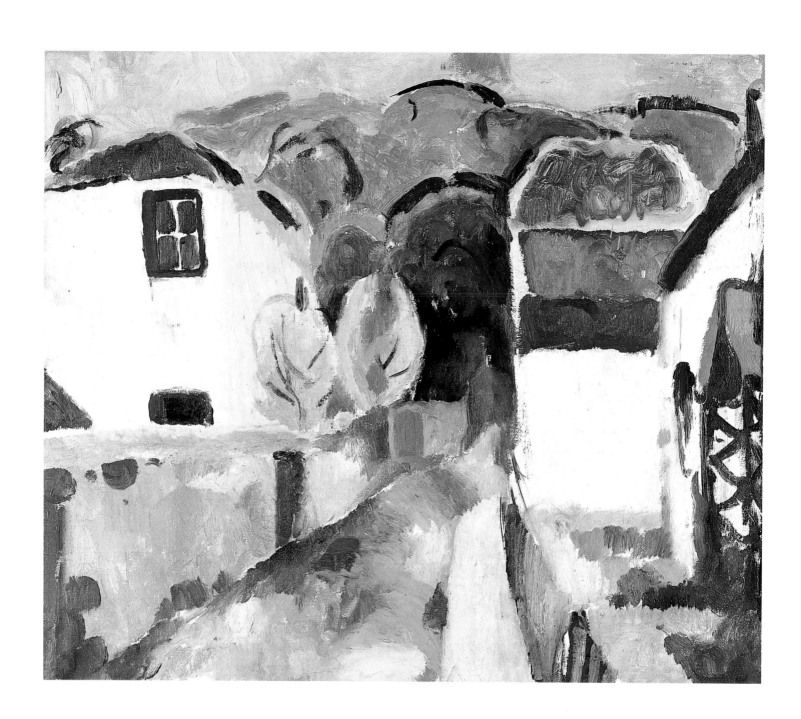

109 W.G. Gillies, *Duddingston*, 1929
oil, 69.7 × 82.5cm, RSA

EDINBURGH AND OTHER URBAN SUBJECTS

Although Gillies is best remembered as a painter of the countryside, either of the remote corners of Scotland or of the rural localities closer to home, he did not consciously turn his back on the urban scene. As we have already noted, he painted the towns of Italy whilst he was on his scholarship travels in 1924. During the rest of the 1920s he worked also in Haddington, Mallaig, Gardenstown and anywhere else that he happened to be in at the time. In the 1930s he produced a series of paintings of Edinburgh and these show some of the directions his work was taking during this period.

In 1929 the Gillies family moved from Haddington to Edinburgh, remaining there until the summer of 1939. They settled in the suburbs at 162 Willowbrae Road, close to open country. For much of that decade Gillies used his urban surroundings as the source of much of his landscape work. Within walking distance of the family home was the ancient village of Duddingston. Although it is now engulfed by city developments, it still retains a sense of its own identity. *Duddingston* (1929) [109], an early painting from this period, depicts a subject which retains a rural feel. Traditional buildings sit four-square behind stone walls flanking the road. One's eye is led back to Arthur's Seat on the horizon. The simplified white shapes of the buildings serve as foils for the dense green background. In contrast, the treatment of the tarmac with its reflected blues and mauves conveys with fine subtlety the reflected lights on the surface of a wet road.

Other Edinburgh subjects were even closer to home. Many pencil sketches survive of studies made from the back and front windows of the family house. These portray flower-filled gardens, the neighbouring properties and the houses across the road. *View from 162 Willowbrae Road* (1932) [see 15] shows the scene from the Gillies's front door. By treating the subject as if seen through a wide-angle lens, the artist presents a broad view within the narrow confines of the picture space. Beyond the family's flowerbeds and newly planted trees, Willowbrae Road curves away to right and left. The new council houses across the road are pulled closely together. Far beyond broods a dark Inchkeith Island

and shipping in the Firth of Forth. In contrast to the darkness of the distance, the foreground sings with colour: the red and yellow of the flowers, the blue and purple of the reflected lights. The road is peopled with shadowy pedestrians going about their business, reminiscent of the blurred figures of old photographs of street scenes. Another painting of Willowbrae Road (RSA), looking down the street rather than across it, reduces detail to broad suggestion through colour. This increased emphasis on colour and brushwork would seem to be another example of the effect which Munch's painting had on Gillies.

An oil painting *Duddingston Church and Arthur's Seat* (RSA) is a deceptively rural view of the church and hill seen through trees and beyond a field. Colour has become more highly pitched and the brushwork has changed from broken dashes to wild, calligraphic lines. A pencil sketch of exactly the same view is executed in a loose, scribbled style, which indicates not only light and shade, but also constant movement.

From September 1930 onwards Gillies made a series of painting trips to Fife, working on another series of urban subjects. With his companions he camped in the grounds of Kellie Castle near Pittenweem, home of the Lorimer family.[21] From there they explored the fishing villages along the Fife coast as well as the countryside inland. Gillies executed large-scale watercolour studies and small oil sketches of the harbours and densely stacked fishermen's cottages. Using strong colours and bold, simple shapes, he combined the patterns of the masts and funnels of the boats with the shapes of the buildings to create complex interlocking patterns. These were developed into an important series of oil paintings. At the very end of 1934 the Society of Scottish Artists included in its Annual Exhibition twenty-five works by Paul Klee, covering the period from 1919 to 1933. With an eye to Klee's use of blocks of colour as a compositional device, Gillies developed his essentially naturalistic watercolours into oil paintings which emphasise the structural qualities of the scene. For example *Harbour, St Monans* [110] is a development from just such a starting point. The horizontal and vertical lines of the buildings are emphasised by the use of contrasting

colours and tones. Detail is suppressed and replaced by a lively and varied paint texture. Parts of the canvas have been painted with a brush and others with a palette knife. Detail has been scored out with the sharp end of the paintbrush. In parts, for example in the muddy harbour water, a wonderfully rich colour and texture has been achieved by the combination of many colours in a single brushstroke. The painting gives the appearance of having been achieved with grace and ease which belies the forethought and complex planning it required. The formal, decorative qualities of works such as this come close to similar paintings by Maxwell in both oils and watercolours, such as his own version *Harbour with Three Boats* (1934, SNGMA).

One of Gillies's later Edinburgh subjects is hard to

date because of its experimental nature. *Edinburgh Abstract* [111] was probably painted in 1935 or 1936, because it was in those years that Gillies was at his most adventurous. In many ways *Edinburgh Abstract* relates to Gillies's still life paintings rather than his landscapes. For here he has restructured the view, altering and distorting the actual features of the cityscape almost beyond recognition. Looking towards the pinnacled skyline of the Old Town from, presumably, an upper floor of one of the shops along Princes Street, Gillies has manipulated the view into a mosaic of shapes and colours. A preparatory drawing for the work helps us to understand it a little better [112]. It shows quite clearly telegraph poles on Princes Street, the smoke of the trains coming and going from Waverley Station and the profile of the

Harbour, St. Monans,
c.1935
oil, 76.2 × 91.9cm, RSA

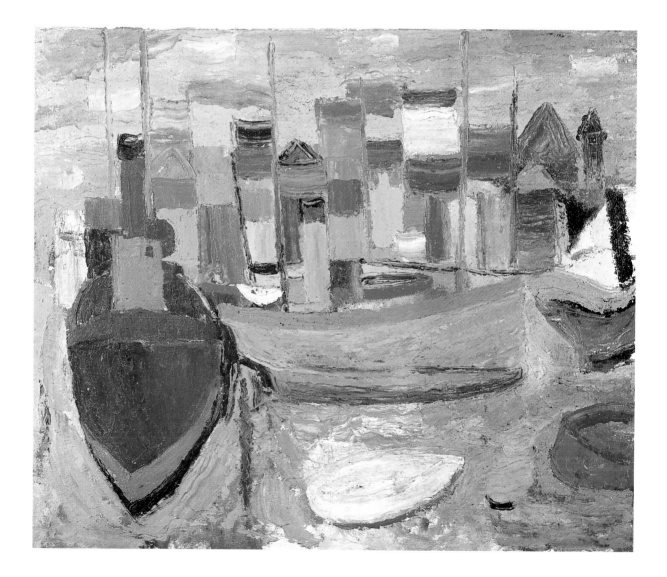

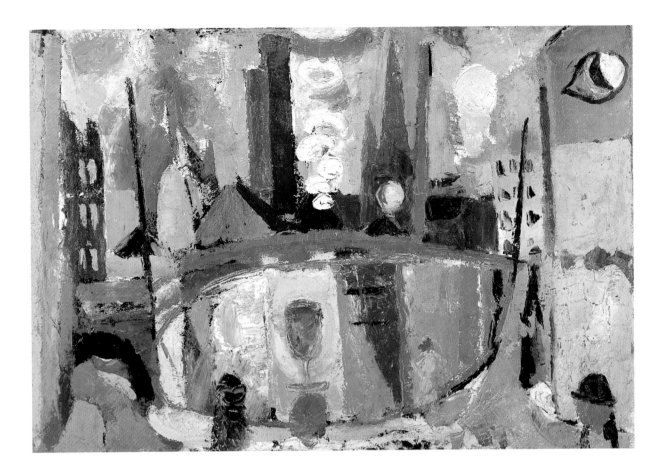

111 W.G. Gillies,
Edinburgh Abstract,
c.1935–36
oil, 75.1 × 112.0cm, RSA

Scott Monument. In front of all of this is a highly polished table, reflecting figures and glasses, and, to the right, part of an elaborately etched glass. The free scribbles of the pencil drawing are translated into vivid reds, blues and yellows in the painting. In the latter detail is subdued and the composition twisted around to include references to landmarks which would be out of sight in reality, such as the North Bridge and the many layered streets of the Old Town. Figures are suggested by small, round heads sketched without any detail to personalise them. The scattered elements of the painting are pulled together by the vestigial shape of a highly polished table-top.

After *Edinburgh Abstract* one of the logical steps for Gillies was to attempt formal abstraction in the manner of Kandinsky's work of the 1920s and that is exactly what he did. In 1935 he exhibited a series of non-representational subjects [see 17] at the exhibition that year of The Society of Eight. He was not entirely happy with the results, summarising later his own feelings in a typically self-effacing manner:

Perhaps my most rebellious time occurred in 1936, when I spent about a year experimenting in abstraction and I showed the results exclusively at that year's Society's exhibition. I remember Professor Orr, Professor of French at the University, buying one, before, as he put it, I went completely mad. But this phase didn't last with me. I felt I was flinging too much overboard and getting little of real significance in return.[22]

112 W.G. Gillies,
Edinburgh Abstract, c.1935
pencil, 16.9 × 22.7cm, RSA

113 *above left* Donald Moodie,
This Way for the View, nd
pencil and wash, 19.8 × 14.0cm, RSA

114 *above right* W.G. Gillies, *View from a Tent*,
c.1933
pencil, 22.7 × 17.9cm, RSA

115 *right* 'The Calidon Show', Durisdeer,
September 1933
RSA

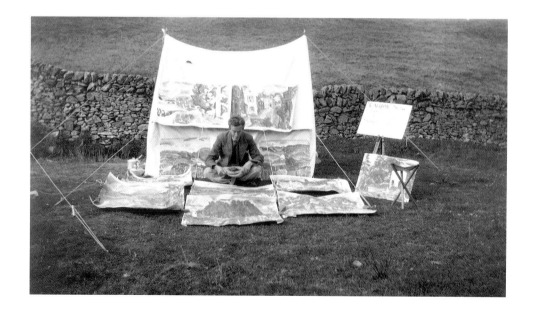

LANDSCAPE PAINTING IN THE 1930S: 'THIS WAY FOR THE VIEW'

As a break from his demanding life at the College, Gillies continued to escape in the vacations to all parts of Scotland with his family and his friends. At least three or four trips a year were quite normal. These might range from a visit to the Galloway coast in the far south-west, journeys north to the Angus glens or the Moray Firth or even further afield to the remote coast of Wester Ross and Sutherland. Many pencil sketches and watercolours were made on these journeys. Gillies had boundless energy and he was a compulsive worker. A gift from Donald Moodie, one of his long-suffering holiday companions, is a watercolour sketch entitled *This Way for the View* [113]. With good humour it encapsulates his friend's constant urge to find the scenery he needed, regardless of self and the safety of his companions.

In 1930 Gillies and a companion (possibly John Maxwell) had joined his sister Emma in the North-west Highlands. On the back of a postcard of Lochinver she wrote to their mother ' ... Willie's party joined us ... It is really a lovely place and quite out in the wilds, no rail to right on the west coast ... The boys will be sketching later on ... '23 The following year Gillies travelled through Glencoe to Fort William, and on to Morar. So the pattern continued. John Maxwell was a very close friend and much of the time was spent in each other's company. It was on such a holiday that Maxwell painted his memorable *View from a Tent* (1933) [see 18]. A little pencil scribble in a sketchbook shows Gillies's version of this view. It is full of the minutiae of a bachelor holiday: cigarettes, cooking pots, a tie hanging from the ridge pole and of course a painting on a travelling easel [114]. An undated postcard of the Cuillins from Maxwell to Emma magically describes the exuberance and deep enjoyment both Gillies and he derived from their surroundings: 'This is the view from our door step! Last night was really amazing with the Cuillins sailing on a raspberry jam sea like an immense pink cake ... '24 Such was the intense response of an artist to the stunning scenery of his surroundings.

In September 1932 Gillies spent a working holiday close to the remote village of Durisdeer in the

Lowther Hills. As usual he camped with Maxwell. On this occasion his younger sister Emma also came along. In addition to having a thoroughly good time, photographs of the holiday show that Gillies (at least) worked very hard. One memorable image presents him seated before a mini exhibition of his new watercolours under the title 'The Calidon Show' [115]. The paintings are large and bold in scale. It is possible to identify some of them and thus also the oils which resulted from this trip. One of the most notable, *The Red House, Durisdeer* (c.1934) [116], turns a simple view of a single house in a landscape into a turbulent painting of vivid colours and powerful brushstrokes. The little house tilts away from the trees and into the distant hills. The blue of a lively evening sky is echoed in the foreground. The overall impression is one of windy dusk in an isolated place, full of the sound of rustling leaves and swaying branches. This work is a fine example of Gillies's 'Expressionistic phase',25 which was at its strongest in the mid-1930s after his discovery of Munch.

William MacTaggart had been instrumental in bringing the Munch paintings to Edinburgh, encouraged in this bold venture by Gillies. They had been close friends for many years. Not only did they share a studio in Frederick Street, but Gillies was a frequent visitor to the MacTaggart family home in Loanhead. There he had the opportunity to see examples of the work both of modern French painters and of the Scottish Colourists, as well as the late landscapes and seascapes of MacTaggart's grandfather William McTaggart RSA (1835–1910).26 It was probably through this friendship that Gillies had been called upon to help MacTaggart arrange the loan of the Munch paintings. MacTaggart had travelled to Norway for this purpose in 1931. In July 1932 Gillies himself visited Scandinavia: 'Arrived Oslo this morning, after a rather stormy day yesterday. We leave for Gothenburg tonight ... '27 It is unclear who was his travelling companion, but it seems likely that it was MacTaggart.

Gillies's friendship with the MacTaggart family also led to working holidays in Perthshire, at Fearnan on Loch Tay. At that time the work of the two friends was very close. For example MacTaggart's *After the Storm*,

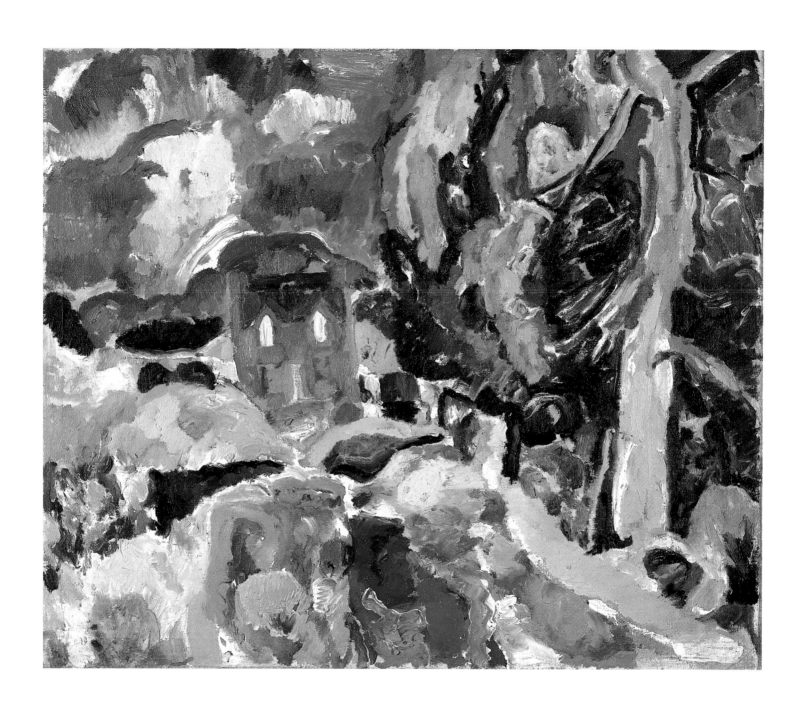

116 W.G. Gillies, *The Red House, Durisdeer*, c.1934

oil, 76.7 × 92.0cm, RSA

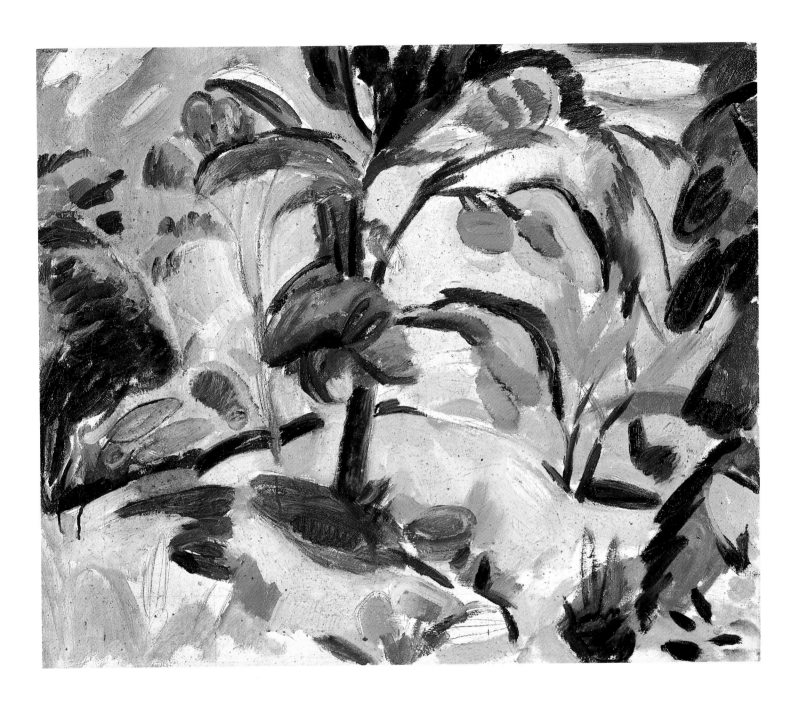

117 W.G. Gillies, *Trees in Leaf*, c.1934

oil, 70.5 × 83.0cm, RSA

Loch Tay (*c*.1931–32) [118] bears strong similarities to the bold sketches by Gillies of around the same time, such as *Haytime, Loch Tay* [119]. MacTaggart's oil paintings of this period show a looser brushwork and an emphasis on the dramatic lights of the Highlands. Gillies's oils acquired a richness and density of texture.

A series of oils and watercolours dating from the mid-1930s develops further the theme of tree forms and woodland. *Trees in Leaf* [117] appears at first glance to be a quite incomplete painting. Much unprimed canvas and pencil underdrawing is clearly visible and the handling has a roughness and spontaneity hitherto unseen. In fact when the final work is

just such a problem. A critic's response to it describes well the emphasis Gillies laid on paint handling and colour. Yet that critic also expressed the difficulties many people were having in understanding and appreciating Gillies's work of the period:

Here we have … a resolute effort to avoid being superficially representational, and to express, so far as may be, the integral character of subject or material. Thus we have in 'Winter Landscape', which is to be considered essentially an abstraction, tree forms, colour and other factors being used as a sort of pictorial alphabet to import what a winter landscape meant for the artist in its effort on his consciousness.[28]

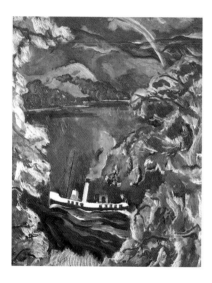
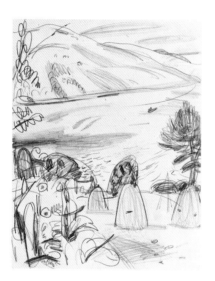
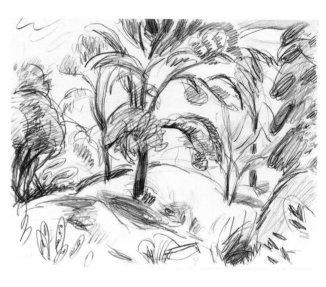

118 *left* William MacTaggart, *After the Storm, Loch Tay*, 1931–32
oil, 127.0 × 101.7cm, Perth Museum and Art Gallery

119 *centre* W.G. Gillies, *Haytime, Loch Tay*, c.1932
pencil, 22.8 × 17.9cm, RSA

120 *right* W.G. Gillies, *Trees in Leaf (study)*, c.1934
pencil, 17.8 × 22.9cm, RSA

compared with his preliminary pencil sketch *Trees in Leaf* [120], it can be seen just how complete it is. Like the oil painting, the drawing demonstrates a vitality often missing in Gillies's more academic subjects. Here the pencil lines are strong and rapid, at times almost cutting right through the paper. This energy is transferred to the oil version. Forms are suggested by bold streaks of paint with light and shade echoing form. The painting demonstrates something that Gillies found natural and easy in his landscapes, but hard in his still life compositions – namely knowing when to stop.

It was works such as this that the public found so difficult to read. An oil painting called *Winter Landscape* (untraced), which was exhibited in The Society of Eight's exhibition in Edinburgh in 1934, presented

In another review of the same exhibition the writer has given up even trying:

Mr Gillies … has already, in his two years' membership, set a new and comparatively exotic note in the Society's exhibitions. This year he goes even further on his chosen way, and his wall hits one straight between the eyes on entering, with stunning effect, and that effect is as a whole not one of pleasure. Closer inspection makes confusion more confounded. It is not only his texture and colour, thick, massed, and seemingly unrelated and perverse but his lack of design, of any coherence in any parts of the painting in certain works that leave one confounded.[29]

On the other hand Gillies's watercolours from his Scottish painting trips found a more appreciative audience. As they were painted in the open air and in

all weathers, they are generally far more naturalistic. They also depict very effectively the transient effects of light and movement in the artist's surroundings. Gillies remarked 'I have always enjoyed weather; always seen landscape pictorially; and I've got immense satisfaction in recording swiftly in line and colour the fugitive, the subtle and the grand in nature.'[30] As works in their own right they were crucial to his development. In 1970 he explained 'My landscape painting began with watercolour, and a great part of my work has continued in this medium. And I feel that the peculiar qualities of the medium have had a strong influence on my conception of landscape, even when I painted in oils.'[31] Indeed, when seen in reproduction and out of context, it can be very easy to mistake an oil painting of the period for a watercolour.

Although his wilderness subjects rarely contain any reference to human life beyond the little crofts and empty boats, on occasion Gillies used figures to create the subject for a painting. One of the artist's favourite watercolours was *In Ardnamurchan* (c.1936) [121]. He commented 'The mood of this one I like. There's a fine threat in the landscape and I feel an honest, rather bathetic note is put into the drawing and seeing of the elderly people having a picnic among the rocks. My mother, sister, and Aunt Margaret were the subjects.'[32] Many photographs

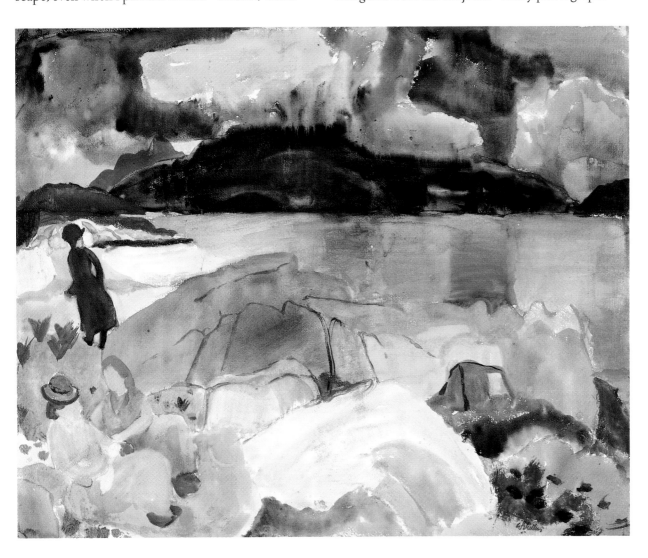

121 W.G. Gillies, *In Ardnamurchan*, 1936
watercolour, 50.6 × 63.0cm
Scottish National Gallery of Modern Art, Edinburgh

122 Mrs Gillies and Aunt
Margaret, Ardnamurchan,
July 1935
RSA

Most of Gillies's watercolours of the period were
large in scale and there is little pencil drawing in
them. They were painted directly using limpid wash-
es, to which he added strong dashes of colour and
tonal contrast with bold brushstrokes. Sometimes
rapid pen and ink lines add detail, the ink being
allowed to run into the watercolour washes. In all
these paintings the sky is of the utmost importance.
In the coastal subjects the stormy skies of the West-
ern Highlands are emphasised by their dramatic
reflections in the lochs and the sea.

survive from this holiday spent in the tiny communi-
ty of Acharacle on Ardnamurchan in July 1936. As
well as views of rugged coasts and the now aban-
doned crofts, there are snapshots of family picnics
and outings. On this trip more than others there is a
strong sense that this was a real family holiday [122].
Of course Gillies could not stop painting.

The oil paintings which resulted from these wa-
tercolours and other sketches were more carefully
worked and deliberately re-formed to accord with
the artist's current inclination. A number of pencil
studies of his companions on the beach is the start-
ing point for a series of paintings which eventually
get very close to abstraction. An early stage is shown
in *Picnic on the Beach, Morar I* [123]. Like the watercol-
ours there is much emphasis on tonal contrasts and
the effects of weather. However, as the series devel-
ops [124], the forms become less definite, but the
decorative features of line and shadow are accentuat-
ed. In addition to these pencil studies a watercolour
Rocks, Morar (private collection) depicts a loose ren-
dering of the same scene in colour, but without any
figures. In the oil painting *Rocks and Water, Morar* [33]
[125] the shapes of the figures on the beach are trans-
formed into areas of grey paint resting upon a snak-
ing black line in the foreground, which is closely
derived from Gillies's watercolour technique. The
background rocks are played down, although the
distant sea and hills quite clearly mark the horizon.
Above, massive blue clouds sit heavily on top of the
view. Dominating everything is a thunderous black
cloud. This work demonstrates a very painterly
abstraction, in which the artist clearly has been
happy to let the primed canvas show through the
thin oil layer in the foreground. Elsewhere Gillies
has added decorative touches by overpainting with
heavy black or light grey paint. The curving lines of
the composition and its colouring are reminiscent of
the major paintings by Gillies's fellow Scot, William
Johnstone (1897–1981). However, whereas Johnstone's
work of this period is marked by strong outlines and
highly finished painting, Gillies's forms are less ex-

123 W.G. Gillies,
Picnic on the Beach, Morar I,
c.1932
pencil, 17.9 × 22.8cm, RSA

124 W.G. Gillies,
Picnic on the Beach, Morar II,
c.1932
pencil, 17.9 × 22.9cm, RSA

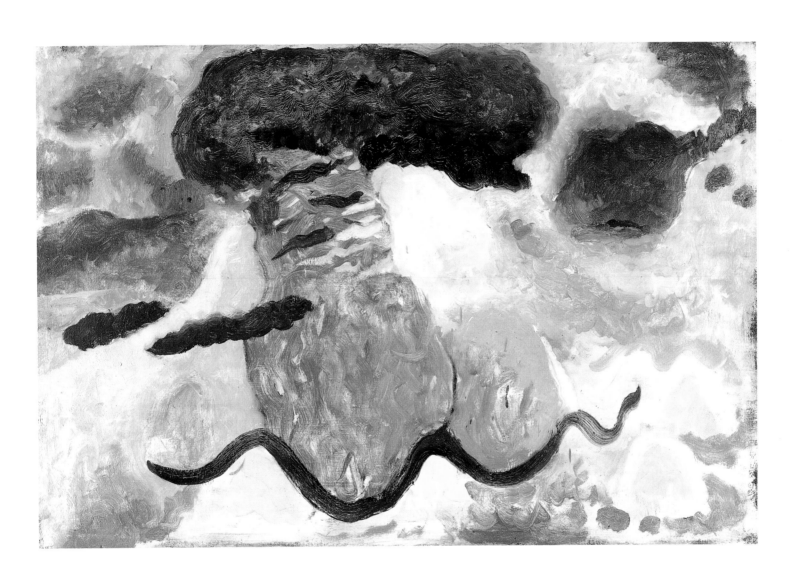

125 W.G. Gillies, *Rocks and Water, Morar*, c.1932–34

oil, 74.8 × 100.1cm, RSA

plicit, leaving paint to imply rather than state. It is probably this painting which caused much controversy when it was exhibited with The Society of Eight at the beginning of the following year:

… Mr Gillies has not been afraid to express his views in a series of large scale pictures which bear little relation to their titles. His rendering of a holiday at Morar, that picturesque resort of the tripper, is a most extraordinary presentation of Highland hills and sky with no realisation of good design.[34]

The late 1930s brought forth a number of paintings depicting the far north-west of Scotland. Following the family holiday on the Ardnamurchan peninsula in 1936, they spent July 1937 and 1938 by the remote crofting community of Laide in Wester Ross. Gillies's friend D.M. Sutherland was also in the area with his family on both occasions. In a letter to Gillies written in 1970, after having seen the catalogue of Gillies's retrospective exhibition, Sutherland reminisced:

… expeditions on the look out for sketching places with queer sounding names. I can think of Loch-na-Beastie on the way to Melon Udrigal [sic] – and it is difficult to forget the prowl alongside the coast road which was so easy to remember as Coast No 1 and Coast No 2 with the ever watchful Maister Coast … [35]

Small pencil sketches executed with a sure line describe the coastline. Large calligraphic drawings in black ink [126] give details of the beaches and rocks. Large watercolours, done in a loose style without any preliminary pencil drawing, lend colour and light to the landscape [see 21].

The works illustrated so far represent Gillies's naturalistic approach. However he was still looking at his surroundings with the eyes of someone who had studied the painting of Klee and Kandinsky. *Achgarve* (c.1937) [128], a fine work in ink and watercolour, demonstrates that Gillies had not entirely discarded his interest in abstraction. The uptilted landscape with its little patchwork of crofters' fields looks back to his European mentors, yet the light of the landscape remains his own personal vision.

Some of the watercolours were developed into oil paintings. For example a series of colour studies of Laide, seen from a high viewpoint and looking across the beach towards the mountains of Wester Ross, were worked up into a large oil titled *Laide, Ross-shire* [127]. There is a clear progression from the earlier naturalistic sketches to the finished oil painting with its stress on non-naturalistic shapes and lines. Gillies has emphasised the patterns of the stone walls and has put into practice methods of composition worked out in his still life painting.

Another landscape even closer to the style of his still life paintings is *Pigeons on a Doocot* (c.1937) [129]. This is a tightly composed arrangement of interlocking forms and planes. In the immediate foreground

126 *right* W.G. Gillies,
The Beach at Laide,
c.1937–38
ink, 30.6 × 63.0cm, RSA

127 *opposite above*
W.G. Gillies, *Laide, Ross-shire*, c.1937
oil, 56.4 × 127.0cm, RSA

128 *opposite below*
W.G. Gillies, *Achgarve*,
c.1937
ink and watercolour,
55.6 × 77.0cm, Perth Museum
and Art Gallery

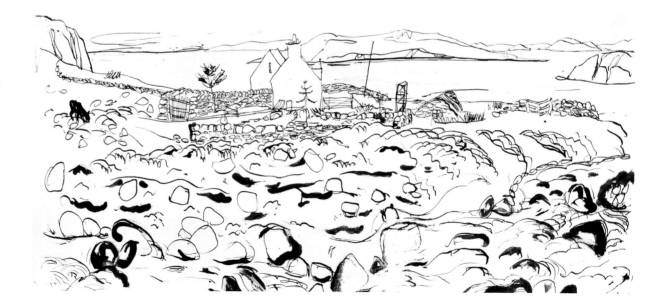

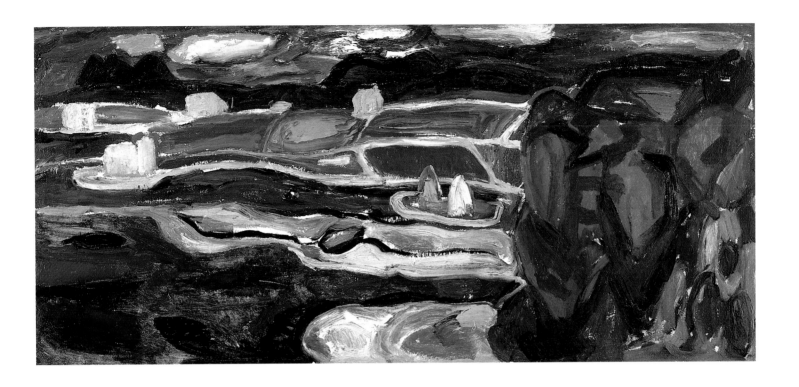

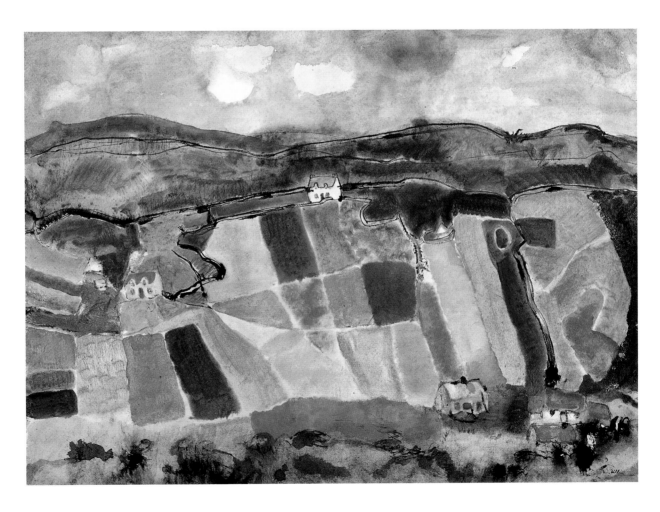

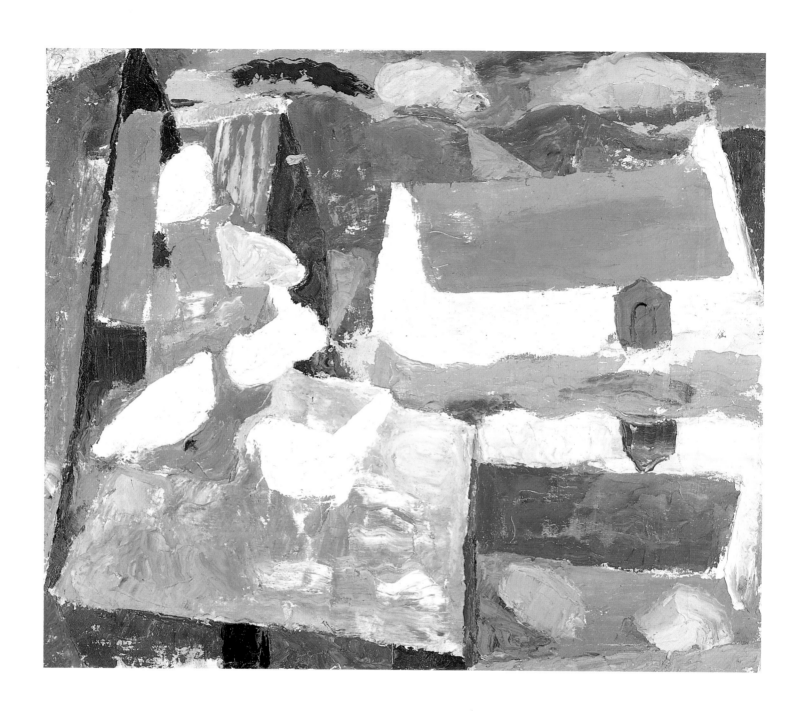

129 W.G. Gillies, *Pigeons on a Doocot*, c.1937

oil, 75.9 × 91.0cm, RSA

is a ledge with the simplified shapes of pecking white doves. Further back is the corrugated roof of a shed and behind that a cottage is reflected in a farm pond. A landscape is hinted at beyond, and over all are scudding white clouds in a blue sky. The colours are restricted largely to blues, greys and white, adding to the abstract quality of the painting. Any sense of recession is denied in favour of the tight overall pattern. The effect comes very close to that achieved in Gillies's more complex still life paintings of the late 1930s and early 1940s.

In July 1939 Gillies and Harold 'Tiny' Morton [36] travelled to Spinningdale on the Dornoch Firth and then on to Auchindoir near Rhynie in Aberdeenshire. This turned out to be the last of Gillies's lengthy journeys for a number of years. The outbreak of the Second World War at the beginning of September that year inevitably led to travel restrictions. In addition the family's move back to the countryside at Temple meant that Gillies's favoured subject matter was virtually on his doorstep. Many pen and ink drawings from the last holiday in the north demonstrate a more precise, nervous touch in Gillies's drawing line – for example, *Spinningdale* (private collection) – and a greater interest in the different textures of a landscape. Among the watercolours is *Speyside* (1939, private collection), executed on a large scale on sugar paper. In it the artist has concentrated on the dappled light on the summer landscape, using the rough texture of the paper to full effect. The light impressionistic touch looks forward to Gillies's landscapes of the 1940s and his exploration of the area around his new home in Temple.

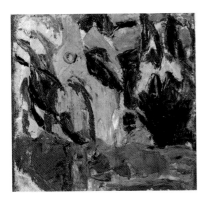

130 W.G. Gillies,
*Temple, Old Parish
Church*, c.1939–40
oil, 33.4 × 35.9cm, RSA

THE DISCOVERY OF TEMPLE

In his review of the Gillies retrospective exhibition of 1970 the writer George Scott-Moncrieff summarised the effect of the move to Temple on the family and on Gillies's painting:

A second landmark in his life ... came when Gillies bought from us our house in the Midlothian village of Temple. I had the privilege of staying on in the house for several weeks with Gillies, his sister, and his beautiful old mother ... I always remember watching Gillies repainting the chipped woodwork on our windowsills with the same enthusiasm and absorption that he bestowed upon his canvasses ... Gillies had longed to get out of Edinburgh ... He had in fact been almost all over Scotland in quest of landscape subjects during his vacations. But now he was to live close to singularly attractive subject matter, ranging from the fine, bare Muirfoots [sic] to the beech trees along the South Esk and the gentler farmland beyond. His colours had for some time become brighter, and now he tended to work on a smaller, more intimate scale.[37]

One of the first oil paintings that Gillies produced in his new home was *The Blue Window* (c.1940) [see 76]. It is really a still life composition, but the viewer is given a glimpse into the summer garden beyond. A flowerbed, a garden fence, a stone wall, part of the lawn and some trees can be seen. This view became an important focus for Gillies. A few months later he painted a companion work *The Blue Window, Winter* (RSA). An icy blanket of snow has replaced the summer colours, turning the detail of a garden into simple abstract shapes. These two works fittingly mark the beginning of Gillies's exploration of his new environment.

The street running through Temple is quite steep and narrow. Lined with eighteenth-century cottages, it curves gently to the east as it drops down to the river. At the lower end of the village are the ruins of Temple Old Parish Church. It is a picturesque spot in the classical manner. The roofless church and its graveyard are surrounded by stone walls. Beyond are the beech woods of the South Esk gorge. A very loose impressionistic oil painting recalls the dappled lights of sun through trees and its mottled effects on the masonry of the fourteenth-century church [130]. In the village itself Gillies painted the view looking

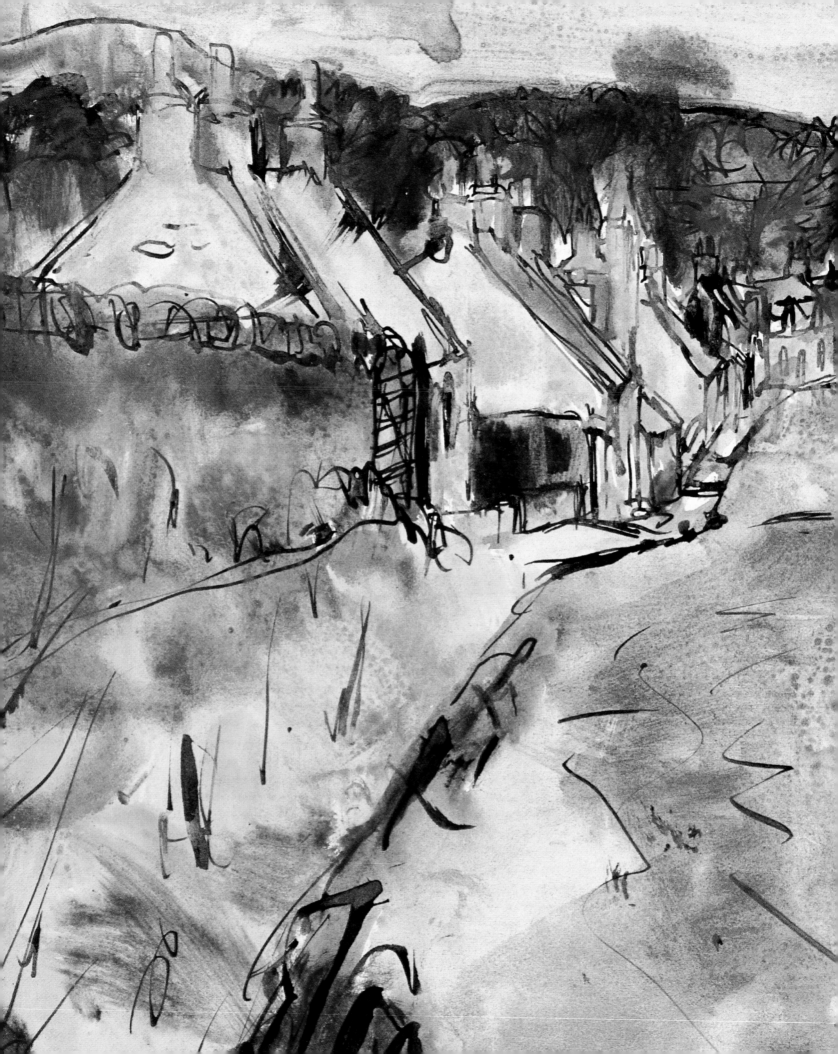

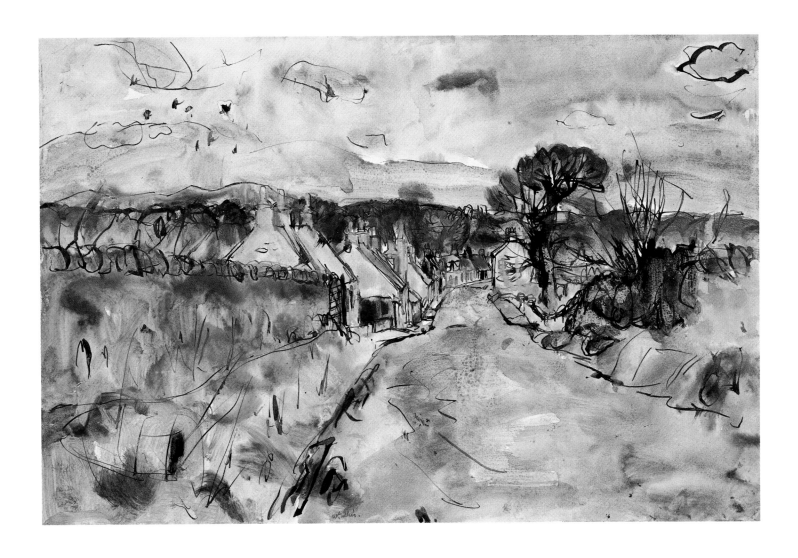

131 W.G. Gillies, *Winter Afternoon, Temple, c.1942*
watercolour, gouache, pen and ink, 34.2 × 51.1cm
Scottish National Gallery of Modern Art, Edinburgh

both up and down the hill. Many of these oil paint-
ings show the cottages dropping out of sight round
the curve in the road and into the valley. In others
Gillies has gone into the field behind his garden to
paint the backs of the cottages in their varied shapes
and sizes with their rough masonry and pantiled
roofs. These free impressionistic paintings portray
the village at all times of the day and in all seasons.
The high summer and blustery autumn, even the
heavy snowfalls of the late 1940s, provided Gillies
with variations on his local themes.

From about the late 1930s onwards Gillies devel-
oped the use of an ink line in his watercolours. It
appears in work dating from his travels to the North-
west Highlands, but until his move to Temple the
line remained subservient to the watercolour itself.
However a series of watercolour views of Temple
and its surroundings show Gillies sketching with a
nervous yet fluid line. To this he applied colour
washes for the overall effect. Referring to *Winter
Afternoon, Temple* [131] Gillies described his methods:

I began with a very sketchy, loose pen line with much
variation in strength and thickness, and then floated on
mostly grey washes, many of them round about the edges
of my paint box which I tend to leave uncleaned for this
very purpose.[38]

Another particularly successful watercolour is
Winter, Temple (c.1939, SNGMA). It presents a view of the
backs of the cottages with all their associated garden
debris in a confident pen and ink line and vivid
colour washes.

An unusual work of the period is *Temple Village,
Children Playing* [132]. In subject matter reminiscent
of the narrative and bucolic paintings of Breughel,
Gillies has filled the painting with local schoolchil-
dren at play. Unlike his Dutch predecessor, however,
his painting style is neither finely detailed nor realis-
tic. Elements of abstraction remain in the manner in
which the artist has emphasised the bold shapes of
the buildings, road and pavement. However, instead
of the carefully structured geometric shapes seen in
his paintings of the mid-1930s, Gillies has clearly
revelled in the joy of paint. In a masterly free way he
gives a rough impression of a girl with her doll, a
child with a hoop and the village dogs. The figures

are naïvely drawn almost to the point of caricature.
Perhaps this is a lingering influence of John Maxwell.
Indeed the colours are no longer impressionistic,
but, like Maxwell's work, are dense and heightened.
The overall effect is one of the sheer joy of colour
and of the quality of paint itself.

This rich painterly style features in other land-
scapes of the 1940s. Gillies had acknowledged from
college days the impact of Gauguin:

I remember seeing in 'Colour' a Breton harvest scene
with a red dog in the foreground by Gauguin [*Farm at Le
Pouldu* (1890)?]. This reverberated in my mind for a long
time, influencing a good many of my landscapes.[39]

Temple Village (PEMAG), one of a series of experimen-
tal oils, presents a view of the uppermost cottages in
Temple from the hayfield behind. By combining
strong complementary colours with a vigorous
impasto, this painting anticipates the richly jewelled
late works of William MacTaggart, or even Joan
Eardley's final Catterline clifftop subjects. Its compo-
sition is simply a series of horizontal bands, but that
is not the important feature. In this work colour and
paint are everything. In a series of short vertical
brushstrokes Gillies has evoked the full colour and
fragrance of a summer evening. By contrast, another
oil painting of the period *Cottages with Green Fence*
[133] has the density of construction reminiscent of
Gauguin. The overall richness and complexity of
colour defies any sense of spatial depth. A significant
change is the raising of the horizon. In almost all of
Gillies's landscapes of the 1920s and 1930s the sky plays
a crucial role. In the 1940s and 1950s, however, the
artist has turned his attention earthwards. The sky is
reduced to a narrow strip across the top of the can-
vas and the pattern of trees, fields, houses and hills
becomes the complete subject of the landscape.

Gillies did not familiarise himself only with the
village and its immediate vicinity. He also explored
all aspects of his wider surroundings. He sketched in
the Arniston and Rosebery Estates, which were rich
with plantations, reservoirs, impressive farm build-
ings and rolling fields. He painted the nearby village
of Carrington with its fine eighteenth-century parish
church, the dramatic lime-kilns at Crichton and at
Esperston (now demolished) and the open views out

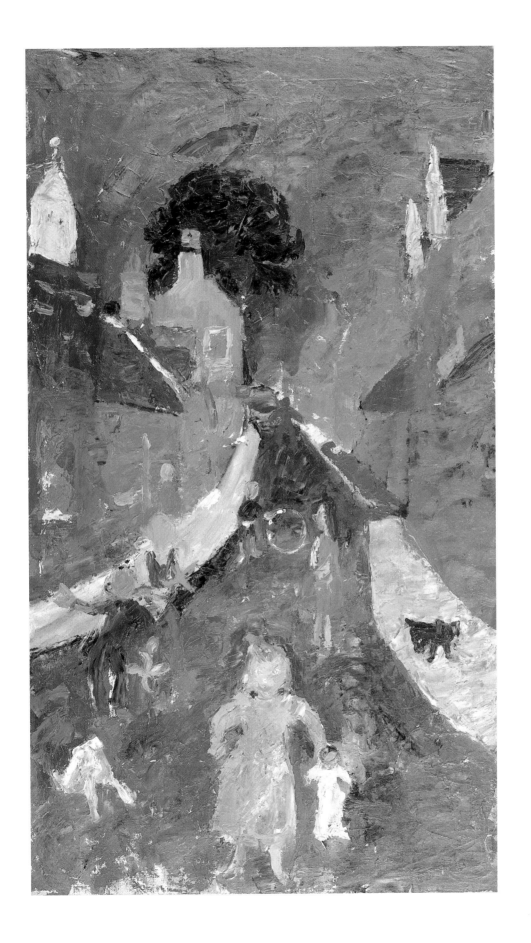

132 W.G. Gillies,
*Temple Village, Children
Playing*, 1940–45
oil, 112.7 × 66.9cm, RSA

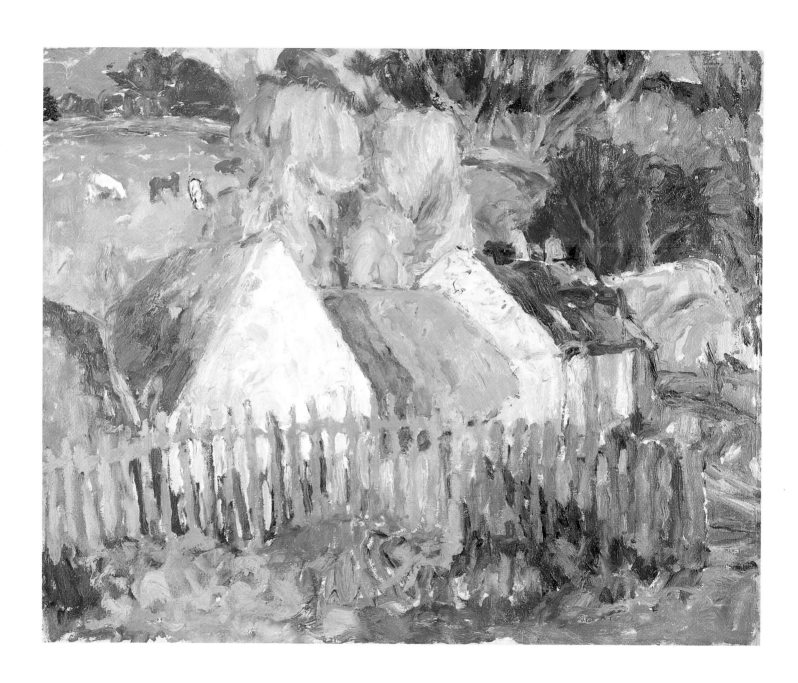

133 W.G. Gillies, *Cottages with Green Fence*, c.1944
oil, 61.2 × 76.4cm, RSA

to the Moorfoot Hills to the south. *Brown and Grey Landscape, Pentland Hills* [134] was painted from near the village of Howgate in Midlothian, looking west towards the Pentlands. This was a favourite view, one to which Gillies was to return for the rest of his life. Although it is very painterly, the work no longer employs the broken colour of Gillies's recent paintings. The winter shades are softened and muted and the brushwork is looser again. The sharp staccato dashes of colour have been replaced by long fluid brushstrokes. From a high roadside vantage point Gillies has focused on the middle distance, to the countryside rising up before him and thence to the distinctive line of the Pentland Hills. As with *Cottages with Green Fence* the artist has not attempted to create a sense of spatial depth. Instead he has concentrated on the patterns of winter trees against country lanes and winter fields. Although not truly naturalistic these colours evoke most effectively the sense of a cold winter's day under a lowering sky. This interest in creating a sense of time and place and in portraying the patterns, rather than the reality, of the landscape was to become a distinctive feature of Gillies's painting into the 1950s.

There was one feature of the local landscape that Gillies turned to above all else. Since his schooldays he had had a fascination for trees in all their aspects. In his earliest work structure and form were all important. Later, as his handling of paint became freer, this solidity was replaced by a spontaneity, which suggested form through colour. By the time Gillies had settled in Temple, however, this spontaneous quality was taking a different form. Now he was concentrating on light and colour, rather than structure, as the main focus of his pictures. A painting such as *Woodland Landscape* (RSA) is a tapestry of colours evocative of the tree trunks and undergrowth of a steep bank in autumn. Slightly later is *Woodland Landscape, Blue Tree* (c.1950) [135], which is more structural again. It is another working of the theme of winter trees on a bank. The distant copse is visible through a network of branches and tree trunks. The pattern Gillies has created is based on the play of light and dark. There is little sense of recession through the picture plane. *Bare Trees on a Bank* (RSA), a pen and ink drawing of about the same period, presents a linear version of this theme. With apparent spontaneity Gillies has drawn a web of branches and tree trunks, through which the backs of the cottages in distant Temple can just be glimpsed.

134 W.G. Gillies,
*Brown and Grey Landscape,
Pentland Hills*, c.1945–48
oil, 57.0 × 94.6cm, RSA

135 W.G. Gillies, *Woodland Landscape, Blue Tree*, c.1950
oil, 46.2 × 97.0cm, RSA

POST-WAR TRAVELS

By 1947 Gillies was able to return to Fife on sketching trips. As before, he camped with friends and colleagues from Edinburgh College of Art, working in the Anstruther area especially. We know from postcards that he returned in 1949. However, judging from the quantity of work he produced, he must have paid many more visits in the late 1940s. Busy pencil drawings with colour notes give details of the streets, houses and harbours of the fishing villages. Watercolours (many with strong pen and ink lines) add local colour. Gillies was particularly attracted to the activities of the fishermen. One rare figure-based subject called *Painting the Boat* (private collection) portrays the bustle on the harbour-side. Other watercolours rely on the patterns of masts, harbour lights and heaped up creels, all long-term favourites with generations of artists. Yet in contrast to the work of earlier painters Gillies's pictures contain colours which are strong and sentimentality plays no part in them. A large oil *Anstruther* (c.1945) [137] is the simplest of compositions, merely horizontal bands of sea, boats, houses and sky. Yet the surface texture is rich with colour and life, both the sea and sky are full of movement and, above all this, the constant wheeling of seagulls creates a feeling of perpetual motion. These paintings are in marked contrast to the products of some ten years earlier [see 110]. Now they have an apparent artlessness which disguises a total virtuosity of paint handling.

The Fife paintings of the late 1940s are complemented by clusters of work executed, for example, at Fearnan on Loch Tay in Perthshire, at Kirriemuir in Angus and in the Western Highlands. Gillies returned to the area of the Balmacara Estate, which had been bequeathed to the National Trust for Scotland in 1946, and to the village of Plockton in particular. He also worked around the tiny village of Letterfearn on the south side of Loch Duich. He had travelled this way many times before, but had taken the main road on the north side of the loch past Balmacara to Kyleakin and the Skye ferry. However on this occasion he spent more time working around Letterfearn itself. He sketched the village, the loch, the surrounding hills and the dramatic view across the water to both Eilean Donan Castle and the bridge at Dornie. In these works again the compositions are simple; the artist's interest lies in colour, paint, texture and movement. The watercolours produced on those visits had an immediate popularity, not least with the most avid collector of Gillies's paintings, Dr R.A. Lillie, who wrote to Gillies's mother 'I enclose G.S-M's [George Scott-Moncrieff] booklet on Balmacara to remind you of your visit there. Fine photos – but I have got some wonderful pictures by W.G.G ... '[40] It was at this time that Dr Lillie began to collect paintings by Gillies in a serious way.[41]

As well as these travels and his regular visits to Maxwell's home in Dalbeattie in Galloway, Gillies returned to another favourite pre-war haunt. In July 1950 he made his way north to Abroath and called in at Hospitalfield. It was here that talented postgraduate students were able to study and work together under a resident warden, who at that time was Ian Fleming (1906–93). Gillies reported home 'Called on Ian Fleming last night at Hospitalfield & saw four of our students there ... are now off in the Montrose direction in bright sunshine!'[42] The next day he was settled in his working destination 'AFFORSK FARM, GAMRIE ... very good place, quite near Gardenstown, and will stay some time. Weather excellent, sunny & breezy. Have not started work yet ... '[43] [136]. In September 1951 he was back again, although not without some problems for a painting holiday 'Afforsk. Getting really glorious weather – <u>not</u> very paintable, though. Sea too blue ... Look in allotment for PEAS. W.'[44]

136 W.G. Gillies, *Gardenstown*, c.1951
pencil, 24.8 × 31.9cm, RSA

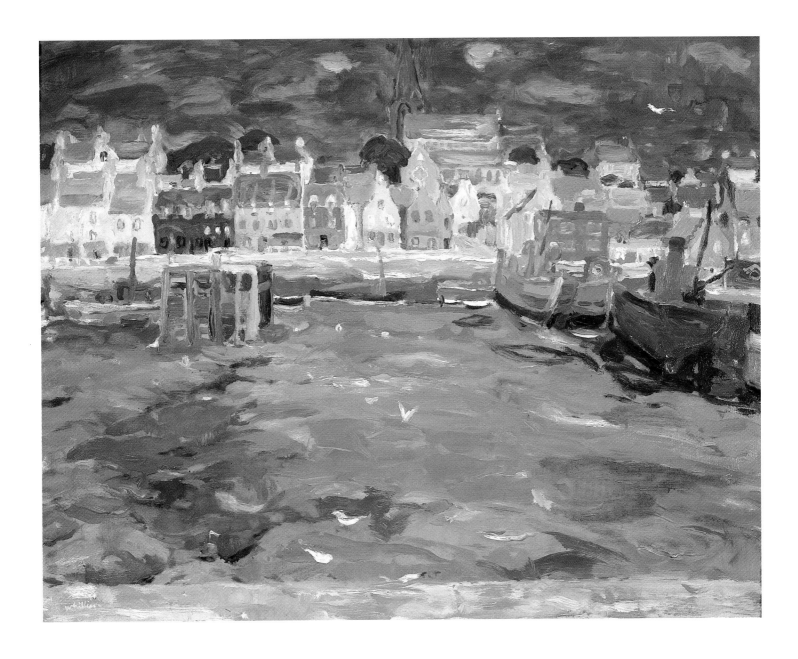

137 W.G. Gillies, *Anstruther, c.1948*

oil, 76.2 × 101.7cm, Private Collection

The landscape paintings of this period, especially the watercolours, found a ready public at last. In 1952 Gillies had a one-man exhibition of landscapes at the Scottish Gallery. In a lengthy review *The Scotsman's* critic wrote:

No figure in contemporary Scottish art has caused so radical a change in public opinion as William Gillies. Twenty or twenty-five years ago, his work was looked upon, not only by nearly all laymen, but also by the majority of older painters, as outrageously revolutionary. It aroused shock and indignation quite comparable with the recent adverse reactions to the Ecole de Paris exhibition. Yet to-day, and for some time past, Gillies's work has been recognised as extraordinarily gifted. It sells readily to an enthusiastic and varied public … This charm is not due to any compromise or retreat on Gillies's part. Although his vision and methods have been constantly enriched since his first visit to France as a young man, they have never altered in their nature, and certainly not in the direction of the unadventurous … It is true … that in the medium of water-colour, though inspired by the same character that animates his oils, Gillies has always resorted less to deliberate distortion or conventions … the true 'abstract' element is as present here as in completely non-representational pictures. The conviction they carry is of naturalness, not naturalism … [45]

138 Robert Henderson Blyth, *Study for Blue and White Float, c.*1951
ink and watercolour, 24.4 × 26cm, RSA

The overall effect of the exhibition on the critic was one of sheer enjoyment. A year later, when reviewing *The Scottish Scene,* another one-man show of landscapes (on that occasion from the Lillie Collection), his erstwhile colleague R.H. Westwater explained:

Gillies is a 'natural' if ever there was one, his prolific output being matched by its ease and variety … Every one of the exhibits … is redolent of the particular beauties of Scottish landscape, and each one could persuade us in its honest freshness that Gillies had opened delighted eyes on that landscape for the first time in his life. [46]

A painting companion of the period was Robert Henderson Blyth (1919–70). 'Bobbie' Blyth had trained at Glasgow School of Art under Hugh Adam Crawford RSA (1898–1982) and then at Hospitalfield with James Cowie RSA (1886–1956). On completion of his war service in 1946 he joined the staff of Edinburgh College of Art, working as assistant to Gillies in the School of Drawing and Painting. Despite their different artistic backgrounds, they found that they were happy to work in each other's company. The painter David McClure later wrote:

Together they made journeys to paint in the harbours of the East Neuk, of Banffshire, and the West Highlands. While Gillies almost floated his subjects onto the canvas with Bonnard-like ease, or, with limpid pen-and-wash, laid out patterns of landscape like Oriental rugs, Henderson Blyth, with substantially the same motifs (harbour walls, boats, creels, cottages, and fields) made paintings more closely spun and wrought, and finally welded together by linear divisions of raised paint like the leading of a stained glass window. [47]

Although Gillies, as the older and more mature painter of this partnership, influenced Blyth, it was not entirely one-way. For it was in the early 1950s that Gillies's oil paintings became tighter again with a heavier reliance on line and the patterns of composition. This clarity was akin to the way that Blyth treated his landscape painting in the late 1940s and early 1950s [138]. Later Blyth was to loosen his handling of paint and to heighten his colours. In contrast Gillies's landscapes were to become more linear.

THE BORDERS LANDSCAPE

The roads from Edinburgh into the Borders follow the river valleys, passing through towns and villages and crossing high moorland. The landscape changes at every twist and turn. It changes also in accordance with the season, the weather and the time of day. Gillies explored every one of those routes again and again from the late 1940s to the end of his life. The paintings which resulted from these trips were numerous and popular. Indeed it is these works by which he is best remembered.

Gillies went by car or motorbike from his home in Temple either south over the Moorfoot Hills towards Lauder or across to Innerleithen, or west towards the Pentland Hills before cutting south on the road either to Galashiels or Peebles. He stopped wherever and whenever his attention was caught. Almost every lay-by and entry to a field served as a parking space. From such spots he made hundreds of pencil sketches, some quick and spare, others de-
tailed and finely shaded. He continued to sketch in watercolours, although now he favoured the application of watercolour washes to already shaded pencil or pen and ink drawings [139].

Gillies also painted in oils on those sketching trips. He worked on a small scale, using either millboard or canvasses stretched over a board. When wet, the sketches would be protected at the corners with blocks and then covered by another board, being carried home in specially prepared panniers.[48] One such example is *Gattonside* [140], a study in oils of the village across the River Tweed from Melrose. The dense colours and richly applied paint suggest that this painting must have been executed in the late 1940s or very early 1950s.

His larger oils were worked up later from the pencil sketches and other studies made in the field. The most frequent view is one taken from the road, looking across a river valley to the hillside opposite.

139 W.G. Gillies,
The Valley of the Gala Water, c.1955
pencil and watercolour,
25.0 × 35.5cm, RSA

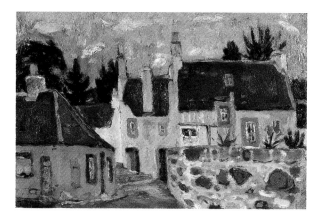

140 W.G. Gillies,
Gattonside, c.1950
oil on board, 30.5 × 46.7cm,
RSA

The foreground may be articulated with a stone wall or thorn bushes. The middle distance dips down out of sight into a flat valley bottom. Here there may be a stream, a river or even a railway line and train. Behind this the hillside rises steeply, perhaps criss-crossed with dry stone dykes. There may be patches of dense conifer woodland or the hillside itself may be cut by fast-flowing burns. Although the colours may at first appear flat, a subtle play of tones describes very accurately the undulating forms of the Border hills. Above all this – almost as an after-thought – a narrow strip of sky closes the top of the composition. In all these paintings there is a tautness to their structure, a paring down, which relates to the discipline so evident in Gillies's still life paintings.

The Cattle Fence [see 32] was exhibited at The Scottish Gallery during the Edinburgh Festival of 1954.[49] Here the viewpoint is low, but the sharp perspective of the log and netting across the burn leads the viewer's eye quickly into the middle distance. Beyond lies the main river valley. In the distance the fields slope up towards a line of wintry trees beneath a leaden sky. The texture of the paint is viscous and the lines of the brushstrokes follow the contours of the land. The subtle variations of green, yellow and grey give a very precise actuality to the scene. One can sense the feel of the grass and gravel underfoot and experience the cold blustery weather.

A year or two later Gillies painted *Mauve Landscape* [141], which shows increased stylisation, although the scene remains quite precise. From close to the village of Howgate in Midlothian the viewer looks west towards the line of the southernmost Pentland Hills. Gillies sketched this view from the roadside and painted more than one finished version.[50] Here the theme is one he had explored many times before, that of the pattern of a landscape seen through the branches of a bare tree. Gillies has manipulated and twisted the branches in a manner reminiscent of the de-formed shapes favoured by Graham Sutherland. The tree appears to grow almost straight from the river and to cast its branches across the whole picture plane. Behind lies a patchwork of bare, brown fields and a dense, dark wood. On the horizon the distinctive peaks of East Kip, West Kip and Scald Law are exaggerated into a series of convex shapes. Detail is suppressed for the sake of the overall pattern. Even the texture of the paint is quite flat. Yet there remains a vivid sense of truth to the view.

In 1959 Gillies painted *Dusk* [142]. This painting also depicts a winding river valley, but the artist has taken the stylisation of the subject a step further. The river is now a dark blue ribbon, which curves across the lower third of the picture plane. Beyond, the very simplified forms of winter trees close the foreground section of the painting. Behind lie woodland, a cottage and hints of fields and rolling hills. Above all this a sombre, striated sky closes the composition. The image is a powerful and memorable one of that brief moment before complete darkness falls over the countryside.

The atmosphere evoked in *Dusk* is far from the fleeting effects of blustery weather recalled so vividly in Gillies's earlier watercolours. In 1961 he attempted to describe his aims in landscape painting:

A landscape has to be digested. Working from nature, one is distracted by the perpetual change – I get led astray from the original conception. I seek the permanent in nature.[51]

Writing in *The Scotsman*, this quotation was discussed by Sydney Goodsir Smith:

This is a revealing remark. When one thinks of a typical Gillies landscape, the atmosphere, the light, the weather seem very local, even topographical and immediate, but, thinking longer, one realises that it is not the impression of a caught moment but the very essence of that particular stretch of hill or sea-wall. 'The permanent in the transient' might be a good enough definition of his finest works in landscape.[52]

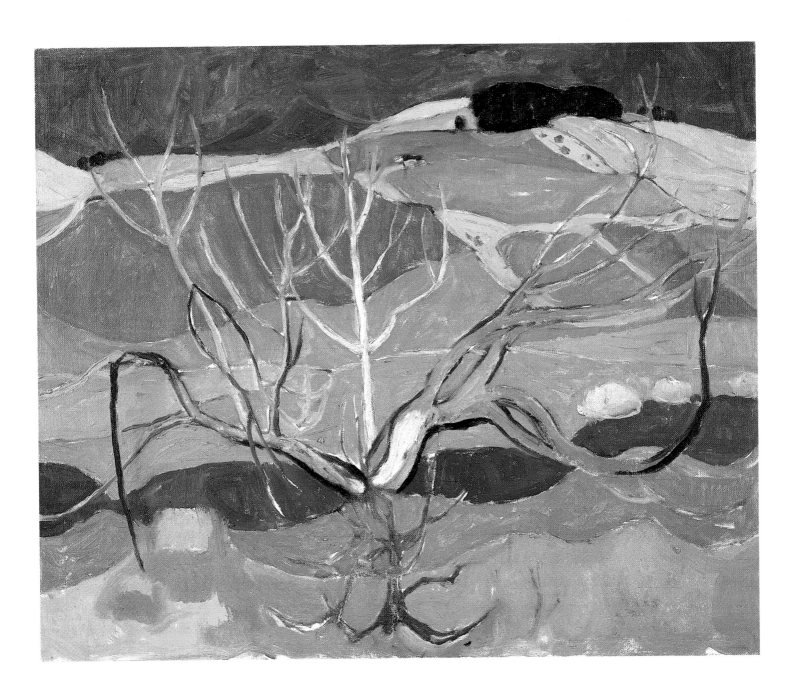

141 W.G. Gillies, *Mauve Landscape*, c.1956
oil, 61.5 × 74.0cm, RSA

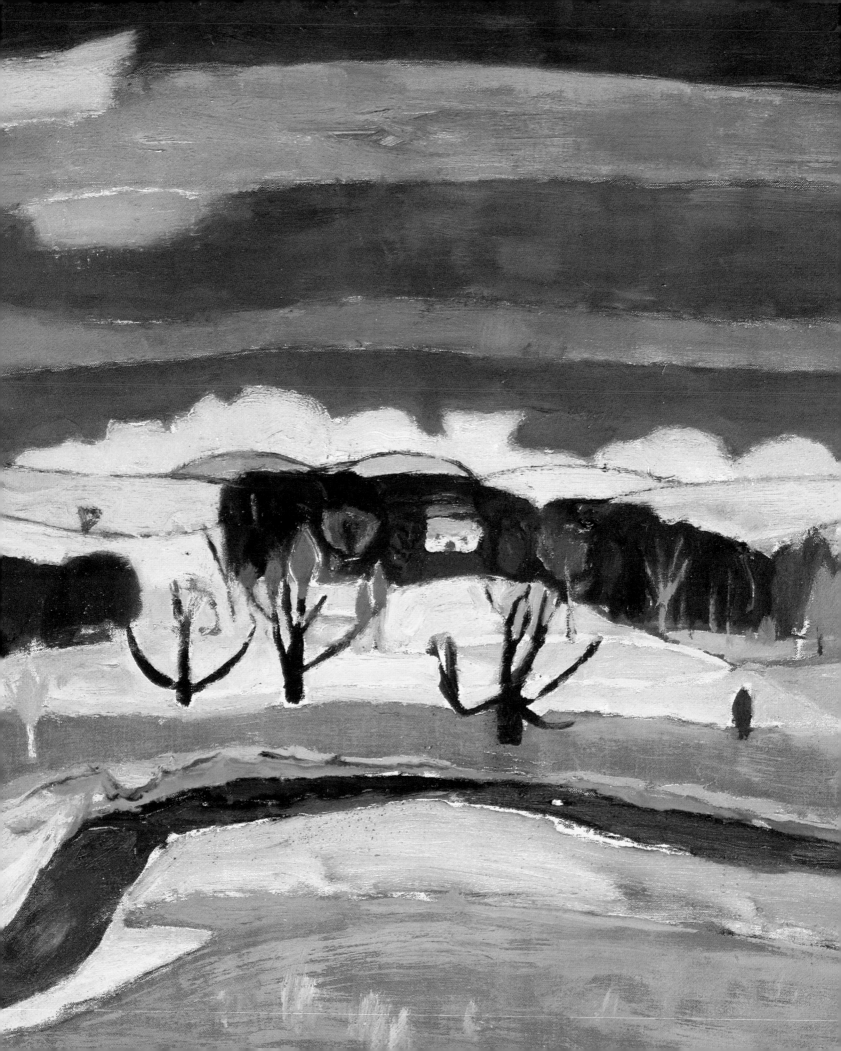

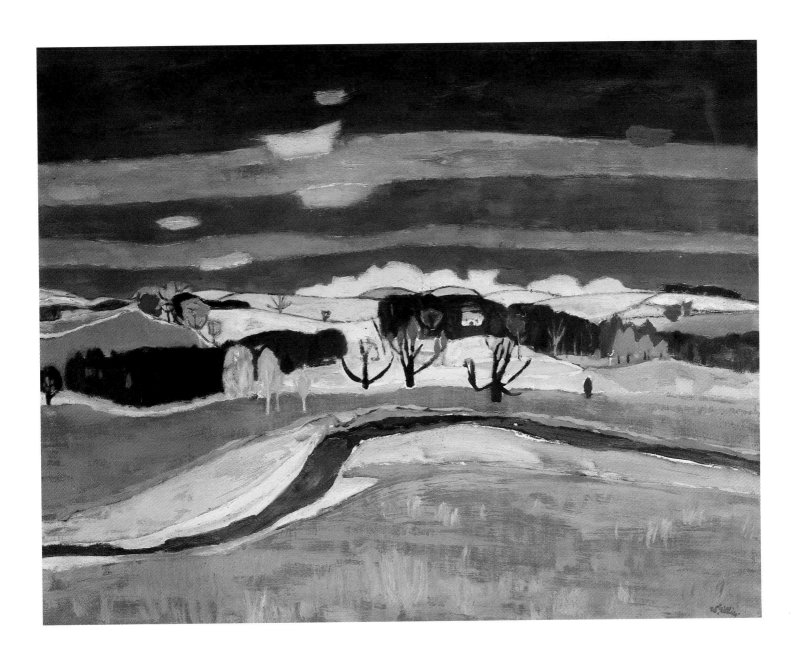

142 W.G. Gillies, *Dusk*, 1959

oil, 71.1 × 91.5cm, Aberdeen Art Gallery and Museums Collections

TEMPLE AND THE GARDEN

As Gillies's paintings of the Borders became more stylised during the 1950s, a similar trend can be discerned in pictures of his garden. Ever since he moved to Temple in 1939 Gillies had painted his immediate surroundings. However it was in the late 1950s and early 1960s that this developed into a series of major works around the theme of his garden. In 1960 he painted the large *The Garden, Winter Sunshine*.[53] It presents a view from his studio window out into the garden. Indoors and outdoors are unquestionably linked by the black lines of a bare tree and its shadow across the walls and window sill. This was followed in 1961 by *Garden, Temple, Winter Moon* [143],

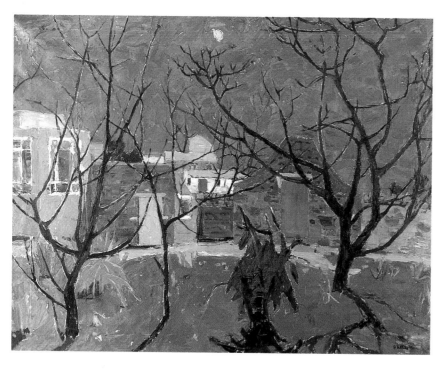

143 W.G. Gillies, *Garden, Temple, Winter Moon*, 1961

oil, 97.0 × 122.0cm, Paisley Museum and Art Galleries

which is a totally outdoor view. Its composition is reminiscent of some of his Border landscapes, because in this work also the artist presents a screen of bare trees, behind which the wintry garden, the outhouses and the dark sky are ranged. The moon appears to cast a powerful light, which creates strong, black shadows across the foreground of the composition, giving an eerie, shifting quality to the painting. Yet despite the darkness of the surroundings, the sheds and outhouses in the middle distance are stacked up in bright, vivid colours in a pattern of rectangles.

Parallel with these garden subjects is a series of still life paintings set against the window of Gillies's studio. One of the major works of this series is *Winter Dusk* (1961–63) [see 86]. Gillies has pulled the landscape of the garden right into the formal still life composition. Elements such as shrubs, stone wall and gateway arch become features of a tapestry set between the window panes. Judging from the many pencil sketches of the garden, the aspects which most attracted Gillies appear to have been the bare bones of the winter trees and shrubs and the contrast between the openness of the field behind the cottage and the density of nearby woodland.

Early Spring (c.1964) [see 33] continues the theme of the artist's back garden. In contrast to *Garden, Temple, Winter Moon* it proves that Gillies had started to move away from the starkly dramatic treatment of the lines and shadows of trees. Although their branches still spread like tentacles, there is no tension or sense of threat. The tonality of the painting is softer and more even. No longer is the sky simply a narrow strip against which the composition is placed; it comes forward and plays a greater role in the whole of the painting. Its subtle blues, greens and mauves echo the colours of the spring growth in the garden.

Temple – Dusk (1968) [144] is another important painting in the Temple series. In this work Gillies has turned his attention to the street running through the village, rather than to his own back garden. A straightforward pencil sketch looking up the hill to the top end of the village is the starting point. From this Gillies has exaggerated the turn in the road and has added two imaginary upright window bars to pull the composition together. However, as in *Garden, Temple, Winter Moon*, the focus of the painting lies in the centre around the brightly painted cottages and the gigantic full moon.

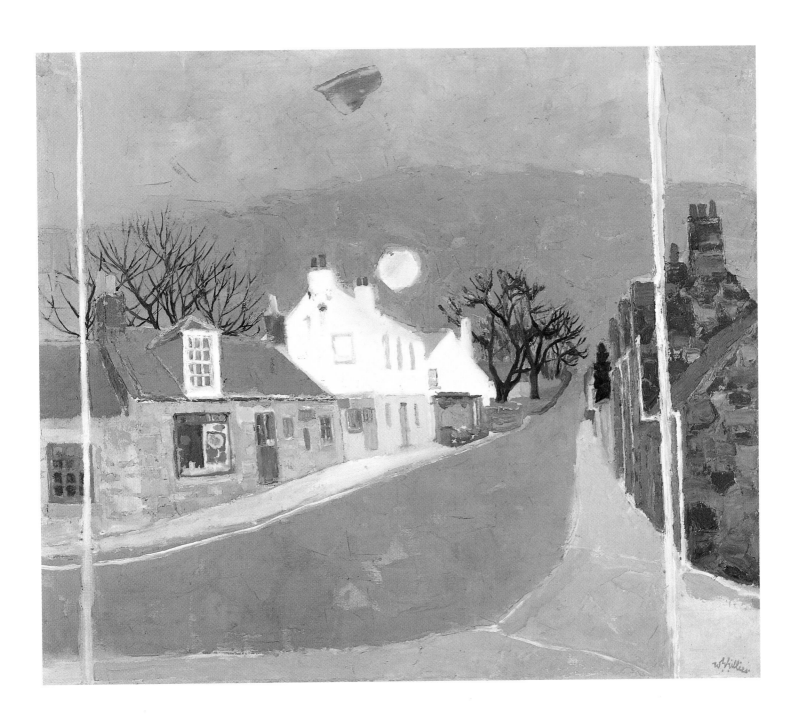

144 W.G. Gillies, *Temple – Dusk*, c.1968
oil, 87.1 × 101.1cm, City Art Centre, Edinburgh

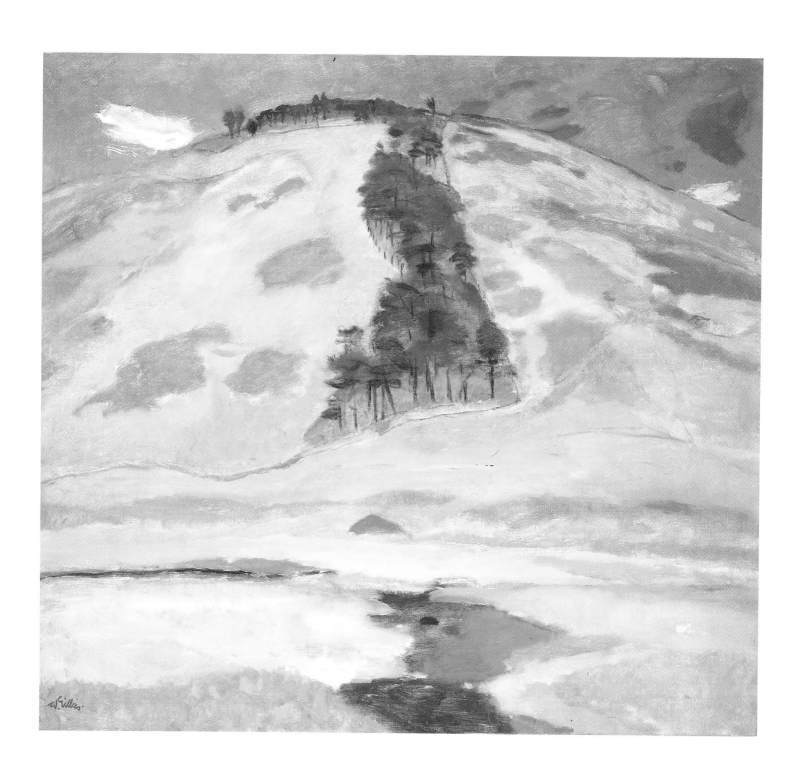

145 W.G. Gillies, *Between Raeshaw and Carcant on Heriot Water*, c.1968
oil, 86.3 × 96.8cm, RSA

LATE LANDSCAPES

Once Gillies had retired as Principal of Edinburgh College of Art in 1966, he had at last more time to paint and to experiment. Liberated from a regime of three terms, two short holidays and one longer one, he was free to paint as and when he wished. Not only did he continue to explore his immediate surroundings, but he also looked further afield, travelling once again, for example, to the far north of Scotland.

His landscapes become softer again. The complexities of rivers, dykes and woodland are distilled down to a quieter vision. An example is *Between Raeshaw and Carcant on Heriot Water* (c.1968) [145]. The rounded profile of Longshaw Law rises straight up from the meandering river. A tightly enclosed section of woodland defines the steep hillside, its dark greens echoed in a cold Heriot Water. On each side

of the woodland the mottled pattern of heather and grass gives shape and form to the hill. There are no longer hard edges and twisted lines. There are no signs of any human habitation. The landscape is just a simple statement.

A further example of his landscape work of the period is *Trees, Rosebery* [146]. The subject is a clump of trees in a field on the Rosebery Estate outside Temple and in its simplicity it pulls no punches. It recalls some of the early tree subjects of the 1920s, but the monumental starkness of *Trees and Coppice* (1928) [see 102] has gone. With a delicate touch Gillies has played on the paleness of the trees caught in sunlight against a wintry sky. The yellowed grass in the field adds softness to the overall colouring. The effect of the painting is one of quiet contemplation.

146 W.G. Gillies, Trees, *Rosebery*, c.1970 oil, 69.0 × 83.1cm, RSA

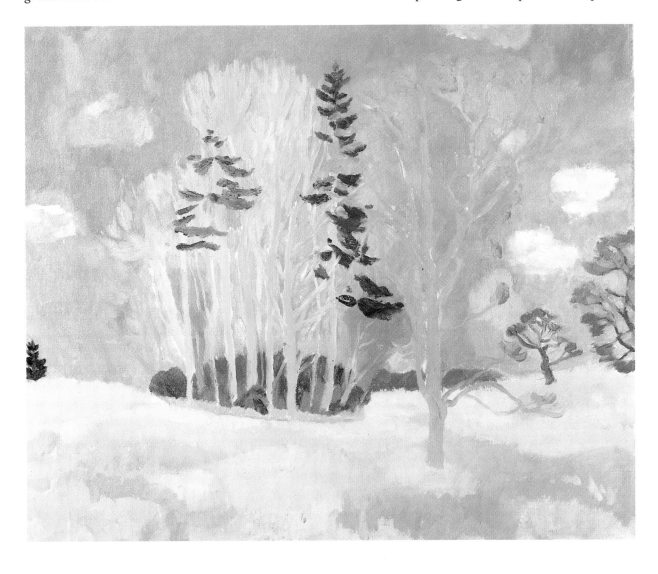

In his very late watercolours there is a similar restraint and contemplative quality. The paper is no longer covered with a helter-skelter of brushstrokes or pen or pencil lines. Instead there is a concentration on the essential qualities of each landscape. For example *Landscape with Pink and Yellow Clouds* (c.1965–70) [147] gently hints at the undulating Lothian landscape on a late summer's evening. Its quality brings to mind the North Frisian watercolours of Emil Nolde (1867–1956), which were exhibited at the Scottish National Gallery of Modern Art during the Edinburgh Festival of 1963.

147 W.G. Gillies,
*Landscape with Pink and
Yellow Clouds, c.1965–70*
watercolour, 39.5 × 57.4cm, RSA

A far more complex late work is *Nairn Beach* [148]. This painting had a gradual evolution. It was based on the view from a caravan site beside the beach at Nairn, looking northwest towards the Moray Firth and the hills of Easter Ross. Gillies had spent holidays in a caravan there with the Winthrop family, but on those occasions Gillies acted as the grandfather and played with the children. He did not paint or even make pencil sketches. However, he also had the chance to spend time in the Winthrop's caravan alone. Then he took the opportunity to work as he always had. It was probably on such a visit in 1965 that Gillies made a series of pencil sketches of the park, the caravan site and the beach.[54] He developed them into more than one finished oil. *Caravans on the Dunes* (RSA), a gentle, lyrical painting of a row of motley caravans, is derived directly from an annotated pencil sketch. *Nairn Beach* on the other hand was worked up much later in the studio and is a more experimental painting. It is also a very rare example of Gillies incorporating figures into a late landscape. Although they are simply shadows – mere memories – these figures call to mind his lively seaside holidays with children, beach ball, kite, deck chairs and dog. The movements of the figures and their toys criss-cross between the caravans and the darkly brooding sea. In this late work the oils are applied extremely thinly and the primed canvas creates a translucency, which gives the painting an ethereal quality.

Throughout his long career Gillies always sought to capture the essence of a landscape. His drawings and watercolours have a directness and immediacy which appealed to the public from the very start. Nevertheless, working *en plein air*, Gillies sought not only to capture the transient effects of sunshine and shower, but also to record the permanent quality of his surroundings. In working up these drawings and watercolours into oil paintings, it was this *lasting* interpretation which was of utmost importance to him. Sometimes this search for permanence led Gillies close to abstraction and at other times to a twentieth-century reworking of classicism. Yet, whatever style he adopted, it was *his* understanding and vision of his own countryside that projects itself so clearly. So strong was this vision that even today it is difficult to travel these same routes through the Scottish Borders and not see the rolling countryside as a series of landscapes by Gillies. J.S.

148 W.G. Gillies, *Nairn Beach*, c.1970
oil, 88.2 × 114.8cm, RSA

POSTSCRIPT

William Gillies's landscape painting has, without doubt, had a major impact on the way many people today view the Scottish landscape. Both his way of seeing the Highlands in grandly sweeping watercolours of sky, water and mountains, and his choice of low viewpoints from which to draw and paint the trees, stone dykes, hills and the ribbon-like twisting roads of the Borders have now become part of a common visual memory. These images present for many the quintessentially Scottish nature of the land: frequently dramatic, but never out of sight of the domestic and human scale of things.

Proud of and loyal to the country of his birth, Gillies was strongly nationalistic. Yet his intellect was sharp and his mind open to things that were happening beyond the confines of Scotland. However, he remained content to spend his working life in his native country and to paint. Painting for him was not a livelihood, it was his whole life. 'What else is there to do but paint?' he once said.

Of course, as well as being a painter Gillies was also a teacher of painting. He was not dogmatic in his methods, and he gave his students room to breathe in their own work. He was a teacher who never talked about the struggle of making art. He would, instead, talk about the pleasure of making art. For Gillies it was paint that was the most important thing, be it watercolour or oil, and whether a portrait, still life or landscape.

Contemporaneous with the growth of Gillies's influence at the Edinburgh College of Art, was the evolution of the so-called 'Edinburgh School' of painters. The loose association of Gillies, Maxwell, MacTaggart and Anne Redpath, with their interest in the rich colours and textures of paint, had a knock-on effect on the students of the ECA at that time and for many years afterwards. One such example was the painter Robin Philipson. He was a student of Gillies's, who then progressed through the College to become Head of Drawing and Painting at the time of Gillies's promotion to Principal in 1960. Philipson remained in that post for twenty years and through him further generations of students were introduced into a method of painting predicated upon the love of rich colour and the tactile handling of paint.

Despite his devotion to the College, Gillies was a very private man. He was quiet, shy and diffident even with his associates. His fiercest loyalties were to a few close friends, and to his immediate family. At this centre were his parents and his sisters. After the deaths of his father and Emma, his younger sister, the bonds between the remaining family members grew even tighter, and in later life his mother and elder sister protected him, as they saw it, from the intrusions of colleagues, collectors and all but the fewest of friends. In such a way Gillies led a compartmentalised life, and very few friends crossed the boundary between college and home. John Maxwell was an early friend who was accepted into his whole life, and Robin Philipson too perhaps later on. But otherwise there were always barriers in place behind which Gillies could retreat should he feel the need.

Though Gillies enjoyed popularity with the public in later years, he never painted for this public or played to an audience with his art. He painted for himself. And although happy to try out new ideas he never took more from outside sources than he could happily cope with at any one time.

At the outset of his career in 1924, Gillies applied for a job at the Bradford School of Art and Crafts. Had he taken up this appointment, it seems likely that his work would have followed the mainsteam of *English* painting, and *Scottish* art would not have been as rich as it is today. J.S. & V.K.

SELECT BIBLIOGRAPHY

BOOKS, ARTICLES AND EXHIBITION CATALOGUES

T. Elder Dickson, 'W.G. Gillies', *Studio*, v 166, January 1960, pp.14–18

T. Elder Dickson, *W.G. Gillies Retrospective Exhibition*, Scottish Arts Council, Edinburgh, 1970

T. Elder Dickson, *W.G. Gillies* (Modern Scottish Painters no.2), Edinburgh, 1974

Ian Finlay, *Art in Scotland*, Oxford, 1948

Jack Firth, *Scottish Watercolour Painting*, Edinburgh, 1979

Norman J. Forrest, 'William G. Gillies', *Edinburgh Today*, vol.2, no.6, 1953

Edward Gage, *The Eye in the Wind, Scottish Painting Since 1945*, London, 1977

Julian Halsby, *Scottish Watercolours 1740–1940*, London, 1986

Keith Hartley and others, *Scottish Art Since 1900*, National Galleries of Scotland, Edinburgh & London, 1989

Victoria Keller and Margaret Mackay, *William Gillies and the Scottish Landscape*, Scottish Arts Council, Edinburgh, 1980

Philip Long, *William Gillies, Watercolours of Scotland*, National Galleries of Scotland, Edinburgh, 1994

Mary and Hector MacIver, *Pilgrim Souls*, Aberdeen, 1990

Duncan Macmillan, *Scottish Art in the Twentieth Century*, Edinburgh & London, 1994

Philip G. Napier, *William Gillies – Our Neighbour*, Temple, 1980

George Scott-Moncrieff, *The Scottish Scene, Watercolours and drawings by W.G. Gillies from the collection of Dr R.A. Lillie*, Edinburgh, 1953

Alastair Smart, 'The Art of W.G. Gillies', *The Scottish Art Review*, vol.5, no.2, 1955

Sidney Goodsir Smith, 'Drawings by W.G. Gillies', *Connoisseur*, vol.158, no.636, Feb. 1965

W. Gordon Smith, *W.G. Gillies, A Very Still Life*, Edinburgh, 1991

R.H. Westwater, *W.G. Gillies and John Maxwell*, Arts Council of Great Britain, London, 1954

OTHER SOURCES

Royal Scottish Academy Archives: Gillies Bequest which includes manuscript notes, postcards, letters, exhibition catalogues, newspaper cuttings, photographs and personal memorabilia

Royal Scottish Academy Archives: General Collections which include Annual Reports, Minute Books, records of Annual Exhibitions, newspaper cuttings and correspondence

Edinburgh College of Art Annual Reports

National Library of Scotland: Dr Robert A. Lillie's personal papers

Edinburgh Public Libraries (Edinburgh Room): newspaper collection

Society of Scottish Artists Archives: Minute Books and exhibition catalogues

Still Life with Honesty (1970), Films of Scotland Collection, Scottish Screen Archive

NOTES

CHAPTER ONE

1 Francis G. Groome (ed.), *Ordnance Gazetteer of Scotland ...* , Edinburgh, 1882.

2 A plaque erected by Haddington Historical Society marks the property.

3 Draft speech to open Leith Schools Art Exhibition, 1966, RSA Archives.

4 Created from the private art collection of William Orchar, this gallery housed a remarkable collection of nineteenth-century Scottish paintings. In 1987 it was incorporated into the collections of Dundee Art Galleries and Museums.

5 James Watterston Herald's landscapes are characterised by a skillful 'blottesque' technique and an interest in colour for its own sake.

6 W.G. Gillies, *Biographical Notes*, RSA Archives.

7 *New Testament*, RSA Archives.

8 Diary in Janet Gillies's handwriting, RSA Archives.

9 T. Elder Dickson, *W.G. Gillies* (Modern Scottish Painters, no.2), Edinburgh, 1974, p.12.

10 Ibid., p.7.

11 Ibid., p.17.

12 *Gillies & Maxwell*, Arts Council of Great Britain, 1954, introduction by R.H. Westwater.

13 Edinburgh College of Art, Annual Report, 1923.

14 Draft speech, Glasgow School of Art Diploma Ceremony, 1970, RSA Archives.

15 Edward Gage, *The Weekend Scotsman*, 31.1.1970.

16 Letter from W. Crozier to RSA, 3.2.1924, RSA Archives.

17 Postcard, 7.11.1923, RSA Archives.

18 Elder Dickson, *Gillies*, 1974, p.20.

19 'The kind of student about which I dream', letter from André Lhote, 8.1.1924, RSA Archives.

20 Pensione Giannini, Lung Arno Serristori 21, Firenze (prop. Signora Santini).

21 Elder Dickson, *Gillies*, 1974, p.22.

22 Conversation with James Henderson, 2.6.1997.

23 Draft speech, Glasgow School of Art Diploma Ceremony, 1970, RSA Archives.

24 Unattributed newspaper cutting, 1923, RSA Archives.

25 Unattributed newspaper cutting, 1927, RSA Archives.

26 W.G. Gillies, 'The Artist Reminisces', *Christian Science Monitor*, 12.3.1970.

27 Conversation with Mrs Beatrice Anderson, 24.11.1995.

28 Gillies himself recorded the year of the move as 1928 but documents in the RSA Archives indicate that the year was 1929.

29 W.G. Gillies, *Biographical Notes*, RSA Archives.

30 Samuel John Peploe, George Leslie Hunter (1879–1931), John Duncan Fergusson (1874–1961) and Francis Campbell Boileau Cadell (1883–1937) are referred to as 'The Scottish Colourists' for their use of strong, undiluted colours.

31 W.G. Gillies, *Biographical Notes*, RSA Archives.

32 A.R. Howell, *Frances Hodgkins, Four Vital Years*, London, 1951, p.4.

33 Ibid., flyleaf note.

34 Newspaper cutting, *The Times*, 27.10.1928, RSA Archives.

35 That year the members were Sir John Lavery RA, RSA, David Alison RSA, Henry Lintott RSA, S.J. Peploe RSA, F.C.B. Cadell RSA, John Duncan RSA and James Paterson RSA.

36 Unattributed newspaper cutting, 1932, RSA Archives.

37 Unattributed newspaper cutting, 1934, 'Society of Eight. Notable Exhibition in Edinburgh. Wide Range of Interest', RSA Archives.

38 Unattributed newspaper cutting, 1935, RSA Archives.

39 W. Grohmann, *Kandinsky*, Editions Cahiers d'Art, 1930.

40 Newspaper cutting, probably *The Scotsman*, 1960, RSA Archives.

41 Newspaper cutting, *The Dispatch*, 27.11.1938, RSA Archives.

42 Postcard, 12.8.1931, RSA Archives.

43 Postcard, 4.8.1933, RSA Archives.

44 Postcard, 1.9.1933, RSA Archives.

45 Postcard, 6.8.1934, RSA Archives.

46 James Henderson (b.1907) enrolled at Edinburgh College of Art in 1925 and was one of Gillies's first students. On completion of his course he took a part-time teaching post at the College and at this time joined Gillies on some of his painting trips. In 1935 he was appointed Head of Art at Galashiels Academy.

47 Conversation with James Henderson, 2.6.1997.

48 Postcard, 27.8.1935, RSA Archives.

49 Conversation with Elizabeth Blackadder and John Houston, 8.12.1995.

50 Postcard, 22.9.1937, RSA Archives.

51 Postcard, 20.8.1938, RSA Archives.

52 Postcards 7.9.1948 and 11.9.1948, RSA Archives.

53 In W.G. Gillies, *Biographical Notes*, RSA Archives, he wrongly records the year of Emma's death as 1935.

54 Postcard, 23.7.1947, RSA Archives.

55 Postcard, ?.9.1951, RSA Archives.

56 Draft speech, opening RSW Annual Exhibition, 1965, RSA Archives.

57 Conversation with William J.L. Baillie, 5.7.1996.

58 Conversation with James Mowatt, 15.10.1996.

59 Draft speech, undated, RSA Archives.

60 Terence Mullaly, *The Daily Telegraph*, 9.2.1970.

61 Edward Gage, *The Scotsman*, 9.2.1970.

62 W.G. Gillies, *Memories of Maxwell*, RSA Archives.

63 Letter to John Thorburn, 3.11.1961, RSA Archives.

64 Edward Gage, *The Scotsman*, 9.2.1970.

65 Conversation with Mr and Mrs J. Winthrop, 10.12.1995.

CHAPTER TWO

1 The nucleus of the art college's collection of casts came from the Trustees Academy, which was housed in the Royal Institution (now known as the Royal Scottish Academy) on the Mound, Edinburgh.

2 R.H. Westwater, *W. MacTaggart*, (Modern Scottish Painters no.3), Edinburgh, 1974, p.5.

3 Ibid., p.5.

4 Elder Dickson, *Gillies*, 1974, p.7.

5 Ibid., p.17.

6 Ibid., p.19.

7 This is discussed concisely in Werner Haftmann, *Painting in the Twentieth Century*, New York, 1965, pp.111–12.

8 See William Crozier's notebook, RSA Archives. It is clear that Gillies and Crozier shared this notebook and it contains notes on specific paintings in the Louvre, such as Poussin, their compositions broken up into geometric sections.

9 Elder Dickson, *Gillies*, 1974, p.20.

10 Mario Sironi (1885–1961) was also associated with the Futurists, but is better known for his later association with the Italian *Novecento* movement, which was active between the two World Wars.

11 D. McClure, *John Maxwell*, (Modern Scottish Painters no.4), Edinburgh, 1976, p.8.

12 Elder Dickson, *Gillies*, 1974, p.26.

13 Postcard to Emma Gillies, 26.7.1932, RSA Archives.

14 *The Listener*, 17.1.1934, p.107.

15 Ibid., p.95.

16 Alexei von Jawlensky (1864–1941), was a Russian painter, who spent most of his working life in Germany. He was part of the Munich avant-garde in the early years of the century, along with Kandinsky and Marc.

17 *The Scotsman*, 'Society of Eight. Notable Exhibition in Edinburgh', no date, cutting from RSA Archives.

18 Gillies owned a small booklet (now in the RSA Archives) on Marie Laurencin (1885–1956), which he had purchased in Paris in 1924.

19 Elder Dickson, *Gillies*, 1974, footnote 19, p.104.

20 Gillies did, however, paint a watercolour portrait of Miss Elizabeth Looker, who retired as Principal Warden of the Suffolk Halls of Residence in 1955, at the request of Miss Elizabeth L. Carrick, the incoming Principal Warden who was a friend of his. There are two versions of the portrait, one now in the RSA Gillies Bequest collection, and the other in the collection of Moray House Institute of Education.

21 The Honourable Lord Cameron, John (Jock) Cameron (1900–96).

22 Conversation in 1990 with Mrs Elizabeth Fletcher. She had asked Gillies a number of times to paint a portrait of her husband, Harold, but Gillies always managed to evade the commission.

23 Edinburgh College of Art Annual Report 1961–62. Robin Philipson, as Head of the School of Drawing and Painting, wrote the report, but Gillies would certainly have endorsed the sentiment.

24 Quotation from *Still Life with Honesty* (1970), Films of Scotland Collection, extracts by permission of the Scottish Screen Archive. Transcription from the film made by Joanna Soden and Victoria Keller.

CHAPTER THREE

1 *Still Life with Honesty* (1970).

2 *The Discourses of Sir Joshua Reynolds*, London, 1842, p.50.

3 G. Peploe, *S.J. Peploe 1871–1935*, Edinburgh, 1985, p.58.

4 Clive Bell, 'Art', in *Art in Theory 1900–1990*, ed. Charles Harrison & Paul Wood, Oxford, 1994, p.113.

5 Draft speech, Glasgow School of Art Diploma Ceremony, 1970, RSA Archives.

6 Review from *The Times* 27.10.1928 of an exhibition at St George's Gallery, London. This was a group show with the Polish sculptor, H. Kuna, and the Irish artist, Thomas Handforth.

7 *The Meaning of Art* was published by Faber & Faber in 1931, the first of many editions. (Gillies owned a first edition, given to him by his sister Emma.).

8 Edinburgh College of Art, Annual Report, 1932–33.

9 Lily McDougall was born in Glasgow in 1875. With the encouragement of her family she studied at the Royal Institution in Edinburgh and then went on to study at The Hague School of Art and in Antwerp. She lived in Paris from 1904 to 1906, studying at the Carriere Académie and the Jacques Emile Blanche studio under Lucien Simon (1861–1945). *Memorial Exhibition of Paintings by the late Lily M.M. McDougall (1875–1958)*, The Scottish Gallery, Edinburgh, 2–14 March 1959. Simon is best known for his warm and colourful portraits as well as his genre scenes of Brittany.

10 Conversation with Mrs Mary Rankin (31.1.1997), whose mother was a first cousin of Lily McDougall's. Their mothers were sisters.

11 The society was renamed the Society of Artists and Artist Craftsmen in 1990.

12 Elder Dickson, *Gillies*, 1974, p.42.

13 Conversation with Elizabeth Blackadder and John Houston, 8.12.1995.

14 Elder Dickson, *Gillies*, 1974, p.29.

15 Ibid., p.28.

16 *Still Life with Honesty* (1970).

17 The owner says it had been painted in a matter of hours, rather than days.

18 In 1952 the exhibition *Ecole de Paris* was arranged by the British Council for the Scottish Committee of the Arts Council of Great Britain.

19 *Still Life with Honesty* (1970).

20 Edinburgh College of Art, Annual Report, 1944–45.

21 Edinburgh College of Art, Annual Report, 1945–46.

22 Edinburgh College of Art, Prospectus, 1945–46.

23 Postcard, 14.9.1946, to Mrs E. Gillies, RSA Archives.

24 Edinburgh College of Art, Annual Report, 1946–47.

25 Conversation with James Mowatt, 15.9.1996.

26 Conversation with Thora Clyne, 5.3.1997.

27 There are two versions of this painting, but the one shown in Plate 80, in the Fletcher Collection on loan to the Edinburgh City Art Centre, is the one that was sent to London.

28 Conversations with various artists, including E. Blackadder and J. Houston (8.12.1995), W.J.L. Baillie (5.7.1996), I.

McKenzie Smith (25.6.1995), A. Campbell (11.9.1996), P. Collins (20.6.1997). Other artists who caught the attention of 1950s Scottish artists besides Morandi and Julius Bissier were Mario Sironi, Massimo Campigli (1895–1971) and Zoran Antonio Music (b.1909).

29 The titles of the two exhibitions were: *The collection of works by Giorgio Morandi 1890–1964 belonging to Professor Luigi Magnani* August–September 1965 and *Julius Bissier 1893–1965*, 31 July to 19 September 1965.

30 Conversation with Elizabeth Blackadder and John Houston 8.12.1995.

31 Werner Schmalenbach, *Julius Bissier*, London, 1964.

32 Conversation with Thora Clyne 5.3.1997.

33 We are grateful to William Buchanan and Thora Clyne for information about Gillies's role in the organisation of the exhibition.

34 *Still Life with Honesty* (1970).

CHAPTER FOUR

1 *Still Life with Honesty* (1970).

2 Ibid.

3 Elder Dickson, *Gillies*, 1974, p.5.

4 *Still Life with Honesty* (1970).

5 Collection Glasgow Museums & Art Galleries, purchased 1942.

6 Letter W. Crozier to W.D. McKay, Secretary, RSA, 3.2.1924, RSA Archives.

7 Photographs of other very early oil paintings, probably done at this period, survive in the RSA Archives.

8 *Gillies Retrospective Exhibition*, SAC, 1970, cat.no.11, illustrated on p.14.

9 Unattributed newspaper cutting, 1927, RSA Archives.

10 Newspaper cutting, *The Daily Telegraph*, 27.10.1928, RSA Archives.

11 An extensive collection of postcards written by Gillies to his family log his travels, unfortunately he did not name his companions on the 1927 trip, RSA Archives.

12 The Scottish painter, Charles Hodge Mackie RSA (1862–1920) worked in East Lothian in the late nineteenth and early twentieth centuries and also in Pont Aven where he met Le Sidaner, Serusier and Maurice Denis.

13 This film is in a private collection.

14 Richard Morphet, *Cedric Morris*, Tate Gallery 1984, p.104.

15 André Cariou & Michael Tooby, *Christopher Wood*, Tate Gallery 1996, see for example plates 11, 12 and 18.

16 E.H. Furst, *Apollo*, December 1928, vol.8, no.48, Art News & Notices, p.381.

17 Newspaper cutting, 'PGK', *The Daily Mail*, 5.11.1928, RSA Archives.

18 *The Print in England*, Fitzwilliam Museum, 1985.

19 Janet Gillies, postcard, 15.7.1929, RSA Archives.

20 Elder Dickson, *Gillies*, 1974, p.26.

21 Members of the family included the painter, John Henry Lorimer (1856–1936), the architect, Sir Robert Lorimer (1864–1929) and the sculptor, Hew Lorimer (1907–93).

22 *Still Life with Honesty* (1970).

23 Emma Gillies, postcard, 1.7.1930, RSA Archives.

24 John Maxwell, postcard, undated and never posted, RSA Archives.

25 Elder Dickson, *Gillies*, 1974, p.26.

26 William McTaggart was the grandfather of William MacTaggart, and the house at Broomieknowe, near Loanhead, had been both his home and studio in later years.

27 William Gillies, postcard, 26.7.1932, RSA Archives.

28 Newspaper cutting, *The Scotsman*, undated, 1934, RSA Archives.

29 Newspaper cutting, *Aberdeen Press & Journal*, undated, 1934 (?), RSA Archives.

30 Elder Dickson, *Gillies*, 1974, p.66.

31 *Still Life with Honesty* (1970).

32 Ibid.

33 This painting is probably the same as *Holiday at Morar*, exhibited with The Society of Eight, 1933 (cat no 5).

34 Newspaper cutting, *Edinburgh Evening News*, 11.1.1933, RSA Archives.

35 D.M. Sutherland, letter, 26.2.1970, RSA Archives.

36 Another painter friend of Gillies, called 'Tiny' because of his lofty build; conversation with the Misses Thomson, 29.7.1996.

37 George Scott-Moncrieff, 'Fresh Aspects of Beauty', *Times Educational Supplement*, 6.2.1970, RSA Archives.

38 *Still Life with Honesty* (1970).

39 Elder Dickson, *Gillies*, 1974, p.19.

40 Dr R.A. Lillie to Mrs Gillies, letter, 29.5.1954, RSA Archives.

41 When Dr Lillie died in 1977 his collection of paintings by Gillies numbered 372; this collection has now been disbursed but a group of 170 paintings and drawings are in the SNGMA.

42 William Gillies, postcard, 12.7.1950, RSA Archives.

43 William Gillies, postcard, 13.7.1950, RSA Archives.

44 William Gillies, postcard, 4.9.1951, RSA Archives.

45 Newspaper cutting, 'William Gillies Water-Colours and Drawings', *The Scotsman*, 9.1.1952, RSA Archives.

46 Newspaper cutting, R.H. Westwater, *The Spectator*, 11.9.1953, RSA Archives.

47 David McClure, *Henderson Blyth Memorial Exhibition Catalogue*, Aberdeen Art Gallery, 1972.

48 Conversation with P. Pope, 9.10.1995.

49 Redpath, Gillies, Wilson & Fleming exhibition, The Scottish Gallery, Edinburgh, 16 August–4 September 1954.

50 Another version of this subject in a private collection uses a completely different colour range based upon shades of yellow ochre and blue.

51 Sydney Goodsir Smith, 'Portrait of the Artist 2. W.G. Gillies, Principal of Edinburgh College of Art', *The Scotsman*, 29.4.1961.

52 Ibid.

53 Elder Dickson, *Gillies*, 1974, p.95 (illus. 41).

54 This is the caravan site where Gillies had spent a series of summer holidays with John Winthrop and his young family in the 1960s. After both Janet and his mother had died, Gillies forged a close relationship with this local family.

SIR WILLIAM GILLIES

CBE RSA RA PPRSW

Obituary from the Royal Scottish Academy Annual Report for 1973

William George Gillies, born in Haddington in 1898, died in tranquility at his luncheon table on Sunday, 15th April 1973. By this sudden death Scotland has lost one of her most distinguished artists. His painting stands out in any contemporary environment – his idiom was very personal and always unmistakably Scottish. After a spell as a brilliant student at the Edinburgh College of Art, interrupted from 1917 to 1919 by military service, he was awarded a travelling scholarship which enabled him to study some time in Paris and later travel in Italy before he settled for good in his native country.

Having been a member of the 1922 Group and, in 1932, one of the 'Society of Eight' – a rare distinction – he entered the brotherhood of this Academy when he was elected ARSA. in 1940, becoming an Academician seven years later. He was awarded the CBE in 1957 for services to Art in Scotland and elected as an Associate of the Royal Academy in 1964. The accolade of knighthood was bestowed on William Gillies in 1970. In 1971 he was made a Royal Academician.

There was something birdlike about him: his tempo was faster than normal and while most people walked Bill Gillies ran – effortless in all his many activities and in conversation he often anticipated what was going to be said to him. In short, he used time to the full, being a prolific painter who managed also to be an inspiring teacher. At the Edinburgh College of Art his first junior appointment in 1925 led to his becoming the Head of the School of Drawing and Painting. Those who heard the cheers of his students when he rose on Graduation Day to read the names of his graduates witnessed an unforgettable testimonial of affection. As a climax to his career as a teacher he became the Principal of the College, an appointment he enjoyed from 1961 to 1966, during which years there were many important developments, including the building of the new School of Architecture. To his distinctions must also be added the compliments paid to this man when, in 1966, he became a Fellow of the Educational Institute of Scotland and the Edinburgh University capped him 'Hon.D.Litt'.

To most people these activities and commitments would have been more than enough, but however onerous they were it seemed to make little or no difference to the large quantity and splendid quality of Gillies's work as a painter – it has been estimated that he completed well over 2,000 works. He was an exciting colourist and his paintings were full of light and poetry. Dedicated as he was to the gravity of his work which ever contained an original quality of Scottish character, Bill Gillies, an inveterate maker of wines and jams, regarded life with an air of detached amusement.

To name but some of the public and private collections in Scotland in which his work is represented, mention can be made of Aberdeen, Dundee, Edinburgh and Glasgow along with the Scottish Arts Council. His pictures also grace National Galleries as far flung as the Tate in London, Ottowa [sic] and Peru. When the Scottish Arts Council gave him his major retrospective exhibition it attracted over 30,000 visitors.

His modest, characteristic opinion of the verdict that posterity might grant him was given in his own words replying to a friendly banter shortly before his unexpected and sudden death, 'More than likely –

och yes, Gillies – a pretty competent minor Scottish Artist'.

Broadly speaking, it could be said that there are two kinds of painters. Those who find their inspiration abroad and those who can only blossom in their native soil, Gillies being a perfect example of the latter. He found all the material he wanted in Scotland – Highland landscape and Lowland townscape, in Fife and the Lothians, in little seaports and bare hillsides, especially in the charming village of Temple where he lived and died.

If he was an important member of the Royal Scottish Academy, our Academy was also all important to him. The final proof, the vindication of the regard this simple man, who remained unmarried throughout his life, had for the Academy lies in the contents of his will. With the exception of one or two minor bequests, his entire and not unsizeable Estate has been left to the Royal Scottish Academy 'to establish a Fund, the income from which shall be devoted to such educational and/or charitable purposes as the President and Council of the Academy shall decide'.

It would be a mistake to say that Gillies, the master of the Scottish scene, was indifferent to the many contemporary trends of art – it would be more true to say that he had something so fundamental, so pressing to say that he was not sidetracked by the passing fashions and whims of the day and his art will endure when a great deal that is fashionable will have long since been forgotten. This dear man, who will be deeply missed by all who knew him, occupied a unique place in Scottish art.

WILLIAM MacTAGGART

EXHIBITIONS

1923 1922 Group (first exhibition).

1925 1922 Group.

1926 1922 Group;
Contemporary English Watercolourists, St George's Gallery, Grosvenor Street, London.

1927 1922 Group; RSA.

1928 1922 Group;
St George's Gallery, London, with Henri Kuna and Thomas Handforth.

1929 1922 Group.

1930 RSA.

1932 Society of Eight;
8th Annual Exhibition, St George's Gallery;
Paintings by Six Scottish Artists, Barbizon House, London.

1933 Society of Eight; RSA.

1934 Society of Eight; SSA.

1935 Society of Eight.

1936 Society of Eight.

1937 Society of Eight; SSA.

1938 Society of Eight; SSA;
Group show, Reid & Lefevre, London.

1939 RSA.

1940 RSA; SSA.

1941 RSA; SSA.

1942 RSA; SSA;
Art for the People, Miners' Institute, Cowdenbeath;
Paintings and Drawings by British Artists, CEMA Tour;
Six Scottish Painters, Reid & Lefevre, London

1943 RSA; SSA;
Living Scottish Artists, CEMA Tour;
Art for the People, Balfour Hostel, Edinburgh.

1944 RSA; SSA Jubilee; RGIFA;
Exposicion de Arte Britannico Contemporaneo, Palacio de Bellas Artes, Santiago, Chile.

1945 RSA; SSA;
Paintings by Seven Scottish Artists, T.&R.Annan,Glasgow;
A Fourth Exhibition of Contemporary Paintings, CEMA Tour;
Watercolours and Drawings by Living Scottish Artists, CEMA Tour;
A Selection from the Royal Scottish Academy Exhibition 1945, ACGB Tour.

1945–46 *Contemporary Paintings by Edinburgh and Glasgow Artists*, ACGB;
Art for the People, Contemporary Scottish Painting, CEMA Tour.

1946 RSA;
Painting and Sculpture by the Edinburgh School, Scottish–Polish House, Edinburgh, BC;
Exposition Internationale d'Art Moderne, Musée d'Art Moderne, Paris, UNESCO;
British Painters 1939 to 1945, Burlington House, London, ACGB.

1947 RSA;
Group show, Scottish Gallery, Edinburgh;
East–West Reciprocal Exhibition, Glasgow Art Club.

1948 RSA; SSA;
One-man show, Lillie Collection, French Institute, Edinburgh;
Drawings and Watercolours by Contemporary Scottish Artists, ACGB Scottish Committee Tour;
Paintings and Sculpture by Contemporary British Artists, ACGB Tour;
Engelsk Nutidkonst, BC Tour, Sweden;
Selection of Paintings from SSA Exhibition, ACGB Tour.

1948–49 *Contemporary British Drawings*, BC Tour, Canada.

156

1949 RSA; SSA;
One-man show, Scottish
Gallery, Edinburgh;
Paintings by Present Day Scots,
T.&R. Annan, Glasgow;
A Selection from the RSA
Exhibition 1949, ACGB Tour;
Contemporary British Painting,
ACGB and EU Art Society.

1950 RSA; RSW;
One-man show, Edinburgh
International House.

1951 RSA; SSA; RSW;
Festival of Britain Exhibition,
ACGB, London;
Britain in Watercolours, RWS,
London;
British Painting 1925–50, ACGB;
Contemporary Scottish Paintings,
ACGB Scottish Committee
Tour;
Scottish Painters' Progress,
Aberdeen Art Gallery.

1952 RSA; SSA; RSW; RGIFA;
One-man show, Scottish
Gallery, Edinburgh;
Festival Group Show,
Scottish Gallery, Edinburgh.

1953 RSA; SSA; RSW; RGIFA;
The Scottish Scene, one-man
show from the Lillie
Collection, The National
Trust, Edinburgh.

1954 RSA; RSW; RGIFA;
Some Edinburgh Painters,
National Gallery, Ottawa;
W.G. Gillies and John Maxwell,
New Burlington Galleries,
London, ACGB;
Three Scottish Painters, Crane
Gallery, Manchester;
Festival Group Show,
Scottish Gallery, Edinburgh;
Europa Kunst, Denmark, BC;
Contemporary Scottish Paintings,

ACGB Scottish Committee;
British Watercolours 1914–1953,
Empire Loans Exhibition
Society, Australia.

1955 RSA; RSW.

1956 RSA; RSW; RGIFA.

1957 RSA; SSA; RSW; JM;
*Contemporary British Paintings
1957–1958*, BC Tour.

1958 RSA; RSW;
W.G. Gillies and Joan Eardley,
Scottish Gallery, Edinburgh;
Edinburgh-Nice Exhibition,
Nice.

1959 RSA; RSW; JM;
Stirling Festival Fortnight;
Six Scottish Artists,
Nottingham.

1960 RSA; RSW;
Aspects of Art 1860–1960,
Ashgate Gallery, Farnham;
Some Edinburgh Painters,
National Gallery, Ottawa;
*Watercolours and Drawings by
Contemporary Scottish Artists*,
ACGB Scottish Committee;
One-man show, Stone
Gallery, Newcastle.

1961 RSA; RSW;
One-man show, Stone
Gallery, Newcastle.

1962 RSA; RSW;
*Modern Scottish Paintings from
the Lillie Collection*, SNGMA.

1963 RSA; RSW;
One-man show of
watercolours, Scottish
Gallery, Edinburgh;
Fourteen Scottish Painters,
Commonwealth Institute,
London;
*Twentieth Century Scottish
Paintings*, Kendal;
Modern Scottish Paintings from

the Lillie Collection, ACGB
Scottish Committee.

1964 RSA; RSW; RGIFA;
Contemporary Scottish Painting,
Reading Art Gallery;
ACGB Scottish Committee.

1965 RSA; RSW; RA;
Scottish Watercolours, Scott
Hay Gallery, Langholm.

1966 RSA; RSW; RA.

1967 RSA; RSW; RGIFA; RA.

1968 RSA; RSW; RGIFA; RA;
*Three Centuries of Scottish
Painting*, National Gallery,
Ottawa;
One-man show, Scottish
Gallery, Edinburgh;
One-man show, Loomshop
Gallery, Lower Largo;
RA Bicentenary Exhibition;
Contemporary Scottish Art, Pier
Pavilion, Felixstowe.

1969 RSA; RSW; RA;
*Modern Art from Scottish
Houses*, SAC Gallery,
Edinburgh;
*Scottish Paintings from the Lillie
Collection*, SAC Tour;
Group show, Loomshop
Gallery, Lower Largo.

1970 One-man show, Scottish
Gallery, Edinburgh;
11th Summer Exhibition,
Dinnet.

1970–71 Retrospective Exhibition,
SAC Gallery, RSA Diploma
Gallery and touring:
Aberdeen, Perth,
Dunfermline, Dundee,
London, Glasgow.

1971 RSA; RSW; RA.

1972 RSA; RA.

1973 RSA; RA (Posthumous).

1974 RSA (Posthumous).

INDEX